Historic Photographic Processes

RICHARD FARBER

ALLWORTH PRESS
NEW YORK

Published by Allworth Press
An imprint of Allworth Communications
10 East 23rd Street, New York, NY 10010

Cover design by Douglas Designs, New York, NY

Cover photo © 1998 Richard Farber

Book design by Sharp Des!gns, Inc., Lansing, MI

ISBN: 1-880559-93-5

Library of Congress Catalog Card Number: 98-70401

Printed in Hong Kong

This book is dedicated
with love to my parents,
Irving and Sylvia Krone,
and to my wife,
Kathleen Sheridan.

Contents

Acknowledgments

To THE MANY PEOPLE WHO HELPED WITH THIS BOOK I GIVE MY SINCERE APPRECIATION. I would like to thank Jan van der Schans, who instigated this project; Tad Crawford for easing the obstacles and helping to make this a reality; Kathleen Sheridan for her unwavering support, great line drawings, and for calmly doing a fine editing job in spite of frequent changes; Dr. W. Robert Nix, a true craftsman, for contributing his elegant guest chapter on the bromoil process; Monona Rossol for her invaluable, detailed advice on chemical safety; Dr. Michael Ware for generously sharing his ideas and expertise; Klaus Pollmeier and Suzanne Pastor for making it possible to use a Drtikol image; Dr. Ingeborg Leyerzapf for her enthusiastic support; Harm Botman for generously allowing me the use of his densitometer; and, for believing, Larry Evans.

Introduction

THE "ALTERNATIVE" PHOTOGRAPHIC PROCESSES POPULAR TODAY WERE ACTUALLY ON THE cutting edge of yesterday's technology. Although today's photographic technology is certainly easier to use and more convenient than older techniques, many of the historic processes have never been equalled for their appearance, longevity, and appeal. Ironically, since computerized output is currently limited to color on resin-coated paper, semi-permanent black-and-white prints, or color from inkjet-type printers, the move toward digital or computer-enhanced images has created a new demand for the historic techniques. Being able to make an attractive permanent print, palladium for example, from a digitized negative is surely the best of both worlds. Traditionalists may bemoan the digital age, but the result should be the important thing, not the source, and this fusion between old and new technologies offers exciting possibilities. In a world seemingly dominated by mass-produced items and increasingly sophisticated technology, the historic processes provide a unique means of expression.

To get started with the historic processes, you need only a minimum of equipment— and a lot of enthusiasm. Although, as with any interest, a lot of money can be spent on equipment, it's perfectly feasible to make a beautiful image using nothing more compli-cated than a pinhole camera and a piece of glass for a sun printing frame. Many people think a print must be large, but size isn't everything; a special image will speak for itself in its own way, regardless of its size. A well-crafted 4 × 5-inch (10 × 12.5-cm) contact print softly glowing on a beautiful fine-art paper is both elegant and intimate. Most certainly it's as much an object of desire and a source of delight as a larger print.

Once you decide to try the historic photographic processes, it will quickly become apparent that for serious information, you need access to either an unusually well-stocked home library or a very good reference section in a local library. In addition, some important books are out of print or difficult to find. And to complicate matters, it can be

difficult to find chemicals and measurements in contemporary terms—comparing British, American, and metric measurements in drams, ounces, grains, and grams, for example, can be an exercise in frustration. This text has been designed to simplify the processes by making the most important information available, by listing often hard to find resources, by giving standardized measurements and technical terms, and by providing the serious artist with further references.

This book has been designed as a user's guide to introduce you as accurately as possible to the historic processes. Since photographers who are interested in these techniques tend to be inquisitive by nature, different variations have been given, when possible, to allow you to compare information and explore possibilities for yourself—to help you discover what works best for you.

The text incorporates information from many sources, which have been liberally cited to encourage further research. These, along with the other texts listed in the bibliography, are highly recommended for further exploration of the historic processes; together they should provide interested readers with answers to most, if not all, of their questions. If you have access to a computer, the Internet is recommended as an unprecedented source of information on a global scale (particularly the archives of *alt-photo-process* on the Internet). Refer to the appendix for more details.

For the best results with the techniques discussed in this book,

- find the characteristics of the materials that you'll be using and the safety precautions they require
- follow directions carefully
- mix formulas in the order given
- observe the safety warnings and cautions given in the text
- keep good notes
- be persistent
- always be on the lookout for a great new paper!

Historic Photographic Processes

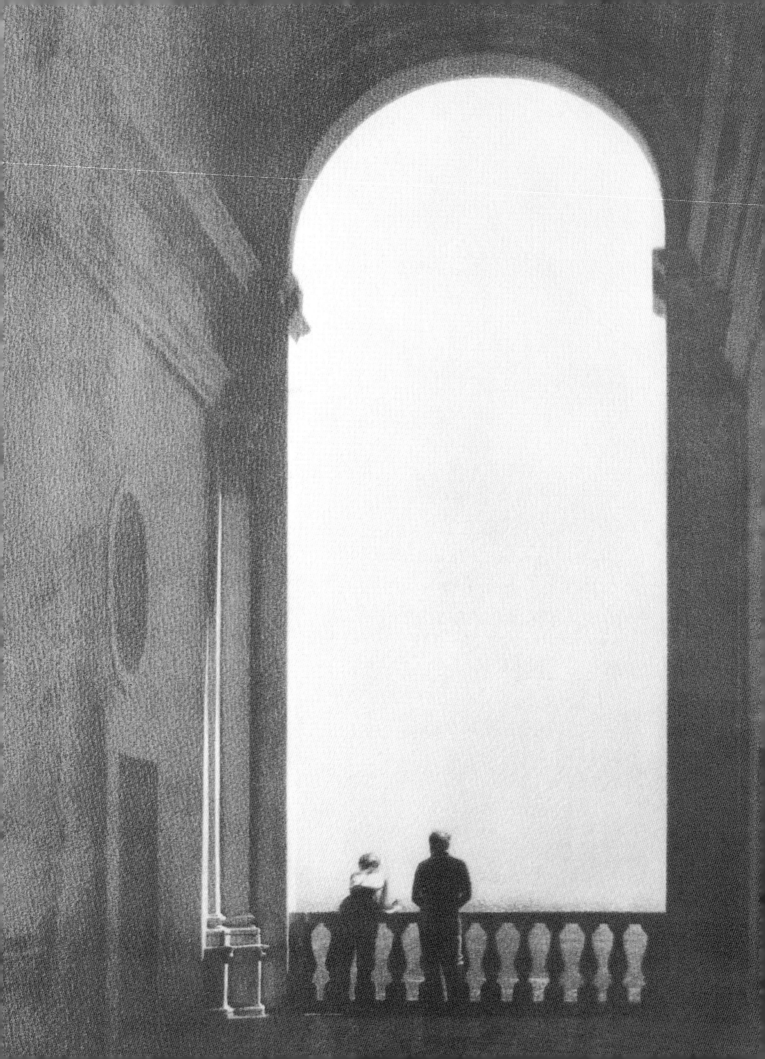

Blue Balustrade *(© Michiel Sonius), gum*
print made with multiple printings.

General Applications

Permanence

Probably the most asked question about the processes described in this book, and related processes, concerns the permanence of the image. This is a complex question and not easily answered. The early images were well known for fading, but this was due in part to improper fixing, toning, and washing practices. For all the faded prints, there are many that have survived in fine condition in spite of less-than-optimum processing and storage. The life span of any silver image, however, should be considered finite; how finite is dependent upon many variables, some of which are listed below:

- How adequately the print has been fixed and washed.
- Whether or not the print has been toned for permanence. Toning greatly prolongs the life of a silver print by combining the vulnerable silver with a more durable substance, such as gold, which is much less affected by environmental conditions.
- Where and how the print is stored. The appropriate pH, humidity, and temperature greatly contribute to the survival of the image.
- The lighting conditions under which the print is displayed. Ultraviolet (UV) light is a known cause of fading for nearly all photographic materials.
- The quality of the support paper that the image is on, or in.

Paper and Sizing

The paper that you choose for interpreting your image is of great importance for both appearance and longevity. An image can be considered only as permanent as the paper upon which it rests, and a paper with archival properties will help give your work an acceptable life span. A full discussion of the types of paper and their properties is beyond the scope of this book, but some of the more important points are briefly covered here.

In a general descending order of quality, paper is made from rag, cotton or linen, and wood pulp. Crawford, however, notes that with careful processing it is possible to make a wood-pulp paper with archival properties for photographic use.[1] He also makes the observation that the most important thing to consider is whether there is acid in the paper or whether there is any material that may eventually cause acid, regardless of the composition of the paper. Finally, what has or has not been added to the paper is also important. Many papers today have alkaline buffering materials added to counter or neutralize acidic elements in the paper. These buffering agents may change the effectiveness of developers by gradually altering their pH as the paper is developed; also, the life span of alkaline-sensitive processes, such as the cyanotype, can be affected, since the image will fade in an alkaline environment. The term *pH* refers to a relative scale of acidity and alkalinity, ranging from 0 for highly acidic to 14 for highly alkaline, with 7 being neutral.

The texture and color of the paper also have an influence on the appearance of the image and could perhaps make the difference between a good print and a great one. If you consider how long it will take to make your special print, it seems reasonable to take a moment to look at, and experiment with, different papers. Something to keep in mind is that once paper has been thoroughly wet and then dried, it may look quite different than it originally did. The paper should also be strong enough that it will not fall apart while wet for an extended period. There are some classic papers with proven track records that are not difficult to find, such as Rives BFK, Fabriano, and Arches watercolor paper. Sources for paper are listed in the appendix.

You may find that *hot-pressed* papers, with their smoother surface, will be more suitable for certain processes than *cold-pressed* papers, which also tend to absorb more liquid. Paper that is sized, either by the factory or you, however, will solve the problem of liquids sinking in too quickly and still permit the use of a more textured surface. Sizing is a substance added to paper either during manufacture or afterwards, which helps to seal the paper fibers and the space between them to prevent an excess amount of liquid being absorbed. Factory-applied sizing may be gelatin, starch, or alum-rosin (which is acidic and should be avoided). Paper may be labeled as *body* or *engine* sized when the sizing has been added directly to the pulp, or *surface* or *tub* sized when the sizing has been applied to the surface of the paper at the factory.[2] You can add additional sizing to sized papers with a variety of materials, some more permanent than others. They include starch (even spray starch), arrowroot, dextrin, gelatin, and commercial sizing. One way to determine if a paper has enough sizing is if you have enough time to spread the sensitizer on the surface of the paper before it soaks in.[3] For only a single coating of sensitizer, most sizing will be adequate; however, for multiple sensitizer coatings, unless you plan to size after each one, a more durable sizing that will not wash off after the first coating (such as gelatin that has been hardened) will be needed.

Gelatin sizing

To gelatin-size paper, prepare a 3% solution of gelatin by adding the gelatin to cold water (3 grams per 100 ml of water) and letting it swell, or "bloom," for 15 minutes. Afterwards, heat the mixture to 46–49°C/115–120°F in a hot water bath and melt it thoroughly. Unless it has been mixed with formaldehyde, the gelatin can be reused. When the gelatin is ready, pour it into a tray and insert the paper. Make certain to brush away air bubbles from each sheet, interleaving the sheets for 3 to 5 minutes. When ready, remove each sheet, let it drain, and hang it on a line by a corner with a clothespin. Depending upon the paper, this process can be done twice if necessary. It's always best to see if one coat will work adequately before bothering with a second coat. If the process is repeated, after the second coat, hang the paper to dry by the opposite corner to equalize the coating.

Hardening gelatin

After the paper has been coated with gelatin (whether once or twice), it needs to be hardened so that the gelatin doesn't wash away with repeated immersion. Alum and formaldehyde have historically been suggested for this purpose. However, unless followed by a very thorough wash, alum may be detrimental to the paper and image over time, and for that reason, it isn't suggested as a first choice. Formaldehyde works well and gradually evaporates, with no long-term problems for the print. Unfortunately, the same can't be said for the person using it, since formaldehyde has a strong, unpleasant odor and irritating fumes, and studies have indicated it to be a carcinogen in animals and it is strongly suspected to be a carcinogen in humans as well.

Some texts recommend adding formaldehyde to the gelatin for the last coat, but it is far safer to use the formaldehyde as a separate step for hardening the gelatin after the paper has been coated. This can be done outside in the open, hanging the paper on a clothesline, thus avoiding making a room, or the entire house, reek of formaldehyde. After the coated paper has dried, make a 3% dilution of formaldehyde (30 ml of formaldehyde per liter of water), pour it into a tray outside and, wearing gloves, immerse the paper. Making certain that you're not downwind, brush away air bubbles and interleaf the paper periodically for 5 minutes (avoid direct contact with the formaldehyde—wear gloves and use a brush and tongs). When the paper is ready, remove each sheet, let it drain, and hang it up by a corner with a clothespin to dry. The formaldehyde will gradually evaporate, leaving no risk of future damage to the paper, and the paper will keep indefinitely. The formaldehyde can be reused; store it in a clearly labeled container.

> **!** If you are using carbon tissue, store it well away from formaldehyde, since the fumes will harden or fog the carbon tissue.

A relatively new material for hardening gelatin that may be as effective as formaldehyde is glyoxal, which comes as a 40% solution. While the odor of glyoxal seems

less noxious than that of formaldehyde, limited studies indicate that it may have the same hazards as formaldehyde.[4] Although it is not listed as a carcinogen, there are reports that it may be mutagenic. The health implications of using glyoxal are not fully known since there has not been a great deal of testing on it.

> **!** Use the same precautions you would for handling any potentially hazardous material: remove contact lenses, wear eye protection and gloves, and handle it only under a fume hood. (See the chemical section in the appendix for details and cautions.)

Glyoxal is used as a 1% solution, made by adding 25 ml of a 40% solution of glyoxal to 900 ml of distilled water. Add enough additional water to bring the level to 1 liter. Soak the gelatin-coated paper for 5–10 minutes in a tray filled with the 1% glyoxal solution. Although there is little odor, this step is best done outside since the vapor can irritate the mucous membranes and eyes. After the paper has soaked, hang it up to dry with a clothespin on a line outside.

Arrowroot sizing

Arrowroot paper is made by brushing on a starchy solution made from arrowroot powder. This fills the pores of the paper and forms a smooth surface. When used as a support for salted paper, the starch imparts the characteristic reddish color to the image, as well as added brilliance due to the smoother surface. Unlike gelatin, however, it is not useful for multiple printing. Arrowroot can be found in most grocery and health-food stores.

To make the arrowroot solution, add enough cold water to 35 grams of arrowroot powder to create a creamy mixture. In a glass or porcelain container, add 35 grams of sodium chloride (table salt) and 3 grams of citric acid to 950 ml of water. Bring the water to a boil and add the arrowroot mixture. Boil for a few minutes, stir with a wooden or glass utensil, and then allow to cool. When the solution is cool, remove the skin that has formed on the surface.[5]

The easiest way to apply the arrowroot solution is with a brush, but it can also be applied with a disposable sponge brush, then evening out the coat with a squeegee or glass rod. Another method involves immersing the paper in the arrowroot solution and pulling the wet paper over or between glass rods to even out the arrowroot coating. The paper can also be floated. However the arrowroot is applied, it needs to be evened out as much as possible on the paper. After this is done, the paper can be hung with a clothespin to dry.

Dextrin sizing

Dextrin can be added to paper as temporary sizing to help prevent the sensitizer from sinking into the fibers. It will later wash out, leaving the surface of the paper with no

coating to obscure the texture. Nadeau suggests making a 10–20% solution (10–20 grams per 100 ml of water) and sponging it on.[6] After the dextrin has been applied, the paper can be hung up by a corner to dry.

Safelight

The historic processes described in this book have very little sensitivity to yellow light; a simple yellow bulb at a reasonable distance makes a very satisfactory safelight. A regular low-wattage tungsten bulb can also be used, as well as a regular darkroom safelight. Fluorescent light should not be used because it will fog the paper (see the section below about light sources).

It should be kept in mind that it's all too easy to exceed the safe amount or duration of light required and to end up with a fogged image.[7] Tracing the source of fog (or any problem, for that matter) can be very time consuming, not to mention frustrating. Minimizing potential errors of this sort will make your relationship with the historic processes much more enjoyable and productive.

Measuring Solutions

In order to avoid confusion, it's important when reading and comparing formulas to know that solutions can be given in three ways, which in turn have three very different meanings:
- weight/volume (*w/v*), which indicates the *weight* of a substance to be added to a specified *volume* of liquid, such as 10 grams of borax added to 90 ml of water
- weight/weight (*w/w*), which indicates the *weight* of a substance to be added to the *weight* of a liquid, such as 10 grams of borax added to 90 grams of water
- volume/volume (*v/v*), which indicates the *volume* of liquid to be added to another *volume* of liquid, such as 10 ml of ammonia added to 90 ml of water

For those who prefer to measure dry materials with implements such as spoons or small containers, as long as the amount measured is not too small, it doesn't make much difference how the materials are measured. It just needs to be done consistently.

> If this sort of measuring method is used, the resulting measurements will be comparable in *volume* only— not in weight.

Percentage solutions

An easy way to think of a percentage solution is as a *total* volume of 100 ml of liquid *including the chemical.* This is made by adding the chemical to an amount of liquid less than 100 ml and then adding enough liquid to bring the total volume up to 100 ml. The

amount of chemical added to the 100 ml can then be directly stated as a percentage. For example, a total volume of 100 ml of water that contains 10 grams of borax would be a 10% solution.

The percentage of a chemical in a liquid can be found by dividing the amount of chemical by the amount of liquid (use the same measuring system, such as metric, for both amounts). For example, the percentage of 200 grams of sodium citrate contained in 500 ml of water would be 200 divided by 500, which would equal 0.4 or 40%.

The amount of chemical per milliliter can also be found by dividing the amount of chemical by the total volume of liquid (use the same measuring system for both amounts). For example, if 10 grams of borax are contained in 100 ml of water, 10 divided by 100 would equal 0.1 of 1 gram in each milliliter. Since weighing very small quantities, such as 0.3 gram, is difficult to do accurately without a very good scale, a convenient way to measure small amounts accurately is to make a higher percentage solution than needed and use small amounts of it. Using the example above, to accurately measure 0.3 gram of borax would be simple, since 1 ml contains 0.1 gram of borax; then 3 ml would contain 3 times 0.1 gram, which would equal 0.3 of a gram of borax. By comparison, if a scale with an accuracy of ±0.1 of a gram were used to weigh 0.3 gram, it could weigh between 0.4 and 0.2 gram, which would be a 30% deviation, which is far too high to be acceptable.

Saturated solutions

A solution is considered to be *saturated* when a liquid at a given temperature contains the maximum amount of a substance that can be dissolved in it.[8] It is important to remember that the amount of a substance that can be dissolved in a given amount of liquid will vary with temperature. More of a substance can be dissolved in a warm or hot solution than in a cold one.

Sensitizing Methods

All the processes described here require sensitizing before use. There are three methods for doing this: brushing, using a rod, and floating.

Unless you are making a large image or using a process that requires floating, the sensitizer can generally be measured with drops into a small plastic or glass (but not metal) container. It will take about 12 drops for a brush and perhaps half that amount using a rod for a 4 × 5-inch (10 × 12.5-cm) image on sized paper. Obviously, if the paper is extremely absorbent and not well sized, it will take a greater amount of solution to sensitize it. Pipettes that have milliliter markings on them are excellent for measurements larger than drops.

> *Do not use your mouth to draw solution into a pipette!* The pipette should come with a rubber bulb on the end, or you should have one available for that purpose.

Because applying sensitizer with a brush or rod is necessary for many of the historic processes, it might be a good idea to first practice with colored water. Beyond the value of practicing this technique, this will also give you some idea of how much liquid is needed to cover a given area adequately.

Make certain that the sensitized paper is dry before use; if it is not, your negative can be permanently stained. A very thin sheet of Mylar, 1 mil (0.025 mm or 0.001 inch) thick, can be placed in between the negative and paper for protection without greatly affecting sharpness. Considering the fact that the negative will also be exposed to strong ultraviolet (UV) light and possibly some heat, it is always a good idea to use a duplicate negative instead of the original.

Sensitizing with a brush

The paper should be larger than the negative to allow for brushstrokes and mounting. Make certain that the selected side of the paper is facing up, and pin or tape the corners down on a firm—preferably waterproof—surface. If the paper has a watermark, the front

of the paper is facing upwards when the watermark is also facing upwards and reads correctly. With light pencil marks, mark the perimeter or corners of the negative on the paper. If you do not want the characteristic brushstrokes to show on the outer part of the image, the edges can be masked with tape, or an opaque mask can be attached to the negative.

Before using the brush, dampen it slightly with distilled water and remove excess water with a paper towel or blotting paper. This helps prevent the brush from absorbing the sensitizer. Under safelight conditions, measure the correct amount of sensitizer into a container, as described above. Then pour the measured sensitizer in a line down the center of the marked area of the paper and brush quickly and evenly: first, top to bottom; then side to side. It is important not to let the

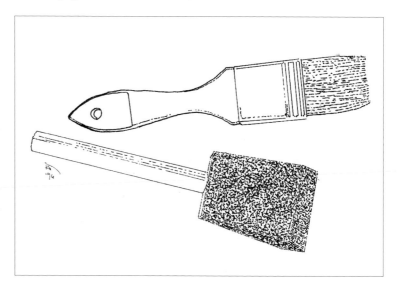

Many of the historic processes use a bristle brush and a plastic foam brush to apply the light-sensitive coatings. A Japanese hake *brush (not shown), which has the brush element sewn on rather than attached with a metal ferrule, is also a satisfactory alternative for many of the processes.*

sensitizer puddle since that will cause a dark streak. Disposable foam brushes and Japanese *hake* brushes work very well for this purpose, as do disposable medicine cups; both can be washed out and used many times.

! To avoid potential problems with contamination, dedicate the brush and container to one purpose or
● process only.

Sensitizing with a rod

Ware describes a method of sensitizing with a rod or tube that is elegant in its simplicity.[9] The rod can be glass or plastic, but it must be smooth and free of scratches to avoid damaging the paper surface. It needs to be at least as long as the length or width of the surface that you plan to coat. The ends can be bent up to form a handle, or a small piece of plastic can be glued on to serve as a handle.

Using tape, fasten the paper to be sensitized to a firm, waterproof surface, and with a pencil, mark the paper around the margins of the negative. Use a pipette or syringe or pour the sensitizer in a straight line across the top of the image area. Place the rod in the sensitizer and draw it toward the bottom margin. Lift the rod slightly at the mark you made for the bottom of the negative. Then place it down again and push it back up to the top mark. Do this slowly five to six times, without rotating the rod. If there's a small amount of liquid left when you have finished, it can be blotted with a small piece of paper towel or blotting paper. You will probably find that this method uses less sensitizer than other methods, thus saving expensive materials.

> **!** While this procedure works well on smooth paper, it isn't as effective with rough-textured papers.

Sensitizing by floating

Sensitizing paper by floating is an acquired skill. The main problem is that the paper will start to curl up into a tight roll as the fibers swell and expand on one side. Some suggestions for success with floating paper are the following:
- keep the paper at the same temperature as the solution
- evenly roll the paper onto the solution, from the center outwards, as you hold two opposite corners or edges
- moisten the back of the paper with a spray container filled with water

An alternative method that works very well is to make a "boat" by folding 1 or 2 cm of the four sides of the paper up, thereby stiffening the paper edges. The boat can then be laid on the solution without too much trouble.[10]

Light Sources

Since glass does not transmit wavelengths shorter than 340 nm, the exposing light should be around 350 nm and the glass should be as thin as possible to avoid extra light absorption.[11]

The sun is an excellent source of UV light, but in different seasons you have to compensate for things such as clouds passing by, time of day, and the position of the sun. Sun printing is obviously limited to the daytime, as well as to fair weather. Because of this, fluorescent UV lights are an attractive option. Sometimes used as tanning lamps,

UV lights are often labeled "BL" in the United States and "UVA" in Europe. Unlike regular daylight or cool-white fluorescent tubes, UV lights emit a large portion of their illumination in the range of 350 nm. They are consistent in light output, give off relatively little heat, are economical to use, and permit you to work regardless of the weather or time of day. There are other light sources that will work well with these processes, but they are inconvenient, more expensive, or potentially dangerous, such as the carbon arc.

Graphic arts printers are also available. They generally include a light integrator for consistent, repeatable lighting, which measures the amount of light delivered over specific time periods, and a vacuum frame that ensures very close contact between the negative and sensitized material, resulting in extremely good sharpness. However, they cost quite a bit more than the more conventional light sources mentioned above.

! Do not use a graphic arts printer with a carbon-
● arc light source. This type is dangerous because it emits hazardous fumes.[12]

Recent experiments by Davis with gum and palladium have demonstrated that ordinary daylight fluorescent tubes emit enough UV light to expose your paper adequately.[13] Data for carbon printing indicate that if the amount of dichromate is adjusted to a higher concentration (thereby *lowering* the contrast), the daylight-type fluorescent tube is just as effective as the UV tubes alone.[14]

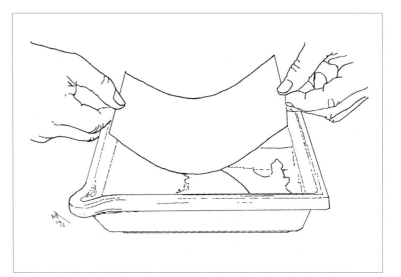

Historically, in some processes, such as albumen, the paper is coated by gently laying it on the coating liquid in a tray for a few minutes to evenly absorb the liquid on one side. This simple procedure usually takes some practice to master.

The first thing usually learned about floating paper is that it has a great tendency to form a tight curl when it comes in contact with the liquid. One solution to this problem is to fold up the edges a bit, making a sort of boat.

! The daylight tube originally used by Davis has probably been changed by the manufacturer, so results
● may not be the same with the tubes that are currently available. In the United States, the GE tube GE F20 (or F40) T12 SP65 might be a close match. In Europe, the Philips number 33 tube seems to work well. Other manufacturers undoubtedly have similar tubes, but you will have to test them yourself to see if they fit your needs. The Philips tube did very well in an informal test with palladium.

It is fairly simple and inexpensive to build your own fluorescent UV light unit. Uncoated fluorescent UV tubes are well suited for this purpose; the coated tubes used for theatrical purposes are more expensive and not any better for this use, nor are the small bulbs used for "black light" displays.

> ! Wear goggles designed to protect your eyes from UV light when working with this type of light source. Make sure these are wraparound, 100% UV protective goggles (which can be easily and inexpensively purchased).

Sources for UV fluorescent light units, such as Edmund Scientific, are listed in the appendix under Sources of Supplies.

Contrast Control
Contrast control with light

The amount of UV and blue light present at exposure will, to some degree, determine contrast; direct sunlight gives less contrast than indirect, thus the old adage of printing in the shade for thin negatives. The higher the proportion of blue light to yellow, the softer the print will be, and vice versa.[15] It has also been suggested that contrast might be controlled slightly by using a blue or yellow filter over the contact frame.[16]

Recent tests with carbon printing indicate that contrast control may also be possible with the use of regular cool-white or daylight fluorescent tubes in place of, or in combination with, regular UV fluorescent tubes. With the use of either cool-white or daylight tubes, the print contrast appears to be nearly the same as when a restrainer is used in the sensitizer, delivering higher contrast and reduced highlight density unless the dichromate concentration is adjusted to the light source.[17] It's important to note that even with the same amounts and concentrations of dichromate, different pigment colors will very likely have different contrasts and speeds. This is due to what is called the *internal filter effect,* which is the filterlike effect of the pigment or other colored substances such as platinum or potassium ferricyanide.[18]

Contrast control with dichromate

> ! Use caution when handling dichromates; they are corrosive and are known carcinogens. They are dangerous through all avenues of exposure. Avoid inhalation of the dust; mix dichromates under a fume hood or in a glove box. Avoid contact with dichromates; wear gloves, goggles, and a dust mask when handling them. (Refer also to the chemical list in the appendix for more detailed information.)

Dichromate is used as the primary means of controlling contrast in carbon, carbro, and kallitype printing. It can also be used as an additional control for the other processes, acting as a restrainer, which reduces highlight density and gives a higher apparent contrast.

There are three types of dichromate: potassium dichromate, ammonium dichromate, and sodium dichromate. Because there is a lack of clarity in some texts describing saturated dichromate solutions, the following should offer more consistent measurement: 100 ml of a saturated solution (see the section on measuring solutions in this chapter) contains 14.2 grams of potassium dichromate (at 25°C/77°F), 33 grams of ammonium dichromate (at 25°C/77°F), or 111.4 grams of sodium dichromate (at 18°C/64°F).[19] The effects of each of these solutions can differ because they each contain substantially different amounts of dichromate ions. Substitution of one type of dichromate for another should be based upon the *concentration* of dichromate in each solution.

Potassium dichromate has traditionally been recommended, with ammonium dichromate suggested for increased sensitivity. However, if the solutions are adjusted to 3.5% and 2.5%, respectively, they have been found to have the same sensitivity.[20] Sodium dichromate has apparently not been popular because it has a tendency to absorb water, which makes consistent weighing difficult; however, this is less of a problem than it would appear. Sodium dichromate is actually closer in sensitivity to ammonium dichromate than potassium dichromate is, although the sensitivity varies in different colloids, such as gum and gelatin.[21] For the techniques described in this text, except for gum, equal concentrations will yield close results.

However, there are times when the specific effects of a saturated solution are desired, for example, with gum printing. In carbon printing, a lower dichromate concentration produces higher contrast, and a higher concentration produces lower contrast. Unlike carbon, gum bichromate responds only slightly to small changes in the dichromate dilution, other than altering the sensitivity.

If you decide to try using daylight fluorescent tubes for your light unit, you may find that because sodium or ammonium dichromate solutions can be made in greater concentrations than potassium dichromate, they can be more effective for increasing sensitivity and managing contrast than the weaker potassium dichromate. Davis, for example, suggests using a 25% solution of ammonium or sodium dichromate for use with daylight fluorescent tubes and gum printing.[22]

Contrast can be controlled in salted paper, cyanotype, and albumen by adding drops of potassium dichromate to the sensitizer and, in the case of the ferric processes (other than cyanotype), to the developer. The amounts and concentrations are given with each process.

Dichromate-sensitized paper will not keep and should be used as soon as possible. If you use dichromate in the developer solution, its effects will gradually become less effective as it is used, since the dichromate will gradually be depleted. To monitor the degree of change, expose a sample of paper with a step tablet and develop it at the beginning of the printing session. Periodically during the developing session, expose another step tablet and develop it. It will be evident when the level of contrast starts falling off, since more exposure steps will be visible on the test strip.

Exposure Control

If the sun is your source of light, the exposure time will differ according to the time of day or the season. But there are ways to determine exposure with the printing-out processes. One time-honored method is to visually check the exposure periodically to see how it's coming along (which can be done with a hinged-back contact printer). There will be an image, called a *provisional* image, visible. And although this is not a foolproof method, a practiced eye can determine exposures fairly well for many of the processes yielding a provisional image.

> This doesn't work with processes like carbon and gum dichromate because the dark pigment generally obscures a provisional image; their exposure must be measured by time.

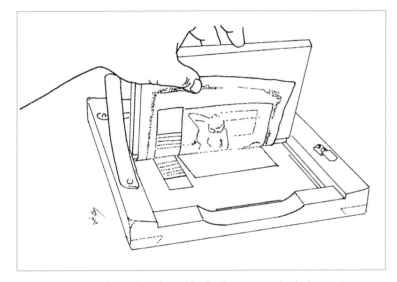

A contact printer with a split or hinged back allows you to check the ongoing exposure of a print-out process from time to time without disturbing the position of the negative. In this illustration, a step tablet is visible in the open part of the back. This can be used to help determine the correct exposure.

A more consistent means of determining exposure is to make an initial test print with a negative step tablet, also called a *step wedge*. A negative step tablet is a film strip of evenly divided sections, or steps, each receiving more exposure than the preceding one. Usually the intervals between steps is 0.15 density or ½ stop. Step tablets are available calibrated and uncalibrated. The less expensive, uncalibrated ones will work fine for the processes described here.

To use this method, you need a small piece of sensitized paper and a small step tablet, such as a Kodak Number 2. Under a safelight, place the step tablet on the sensitized paper and put them together in a contact printer with the negative side up. Make a guess at the time for exposure, make the exposure, and then, using a safelight, remove the exposed paper. Look for the first step that's just darker than the paper base itself and make a mark next to it. Process the print, dry it, and again look for the first step that's just darker than the paper base. Count the number of steps that it has changed. Place the step tablet and your negative on a light table and find the density on the step tablet that is the same as the highlight density on the negative and make a note of it. When you expose your negative, also put the step tablet on the sensitized paper, outside of the image area. When the highlight density of the negative, plus the number of steps lost during processing are reached, the exposure has been long enough. In summary, overexpose the print for the number of step-tablet steps that are lost in processing.

A normal timer with an integrated light sensor is useless for measuring and timing UV light. Aside from the light integrator in a graphic arts printer, however, there is a

versatile digital timer that was designed to be used in the darkroom to compensate for fluctuating cold-light heads but also has the capacity to accurately time and compensate for fluctuating UV light sources, including the sun.[23]

Contact Printers

The split- or hinged-back contact printer was designed for the historic processes because it allows for periodic checking to see how the exposure is going without disturbing the position of the negative on the paper. As the exposure progresses, one part of the back can be opened—in very subdued light or under a safelight—and the provisional image can be examined to determine how much more exposure is needed, if any (see above).

Used printing frames can frequently be found for reasonable prices at flea markets and secondhand shops. Not all contact printers are well designed, however, especially some of the inexpensive modern ones. A well-constructed contact printer, like any good tool, will be a pleasure to use for many years. The hinged back should have a thin pad of felt or similar material, and the springs should hold the negative and paper tightly and evenly together. Modern variations using surgical tubing to hold the back to the glass tend to be less convenient to use.

While the hinged-back contact printer is easy to use, unless it is very well designed, it may not give the sharpest image because of imperfect contact between the negative and sensitized material. Although more expensive, a vacuum-type frame will, at the expense of portability and the ability to monitor exposure visually, deliver the sharpest image possible.

Glass absorbs some UV light but allows the transmission of about 350 nm, which is satisfactory for the printing-out processes.[24] Some modern printing frames have a special type of plastic that transmits a greater amount of UV light than glass; however, it must be remembered that plastic is much easier to scratch and costlier to replace than glass. It's also doubtful whether there's a great enough increase in printing speed to justify the added cost.

Although a hinged-back contact printer is ideal for the historic processes, it isn't a necessity. A contact printer with glass hinged on one end, commonly used to proof negatives, or even a heavy piece of glass, will also work for this purpose. The drawback, of course, is that it will be difficult to examine the exposure without disturbing the negative alignment.

Sources for contact printing frames are given in the appendix.

Registration Methods for Multiple Printing

Paper shrinks after the first processing, so for accuracy with multiple prints and, particularly, for large prints, the paper should be preshrunk before it is sized. This is easily done by soaking the paper in hot water for 3–10 minutes and letting it dry. In practice, however, the paper doesn't necessarily return to its original dimensions even if preshrunk.

If the multiple printings must be precisely aligned, it's a good idea to position the negative over the image and examine it visually to make certain that everything lines up.

There are several ways to register, or align, the negative and paper for multiple printings, all done before the paper is sensitized. Some of them are listed below:

1. Lay the negative down on the paper and make pencil marks at each corner, or outline the entire negative, aligning the negative with the marks before each printing.

2. Sullivan suggests dry-mounting the uncoated paper with releasable tissue to perforated "computer" board, a thin plastic used for circuit boards, or some other heat-resistant material, such as aluminum. When all the printings are completed, the paper/board sandwich is heated to the appropriate temperature for release and the paper is removed from the board.[25]

> **!** With this method, there is the possibility that an adhesive residue will be left on the back of the paper.

3. Another method is to use registration pins. Commercial registration pins can be used to align the paper and negative, or you can make your own. Commercial pins have a small raised pillar (usually ¼ inch, 6 mm, in diameter) on a metal tab. A homemade pin system can be made by gluing two ¼-inch pins into position on a firm, thin surface, such as a piece of thin plastic.

To use the pin system, attach a narrow piece of clear plastic, such as that used for overhead transparencies, to one side of the negative with transparent tape. Lay the negative on the paper and, using a standard two-hole paper punch, punch through the clear plastic and paper. There should be enough clear plastic that the negative can be positioned at the desired spot on the paper and also that the registration holes will be near the top of the paper, so that the area with registration holes can be removed later. Using a scrap piece of plastic that has been punched with the paper punch for a template, attach the two pins to the inside of the glass of the contact printing frame by taping them down. When you are ready to make an exposure, attach the negative with the punched plastic to the two pins, *emulsion side up*, place the sensitized paper over the pins, *emulsion side down*, and then put the back of the contact printer into place.

A mask that is either larger or smaller than the support paper can be made from heavy paper or a plastic material such as acetate. Place a ruler vertically in the center of the mask and make a short registration mark on the top and bottom edge. Do the same on the two horizontal edges. Cut a window in the mask slightly smaller than the negative and tape the negative to it by the edges. Cut or make a mark on the top edge of the mask so that later you can orient it correctly. Place the mask over the sensitized paper and fasten it down with a few pieces of tape. Make registration marks on the sensitized support paper that correspond with the registration marks on the mask. If the mask is larger than the

support paper, make the marks on the back of the paper. If the mask is smaller than the support, make the marks on the front of the support paper.

Make the exposure with the mask in place and remove it before processing. After the first exposure has been dried and the paper resensitized, the mask can be put back on the support paper and the registration marks previously made can be easily lined up. The drawback to this method of registration is that the support paper tends to curl after it's been wet, which makes it difficult to line up with the mask again.[26]

Negatives

All the techniques in this book, with the exception of carbro, gelabrome, and bromoil, are contact processes that require a negative the same size as the desired print size. This means that either a large-format camera must be used or an enlarged duplicate negative must be made from a smaller format.

The easiest and most accurate method is to use a large-format camera with a large negative. An alternative for those who don't have a large-format camera and don't mind a lack of flexibility is a pinhole camera. While a pinhole image can be quite beautiful, it involves long exposures and a lack of sharpness compared to a conventional camera system. However, if it fits within your needs, it is a method well worth exploring.

Whatever the size of the original negative, remember that unless you have a copy, if the negative is damaged, it can't easily be replaced. You should also remember that if you expose and develop for a specific density range, such as for salted paper, the resulting negative will not be suitable for processes that require a substantially different density range, such as gum bichromate.

A duplicate image, even if it is a second- or third-generation translation, has many advantages. One especially valuable function of a duplicate is that if it's damaged, it can easily be replaced. Using duplicate negatives can also add flexibility by providing negatives of different density ranges for specific techniques from an original with a normal density range. A duplicate negative can also be corrected or even improved over the original by modifying the exposure and developing.

Making the duplicate negative

Duplicate negatives can be made in a number of ways. A larger negative can easily be made directly from a smaller-format negative with Kodak Direct Duplicating Film in only one step, although the film size is limited to 8×10 inches (20×25 cm). If you use a direct duplicating film, remember that a longer exposure lightens the image and a shorter one darkens it. Burn in an area by dodging it, and dodge an area by burning it in. Try using Kodak Dektol (also known as D-72), diluted 1:1 (one part Dektol to one part water) for 2–6 minutes at 20°C/68°F.

You will find that the use of a negative step tablet will make the duplicating process

easier and more accurate. A densitometer isn't a necessity, but it is obviously more efficient and accurate than the unaided eye for critical measurements. Nonetheless, reasonably accurate measurements can be done by eye using a step tablet to compare tonal values on a light table.

More control, as well as larger film sizes, can be gained by using a two-step process: from the original small negative to a contact, or enlarged positive, and then to the final enlarged negative. The films used in these processes are orthochromatic and can be safely handled under a safelight, unlike panchromatic film, which is more sensitive and must be handled in darkness. Panchromatic film can be used with excellent results, but there is the inconvenience of working in the dark and you must also be able to time extremely short exposures accurately.

Using the two-step method of duplicating negatives, there are three basic ways to make the duplicate positive: contact printing, using an intermediate-sized positive, and a using full-sized positive. If you're enlarging a negative smaller than 2¼ inches (6 × 7 cm), it will be easier to enlarge it slightly rather than trying to contend with a small image if modifications are needed.

There are several types of film available for enlarging, each with its own characteristics; however, if you're looking for film in sizes larger than 8 × 10 inches (20 × 25 cm), you may have some difficulty finding it. Kodak makes several films, such as 4125, which has an enhanced highlight contrast, and 4127, which has moderate contrast. Ilford makes a film called Commercial Ortho, which has fine grain and medium contrast. Agfa has a film called N31-P and a version with a thicker base called N33-P; they are fine grained, medium contrast, and available in larger sizes. There is also an Agfa film available that can have the contrast determined by the color of the exposing light. This variable-contrast film is called Gevarex GO 210p and 230p. Unfortunately, this unique film can be quite difficult to find. With a little searching, other films, such as inexpensive litho film, can be found and used with good results. Instead of processing these films in a high-contrast developer, use a more dilute developer, such as diluted Dektol, for a continuous tone.

You only need to know a few basic sensitometry values for duplicating. If you use neutral density filters, these values may already be familiar to you. The logarithmic value of 2 is 0.30, which is also the equivalent of one f-stop; therefore, two stops would equal 0.60, three stops would equal 0.90, and so forth. A half stop would be 0.15, one and one-half stops would be 0.45, and so forth. The first value (the lightest step) of a step wedge, such as the Kodak Number 2 step tablet, is 0.05 in density, with each additional step of density increasing by 0.15, or one-half stop.

Density range, for the purpose of this explanation, is the difference between the brightest highlight and the deepest shadow with some texture. For example, if the highlight measurement is 2.1 and the shadow is 0.6, the density range is 2.1 − 0.6, or 1.5. Dividing 1.5 by 0.3, you will find that the density range of 1.5 is equal to five stops. Developed film, even with no image, still has a very slight density, called *film base plus fog (fb + f)*. The measurements suggested here will include *fb + f*.

For optimum results, each process requires a negative of a specific density range. A

negative step tablet or gray scale can be used to find the negative density range best suited to your paper. This procedure is very similar to that described above for determining the proper exposure time for your paper. Expose a negative step tablet on your sensitized paper and process it normally. Since you're looking for the maximum density, when the first (or lightest) density step matches the area of the paper outside of the step tablet in tone, then you have reached the maximum exposure for paper and gray scale. This will enable you to find the density range. Count the number of steps that can be seen as different in tone from one another and multiply their values.[27] For example, if each step of your step tablet is equal to 0.15 density and the number of steps that can be differentiated from each other is 11, then you would multiply 0.15 by 11 and find that the negative density range best suited to your paper is about 1.65.

To make the positive, expose for the highlight values and develop for the shadow values. Begin by placing the small negative into the enlarger and focusing for the size wanted; put a piece of black paper on the easel to keep light from bouncing back and affecting the exposure. Put the duplicating film (a whole piece is best) into position, emulsion side up. If there's a code notch, this will be with the notch to the right; if there's no notch, the emulsion side is the lighter colored side. At $f/8$ or $f/11$, make a test strip with a series of 3-second exposures. Process the film and dry it before evaluating it. Process it in a drum or tray. For tray processing, use a tray one size larger than the film to allow for more even development.[28]

Although there are many developers, you might try Kodak HC-110 dilution C (1:4) for 5½ minutes, or a softer-working dilution B (1:7) if the original is contrasty—each at 20°C/68°F. Note that these dilutions are from the stock solution, not the concentrate. If the shadows are too dense, try reducing the developing time, but less than 3 minutes isn't recommended because of the risk of uneven development. If these dilutions are not adequate, try a more dilute solution.

The positive should be somewhat flat, with information in the shadows and highlights. Compared to a step wedge on a light table or to a densitometer, the highlights should be about 0.5–0.7, the midtones about 1.2, and the shadows about 1.7–1.9. The density range should be three or four stops, or 0.9–1.2. If corrections need to be made, change the exposure time for the highlights and the development time for the shadows. The midtone value, if necessary, can be modified by using a different developer dilution.[29]

To make the negative, expose for the shadow values and develop for the highlight values. Unless a contact duplicate is being made, put the positive in the enlarger and focus for the size wanted. Make a test strip the same way you did for the positive, using a full sheet of film. Make sure that you have a black piece of paper on the easel to prevent light from affecting the exposure.

Again, using the example of Kodak HC-110, try starting with dilution C (1:4) from the stock solution at 20°C/68°F for 5½–8 minutes. To raise or lower the midtone values, try using a more concentrated developer dilution for a shorter time, or a more dilute developer for a longer time.

If the final negative still doesn't have enough density, you might try a more contrasty

film for the positive, such as a litho film developed in HC-110 with a 1:19 dilution for 4 minutes.[30] Another possibility is to use Kodak selenium toner to intensify the positive and/or the negative. Make a selenium bath by diluting selenium toner solution (1:2) with water or a hypo clearing agent (one part selenium toner to two parts water or clearing agent). *Wearing gloves,* immerse the negative into the selenium bath for up to 5 minutes. Afterward, treat the negative in a hypo clearing bath or 1% sodium sulfite, and then wash and dry it. The highlights will be most affected, with little change in the low values.[31] The selenium can be saved and reused, so keep it in a clearly labeled container.

> **!** Selenium is a dangerous material. Do not mix it yourself; use the premixed solution. Be sure to have good ventilation when using this product. Selenium can be absorbed through the skin; wear gloves and eye protection. Do not pour used selenium down the drain; save it and take it to your chemical recycling center.

After the negative has been processed and dried, examine the densities with a densitometer or on a light table with a step wedge. Depending upon the technique that you intend to use, the shadow value should be about 0.45–0.60 and the highlights around 2.00–2.35. If corrections need to be made, change the exposure time for the shadows and the development time for the highlights (notice that this is the opposite of the procedure for a positive image). The midtones can be fine-tuned by changing the developer dilution.[32]

Alternative methods

There are also less traditional ways to produce a duplicate negative. If you use a reversal film (which will give a positive transparency), such as Agfa's unique black-and-white Scala for the original, then it can be enlarged directly to a negative in one step. Polaroid 35 mm Polapan CT goes one step further by being an instant-process film; high-contrast variations are also available. Regular panchromatic film can be reversal processed to yield a positive, which can then also be directly enlarged to a negative in one step; some, such as T-Max, are available with a convenient kit.

Color slides can be directly enlarged to negatives by using a copy film of the size wanted; for a more accurate rendition of gray tones, a panchromatic film can be used. Both black-and-white and color work can be digitally enlarged on a computer and then reproduced on special printers or printed by a service bureau. Negatives can also be made from scanned images. This is an area of consternation to some who do not regard the use of a computer as "photography." But the same argument could probably have been made scores of times as photographic technology has changed since its inception. It would seem to make little difference whether an image is enhanced by computer or hand. The best advice is to use the tools available to your advantage and leave the worrying to others.

Black-and-white and color photographs can be rephotographed with black-and-white film, producing a black-and-white negative, which can then be duplicated if necessary. Photographs can also be copied in duplicating machines, yielding a transparency or a negative on acetate or paper. Some of the more recent duplicating machines have more specialized functions and can perform a number of advanced tasks, such as adding a halftone mask. Paper or acetate negatives can also be made on computer printers.

Finally, it is possible to use a paper negative made from enlarging paper. Because of the thickness of the paper, the exposure will have to be longer than when using conventional negative material. It is best to use as thin a paper as possible to counter the light loss. There is one type of enlarging paper called *document weight* that is very thin. Resin-coated paper also works well because it has little paper structure to interfere with the image. Fiber-based paper can be waxed or given a light coat of baby oil to make it more translucent. Be sure not to apply the wax or oil to the emulsion side and to blot it well before use.

To help disguise the grain of the paper, a special procedure called *flashing* is sometimes used for making the negative. To do this, first make a test strip with no negative in the enlarger and with the paper turned emulsion side down. Then develop and fix it. Find the strip just before the first one that shows density beyond paper white. This additional exposure will add a small amount of overall density. After determining the flashing time, make the exposure with the negative in the carrier. After the exposure has been made, take the negative out of the carrier, turn the exposed paper emulsion side down, and give the flashing exposure. Process normally.

After the paper has been processed and dried, the positive paper image can be enhanced or manipulated by putting the positive facedown on a light table and, on the back, using a soft-lead pencil to darken parts of the image, thereby making them lighter in the final negative and darker in the print made from that negative. Another modification is to use a ferricyanide bleach to *carefully* lighten areas that you want to appear darker in the negative and lighter in the print made from the negative. After the modifications have been made to the positive, it is contact printed, emulsion side *up*, on the emulsion of another piece of enlarging paper. After being developed and dried, the paper negative can then be placed on a light table and, if desired, manipulated by using a soft-lead pencil on the back. The negative image is made with the positive facing the light source and the papers placed emulsion to emulsion.

Notes

There are several articles dealing with making a duplicate negative. The one by Crane (1992) is exceptionally clear and easy to understand. The one by Davis (1992) is a very good explanation about using sensitometry to design an appropriate duplicate negative.

The book by Burkholder (1995) provides excellent directions for making negatives with a computer.

There is a set of articles by Jilg and McNutt (1989) that cover negative masking for contrast reduction, shadow contrast control, and highlight control, and also give excellent directions for negative registration. Using these methods, the shape of the film curve can be modified for different goals.

Directions for building your own UV fluorescent light source can be found in Davis (1996), Stevens (1993), Sullivan (1982a), and Nadeau's books. Your local electric-supply or hardware store can also help you put together a simple unit. Although fluorescent lighting is cooler in operation than incandescent lighting, it still generates some heat, so remember to include openings in the light unit for ventilation.

At the time of this writing, Chicago Albumen Works will make enlarged negatives. A search through the alternate photo processes should reveal more sources for enlarged negatives.

1. Crawford (1979).
2. Ibid.
3. Nadeau (1989).
4. Centers for Disease Control (1991).
5. Reilly (1980).
6. Nadeau (1989).
7. Ibid.
8. *Encyclopedia of Photography* (1969).
9. Malde (1994), Ware (1986).
10. Reilly (1980).
11. Kosar (1965).
12. Shaw and Rossol (1991).
13. King (1996a).
14. King (1996b).
15. Reilly (1980).
16. Matus (1983).
17. King (1996b).
18. Ware (1996).
19. Merck & Co. (1996).
20. Kosar (1965).
21. Ibid.
22. Davis (1996).
23. This is the Metrolux, available from Redlight Enterprises, 151 Alderwood Lane, Walnut Creek, California 94398; (510) 935-5446.

24. Kosar (1965).
25. Sullivan (1982b).
26. Anderson (1939).
27. Reilly (1980).
28. Crawford (1979).
29. Crane (1992).
30. Steinberg (1990).
31. Adams (1981).
32. Crane (1992).

Untitled bromoil print (© Robert Nix).

Safety

TAKE THE TIME TO READ THIS CHAPTER CAREFULLY AND TO REVIEW THE APPENDIX REGARDING the properties of the materials and chemicals used for the historic processes in this book.

You are strongly urged to use the Chemical Abstracts Service (CAS) numbers given in the appendix and the material safety data sheets from the manufacturers of the products you use in order to obtain accurate and current information about the chemicals to which you are exposed.

Other valuable sources of information are pharmacies, public-safety offices, and environmental safety offices at local universities. The book *Overexposure* by Shaw and Rossol[1] is highly recommended for more complete listings and information about photographic chemical hazards and safe darkroom design. Exposure to toxic materials takes place through three main routes: skin contact, inhalation, or ingestion.

- *Skin contact.* Chemicals can damage the skin or be absorbed through the skin into the body. Wearing appropriate gloves and washing the hands after handling chemicals can eliminate a great deal of risk from skin contact with most chemicals. However, some chemicals can be absorbed though skin *and* gloves without your knowledge. Even these chemicals can be used safely if you are aware of their hazards and how to protect yourself.

- *Inhalation.* The vapors, gases, and dusts in the darkroom can damage the lungs directly or can be absorbed into the body through the lungs. Inhalation hazards can be minimized by using proper ventilation or respiratory protection (discussed in detail below).

- *Ingestion.* This hazard is easily avoided by simply not eating, drinking, or smoking in the darkroom; not storing photochemicals in the kitchen refrigerator; and keeping darkroom activities separate from all living and eating activities.

The effects of chemical exposure may not be noticed at once, but they can be cumulative and potentially serious, or even life threatening. It is important to remember that one can suffer serious injury, without immediate effects, through prolonged or repeated exposure over time. It makes little sense to compromise your health with haphazard darkroom habits.

If you are pregnant or if pregnancy is planned, then special precautions should be taken to minimize chemical exposure, especially to agents that are known to be carcinogenic (causing cancer), teratogenic (causing birth defects), or mutagenic (causing genetic changes or mutations). It is probably best to avoid potentially dangerous chemicals altogether for the time during which you are at risk. These considerations and precautions apply to both men and women, since some chemicals can cause defects in the genes of either parent, which are then passed on to the child. In addition, you should also avoid chemicals that have not been tested for long-term effects or for their effects on the developing fetus. Rossol notes that health-hazard warnings for most of the chemicals used in photography are based on very limited, short-term animal studies.[2] Only rarely are long-term animal studies or significant human data available. She further notes that these warnings should be viewed as interim rather than definitive statements, since future studies may well find more serious health effects. Although safe darkroom practices seem obvious, they're easy to overlook. As a reminder, some basic questions and answers about safety are listed below.

Do You Know What to Do in an Emergency?

You should have a telephone in or near the darkroom with emergency numbers—such as poison control and fire services—clearly posted next to it. Keep handy a file of material safety data sheets (MSDSs) for all photochemicals. They are supplied on request by the manufacturer for all chemicals (for more information, see the appendix). MSDSs also have emergency phone numbers and precautions in case of fire, spills, and accidental exposures. Plan escape routes in case of chemical accidents or fires. Be sure all emergency procedures are understood by the rest of the family if you work at home. Ideally, you should only work with chemicals when there is another person within calling distance so that he or she can summon help if you need it.

Is There Proper Ventilation in Your Darkroom?

Many of the chemicals used in photography release gases or vapors into the air; however, you can't always rely on your nose to tell you when you are overexposed since you become used to these odors (olfactory fatigue) and are no longer warned by the chemical's smell. In addition, some photochemicals are odorless, almost invisible, fine powders that can become airborne during handling. For these reasons, ventilation is essential to working safely with photochemicals.

There are two basic types of ventilation:

- *General ventilation.* All darkrooms should have general ventilation for the small amounts of sulfur oxides, ammonia, acetic acid, and other emissions that are involved in all photo processes. The system should be capable of ten to thirty room exchanges per hour. The smaller the darkroom, the higher the rate of exchange should be. These systems usually employ lighttight exhaust fans coupled with a lighttight louver in a wall or door to supply the air. The direction of the air movement from the supply to the exhaust fan should be such that the chemical emissions are directed away from you and to the outside.

- *Local exhaust ventilation.* Local ventilation systems are needed for processes that generate large amounts of moderately toxic substances, small amounts of highly toxic substances, or airborne dusts or powdered chemicals. Examples of local exhaust systems are spray booths, slot hoods, chemical fume cabinets, or other hooded or enclosed systems. These systems capture contaminants before they can get into the general darkroom air and exhaust them to the outside.

Design and installation of ventilation systems, including selection of fan types, fan placement, and other elements, are discussed in Clark, Cutter, and McGrane[3] and Shaw and Rossol.[4] In some cases, a professional ventilation engineer is well worth the investment.

For individuals who cannot afford local exhaust systems, there are other methods that may provide sufficient protection for mixing small amounts of dry chemicals. One is to install a window exhaust fan at the back of a worktable that draws air away from you as you mix. Another method is to construct a glove box (a box with a clear lid and holes in the sides for gloves) that can be used to contain dust. Some creative photographers have even installed small hoses into the back of the box leading to exhaust fans in order to provide some ventilation for the box. Or you can avoid the whole problem of dust control by buying premixed chemicals. In most cases, it is false economy to measure your own chemicals if they are available premeasured at little or no extra cost. By minimizing your exposure, you are also minimizing your risk.

Can You Use Respiratory Protection?

If your darkroom is not sufficiently ventilated, respiratory protection can be used. However, respiratory protection is not recommended for home use unless you can answer the following questions affirmatively:

- *Are you physically able to wear a mask or respirator safely?* Respirators are not advised for everyone. For example, people with certain physical conditions, such as asthma, heart problems, or pregnancy, may be harmed by the added breathing stress caused by the filters. Check with your doctor.

- *Does the mask or respirator fit you properly?* Often the shape of a person's face

prevents the respirator to form a good seal with the face. Facial hair will also interfere with a proper fit. If the respirator doesn't fit, the wearer is not protected and is only fooling him- or herself.

- *Do you know precisely which cartridges or filters to use?* For example, *dust* masks will help you with powdered materials but offer no protection against sulfur dioxide gas. An *acid gas* cartridge will capture sulfur dioxide but not ammonia, and so on. And there are some substances for which there are no air-purifying filters or cartridges, such as ozone and nitrogen oxides from carbon arcs, nitric acid, and hydrogen sulfide gas (e.g., from sepia toners). It is important to consult with the company that makes the respirators to be sure that you have the right cartridge for the right process.

These concerns and the limited protection offered by respiratory protection are some of the strongest reasons to install ventilation in the darkroom.

Do You Know How to Handle Chemicals Safely?

Know the general rules for handling chemicals. For example, diluting strong acids and bases too rapidly can release enough heat to shatter glass containers. This phenomenon is also the reason you should always add acid to water, not the reverse. Otherwise the hot acid will spatter.

Good information on handling chemicals can usually be found in the MSDSs. Check MSDSs especially for chemical incompatibilities, that is, chemicals that will react with deadly force. For example, a little starch or sugar accidently getting into a bottle of potassium chlorate can convert this chemical into a shock-sensitive explosive.

Can You Protect Your Hands?

The best way to protect your hands is to avoid getting chemicals on them in the first place. Using tongs helps, but if splashes are inevitable, they are not enough.

Barrier creams are only adequate for protection against occasional small splashes of chemicals, and they are not recommended.[5] Instead, there are a variety of rubber and plastic gloves available that provide excellent protection.

If you work with photo processes that employ solvents, strong acids, or highly caustic chemicals, get advice from the manufacturer of your gloves about which type of glove to use. Some chemicals will degrade and dissolve gloves, and *many chemicals can go through gloves without changing the appearance of the glove.* Glove manufacturers will provide customers with a chart that lists the breakthrough times of many chemicals for each type of glove they make.

Avoid natural rubber gloves if possible because of the serious allergies they can cause. Always wash your hands thoroughly after handling chemicals, even when you have used gloves.[6]

Can You Protect Your Eyes?

There are several different types of eye protection and each kind is approved only for a specific use. Be sure to wear the right type for the work you are doing. For example, you may need three separate pairs of goggles for protection against ultraviolet (UV) radiation, impact, and chemical splashes. Even chemical splash goggles come in two basic types: vented and unvented. Unvented ones protect the eyes when the air itself is highly contaminated with corrosive vapors. This situation is rare in photography, and the directly vented types of eyewear (those with small holes to let in air) are usually sufficient.

Always wear eye protection when you use or mix chemicals. Do not rely on prescription glasses to provide adequate protection. While ordinary large eyeglasses have been estimated to prevent up to 90% of splash injuries,[7] this is not sufficient when it comes to protecting your eyesight. Either use prescription vented safety goggles or chemical splash goggles that will fit over prescription lenses. Contact lenses are not recommended for darkroom work, even with goggles, because harmful materials can be trapped between the lens and the cornea.

All darkrooms need a clean source of water coming from a fixture that can be directed to your eyes in a safe, steady stream. A commercial eyewash station is best if you can afford it. A length of flexible rubber hose on a faucet may suffice for small home darkrooms.

In the United States, an eyewash station is required in all workplaces where chemicals present an eye hazard. Eyewash stations must be capable of being turned on in 1 second, deliver a minimum of 15 minutes of continuous flushing, and be located where the worker doesn't have to go through doors or up or down stairs to get to it. It must also be within a 10-second walk or 100 feet (30 meters) from where the chemicals are being used. This essentially means that there must be an eyewash station in each room where chemicals labeled as eye hazards are used or mixed.[8] If chemicals splash into your eyes, flush them right away for at least 15 minutes with running water. Then seek medical attention immediately. Again, work only when there is another person who is within earshot and can come to your aid if you need help.

Do You Practice Good Hygiene in the Darkroom?

All the ventilation and protective equipment in the world are not sufficient if you eat, drink, or smoke in the darkroom. Small amounts of chemicals can easily contaminate food or drink; smoking facilitates the inhalation of contaminants and is extremely dangerous around flammable materials. In the United States, it is a violation of occupational regulations to eat or store food in an area where chemicals are used or stored.

Clean all spills immediately and wet-clean the darkroom daily. Floors and surfaces throughout the darkroom should be made of materials that can be easily wet-cleaned. Ordinary vacuums should never be used to clean the darkroom since fine powders go through their filters and into the air.

Are You Protecting Others in the Family?

Other family members, especially children, the elderly, pregnant women, people in ill health, and even the family pet, must be considered when photochemicals are introduced into the home environment. A relatively small amount of many chemicals can prove fatal to a child or pet. Darkroom areas must be kept locked and secured.

More insidious than an accident where chemicals are ingested are small amounts of chemicals that are inhaled repeatedly. If people can smell photochemicals in your home, it is not a proper living environment, especially for young children or other vulnerable individuals. Isolate the darkroom or provide enough ventilation to keep gases and vapors out of the rest of the house. And be careful not to track even small amounts of photochemical dust into the rest of the house on shoes or clothing.

Can You Store Your Chemicals Safely?

MSDSs also provide information on the best ways to store products. Some products should be stored in a cool place, but this does *not* mean the family refrigerator. If you need to keep chemicals cold, get a small refrigerator, use it for only chemical storage, and make sure that children do not have access to it.

Chemicals used at home must never be stored in living, sleeping, bathroom, or eating areas. They also should not be kept on shelves so high that they are hard to reach or where there is any danger of their breaking if they fall.

Keep chemicals in their original containers. If they must be transferred, be sure the new container material (e.g., glass or plastic) is compatible with the chemical and that all the important label information on the original container is also transferred to the new label. *Never* leave old labels on reused containers.

Purchase chemicals in unbreakable plastic whenever possible. Purchase them in small quantities in order to avoid having to store large amounts, and order them in small bottles, which are easier and safer to handle.

Is Your Darkroom Electrically Safe?

Unless specifically constructed to be used in a wet area, electrical appliances should be used only on the dry side of the darkroom. Ground-fault circuit interrupters should be installed on all darkroom outlets. These devices stop the current within milliseconds after a short circuit—an important feature in a wet environment. In many countries, including the United States, ground-fault circuit interrupters are required on all outlets within 10 feet (3 meters) of a water source.

Never attempt to defeat electrical safety features: only a grounded appliance should be plugged into a grounded outlet. If you choose to make your own electrical equipment (such as an apparatus for UV exposure), have a licensed electrician check it to make sure it is safely constructed.

Do You Know the Local Regulations for Chemical Disposal?

Be kind to your environment: we have only one planet and we all have to live on it. In most if not all localities, it is illegal to dispose of certain chemicals, such as dichromates and used fixer, in the public sewage system. Most cities now have a chemical collection service or disposal site you can use. Fortunately, the historic processes generally use small amounts of chemistry that are easily contained. For those chemicals that you are allowed to pour down the drain, be sure to flush the drain with plenty of water. Also make sure you are not mixing chemicals in the drain that could react to generate toxic fumes, such as deadly cyanide gas from combining potassium ferricyanide and an acid such as stop bath.

Photographers with septic systems should check with the proper authorities about which chemicals can be safely and legally disposed of in a septic tank and in what amounts. Chemicals can leach into the surrounding soil and groundwater from the septic field. Be careful even with chemicals that can legally be put into the system. If they kill off the system's microorganisms, it will end up being more trouble than it was worth!

Notes
Safety information

Fortunately, there is never a need to claim, "I didn't know who to ask," because for further information, both technical and general, the authors of the book *Overexposure*, Susan Shaw and Monona Rossol, can be reached at: Arts, Crafts, and Theater Safety, Inc. (ACTS), 181 Thompson Street, #23, New York, NY 10012; (212) 777-0062; *www.caseweb.com/acts*; e-mail: *ACTS@CaseWeb. com*. ACTS provides an information and consulting service on safety in the theater and the arts at no charge. Monona Rossol can also be reached via e-mail at *75054.2542@compuserve.com*

Emergency numbers

Both Kodak and Ilford operate special 24-hour emergency telephone lines (in the United States only) for information about their photographic chemicals and attendant hazards: Ilford (emergency): (800) 842-9660; Kodak (emergency): (716) 722-5151.

In the United Kingdom, call the emergency services number 999 and ask for the National Poison Information Services, London Centre.

In the Netherlands, call the Utrecht University Hospital and ask for poison control information at (030) 250-9111.

For other countries, call your emergency services number and ask for the poison control center.

References

1. Shaw and Rossol (1991).
2. Rossol (personal communication, 1996).
3. Clark, Cutter, and McGrane (1995).

4. Shaw and Rossol (1991).
5. Ibid.
6. Ibid.
7. Henry (1986).
8. Rossol (personal communication, 1997).

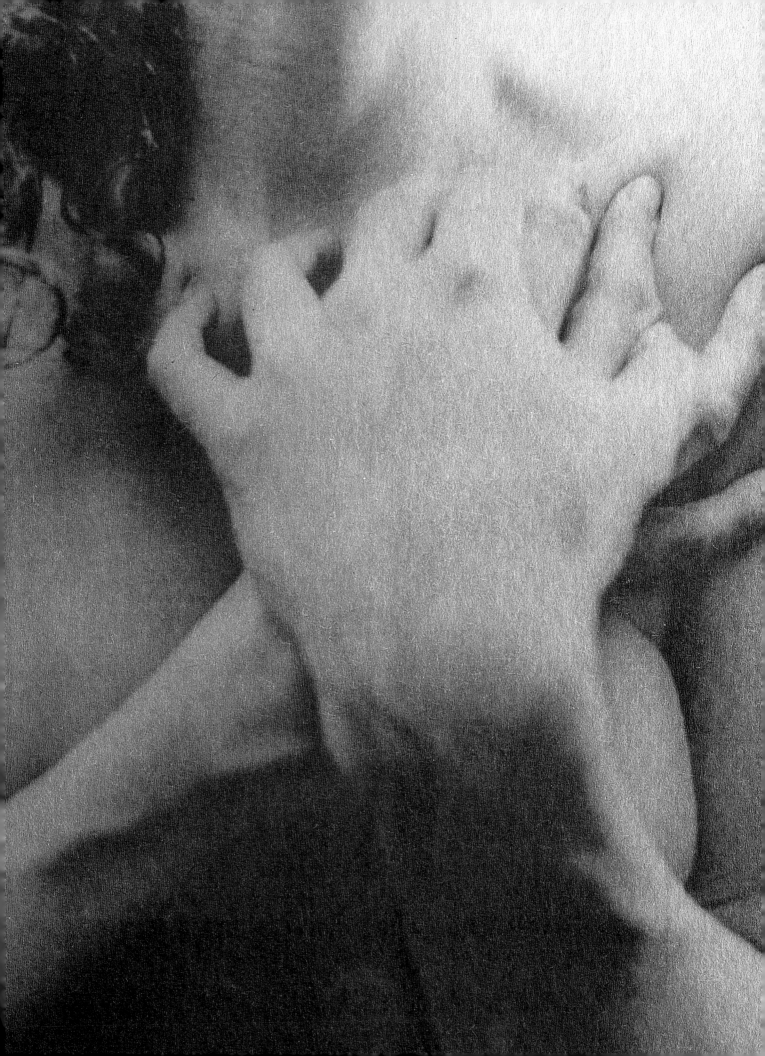

For Keeps (© Mieke Bijleveld), salted paper.

3

Salted Paper

SALTED PAPER IS THE OLDEST SILVER PAPER PROCESS, PERFECTED BY WILLIAM HENRY FOX Talbot in 1839. His negative/positive process, announced in 1840, was called the *calotype*, meaning "beautiful picture." This landmark process was used intensively during the period of 1840 to 1855.[1] The positive portion of a calotype was made on a sensitized paper called *salted paper*.

This type of printing-out paper (POP) is called salted paper because it is prepared by first treating it with a chloride, or "salt," and then with a silver nitrate solution, transforming the chloride into the more sensitive silver chloride. The chloride and silver nitrate must be applied separately because if they are combined together in solution, the silver chloride precipitates out, making it unusable for coating.

The proper negative for salted paper should have quite a bit of information in both the shadows and highlights, with a density range of 1.6–1.8, which would be far too dense to print, even on a grade 0 paper. A negative step tablet (see chapter 1) can be used to find the negative density range best suited to your paper.

Salted paper has a long tonal range, with very good separation possible within the highlights, but the shadow areas lack the same degree of tonal separation and might even seem somewhat flat in comparison. The dense highlights in the negative are allowed to be fully exposed, without hopelessly overexposing the less dense shadow areas, because as the image is printing out, a process called self-masking is taking place. This means that the darker exposed part shields, or masks, light from the unexposed silver underneath, permitting less and less light to pass through as it becomes darker, or denser, during the exposure.

The paper that you choose to print on will, to some degree, determine the color and contrast of the final image. Many papers found in art stores are factory sized with gelatin, which gives a somewhat cooler tone than those sized with starch. If the paper is not well

sized, the sensitizer may sink too far into the paper fibers and produce a flatter-appearing print. To increase the brilliance and influence the color, you may want to size with gelatin or with arrowroot starch (see chapter 1).

The following supplies are needed to make a salted print:

- a 12% solution of silver nitrate
- sodium chloride (ordinary table salt) or ammonium chloride
- sodium citrate or citric acid
- gelatin
- a brush or rod for applying the sensitizer (disposable sponge brushes are excellent for this purpose)
- a weak yellow or tungsten safelight
- sodium thiosulfate
- a 5% solution of potassium dichromate (optional)
- arrowroot, if making arrowroot paper

Salting the Paper

As mentioned above, if the silver nitrate is added directly to the salting solution, it will result in a silver precipitate, making the solution useless. Therefore, it is necessary to sensitize the paper in two steps: the paper must first be "salted" with a solution of ammonium chloride (or sodium chloride) and citric acid (or sodium citrate).[2]

Although using a negative with the proper density range is the best means of obtaining good contrast, there are ways to compensate for less-than-ideal negatives. Adding 2–3 drops of a 5% potassium dichromate solution per 25 ml of salting solution will increase contrast to some extent.[3]

> Dichromates are known carcinogens—always use gloves and protective glasses when handling. See the chemical list in the appendix for further precautions.

The contrast can also be increased slightly by decreasing the percentage of salt in the salting solution from the normal 2% to 1.5% and using a weaker 8–9% silver solution.[4]

Because the salting solution is colorless, you should pencil a small X on the back of the paper so that the proper side can later be sensitized. Salted paper may be stored indefinitely because it is not light sensitive until the silver nitrate has been added. After that, however, it should be used the same day.

> There are many salting formulas. A basic one is as follows:[5]
>
> | Water | 250 ml |
> | Gelatin | 2 grams |
> | Sodium Citrate | 5 grams |
> | Ammonium Chloride | 5 grams |

Although it is suggested that you use the formula as shown, it can be modified. The gelatin is not absolutely necessary and can be left out if desired. Its main purpose is to act as sizing to help prevent the solution from sinking into the paper fiber. It also gives a slightly cooler color.[6] The amount of sodium citrate can be reduced, or it can be left out altogether. The presence of the citrate adds a bit of color and slightly increases the speed of the paper, but gives slightly less contrast.[7]

Since, at this stage, the materials are not sensitive to light, the salting can be done in full light. Historically, the paper was floated on the salting solution for a few minutes to avoid wetting the back, which could cause the silver nitrate to migrate to the back, resulting in dark patches.[8] The likelihood of this happening depends upon the characteristics of the paper that you are using.

An easier method of salting only the front of the paper is to pin or tape the corners down and brush the solution on with a brush or sponge. If you use this method, do not use the same brush for the later step of sensitizing with silver nitrate, since the silver nitrate will combine with the salting solution in the brush.

Because the paper will curl after being wet on one side, it will be necessary to let it dry with the edges held down, or hang it with weighted clips. With many papers, there is

Leiden (© *Richard Farber*), *salted paper.*

no problem with simply immersing the paper in the salting solution for 2 minutes, making certain to brush away air bubbles. It can then be hung up with a clothespin to dry.

Arrowroot Paper

Arrowroot paper was favored by some photographers for its better rendering of detail, as well as for its color. It can be prepared as follows:[9]

> ARROWROOT PAPER
> 1. Mix 17 grams of arrowroot starch with a little cold water to make a creamy solution.
> 2. Boil 475 ml of water and slowly stir in the arrowroot cream. Because the arrowroot mixture will separate, stir it up well before adding it slowly to the boiling water.
> 3. Add 17 grams of sodium chloride (table salt) and 1.5 grams of citric acid. Let it boil for a few minutes, stirring regularly.
> 4. Remove the solution from the heat and let it cool. As it cools, a skin will form on the surface, which can be removed. The arrowroot starch is now ready to apply.

If the solution is thin enough, the paper can be floated on it. It is easier, however, to use a disposable foam brush to apply the arrowroot. Brush the solution in well, with lengthwise and sideways strokes, making certain that the coating is even and smooth. The paper can then be dried.

Sensitizing
Sensitizing the salted paper

Safelight conditions are necessary when you sensitize the salted paper with the silver nitrate solutions.

> ! Use caution and wear gloves and goggles when mixing and handling silver nitrate. It can cause permanent blindness if it comes in contact with your eyes. It will also cause dark brown-black staining of the skin. See the chemical list in the appendix for further precautions.

The original method of sensitizing the salted paper was to float it on the silver nitrate solution.[10] The disadvantages of this method are that it is much more expensive because a greater amount of silver is needed, and with use, the silver is gradually depleted, lessening the solution strength.

The recommended procedure of brushing the sensitizer on is much easier, more consistent in results, and more economical than floating. Disposable foam brushes are excellent for this purpose. A sensitizing rod can work well if the paper is fairly smooth. The sensitizing solutions for smaller prints can be measured with an eyedropper into a small glass or plastic (not metal) container. A 4×5-inch (10×12.5-cm) image, for example, might take 20–25 drops, depending on the method used to apply it and the absorbency

of the paper. Be sure to use an adequate amount of silver nitrate and thoroughly brush it on with overlapping strokes in order to avoid mottling. The paper, salted side up, can be attached to a piece of cardboard by taping or pinning the corners down. It should be dried in a dark area and can be left on the cardboard to prevent it from curling.

12% SENSITIZER SOLUTION

Water (distilled)	90 ml
Silver nitrate	12 grams
Water (distilled) to make	100 ml

! If arrowroot paper is used, Reilly suggests that the sensitizer should contain 4–5% citric acid.[11]

After the paper has been sensitized, it needs to be thoroughly dried before use; otherwise, the negative can be permanently stained by contact with the sensitizer. It should only take the paper about 20 minutes to air-dry if it is hung up in a dark area. Once sensitized, the paper will keep for several hours to one day, depending upon the temperature and humidity. But for the best results, particularly if dichromate has been used, the paper should be used as soon as possible.

Exposure

Under safelight conditions, when the paper is thoroughly dry, place the negative, emulsion side down, on the sensitized side of the paper (remember that you marked the back of the paper earlier with a small, penciled X). Place the paper and negative together in a contact printer—with the negative side facing the glass—and close the back. The sensitized paper is then ready to be exposed to your choice of UV light. As noted in the directions for contrast control in chapter 1, contrast can be controlled somewhat by the type, as well as color, of light. Burbank suggests that the printing frame face the north sky for greater contrast and face the sun for less contrast.[12] Although the exposure time will be lengthened, contrast can also be increased by laying a tissue over the printing frame glass or by increasing the distance from the light source.[13] If you are printing outside with the sun, you need to remember that the sensitivity of salted and albumen paper is dramatically reduced when the temperature drops below 5°C/41°F.[14]

Generally speaking, because the image will bleach back in the fixer, it may be considered adequately exposed when the provisional image appears darker than you want in the finished print and the shadows look almost bronzed. Using a step tablet as an exposure guide will help you control the image density (see chapter 1 for more details).

When the image has the desired density, remove the salted paper from the contact printer, under a safelight, and place the print in a tray of running water for a few minutes. You will see a milky cloud coming from the paper surface. This is the unexposed silver

Voorschoten Farm
(© Richard Farber),
salted paper.

salts combining with elements in the water. The print will change slightly in both color and density once it is in the water. Wash several minutes until you observe no further milkiness—but not too long or you may weaken the image.

Toning

The salted paper can be toned to add color, to improve permanence, and to help prevent the sometimes severe bleaching that can occur in the fixer.

Most POP toning is done before the print has been fixed, but there is one method, called *heat toning*, that is done *after* the print has been fixed, washed, and dried. While not known to add permanence, heat toning will darken the color.[15] It can be done with an iron at an intermediate setting, but take care not to heat the image directly. Protect it by covering it with a layer of paper.

Gold toning is the most frequently employed toning method, although platinum has also been used—both alone and in combination with gold. There are many gold-toning solutions in use for albumen and salted paper. For example, the toner can be an alkaline form, such as one with borax, which gives a warmer tone. Or it can have a solvent-type

action, such as one containing thiocyanate, which gives a cooler tone. A search through older texts will reveal many variations on gold toners.

If the image hasn't been masked, you might want to trim off most of the darkened silver on the paper outside the image before toning to avoid using up the gold in the toner on nonimage silver.

! ● Wear gloves when handling these toners or the chemicals used to make them. See the chemical list in the appendix for further precautions.

Gold toners

Gold chloride can be purchased as a premixed solution or as 1 gram (15 grains) of gold chloride crystals sealed in a glass tube. The gold chloride crystals are very hygroscopic; that is, they absorb moisture from the air very quickly. For this reason, it is best to measure the desired amount of water and, wearing gloves, break the glass capsule under the surface of the water, then filter out the broken glass with a paper filter. To avoid being cut, it is a good idea to use a clean pair of pliers instead of your fingers to break the tube.

A 1% solution of gold chloride is made by adding the contents of a 1-gram (15-grains) tube to 100 ml of distilled water. Clearly, a premeasured solution is much more convenient. The gold chloride should be stored in a dark glass container in a dark area.

Before toning, wash the print for 5 minutes or until the milky cloud coming off the print is no longer visible.

A simple gold-toning formula for a warm image tone:[16]

Water (distilled) 38°C/100°F .. 350 ml

Borax .. 3 grams

Gold chloride 1% solution .. 6 ml

Water (distilled) .. to make 400 ml

Cool to 21°C/70°F. Wait for 1 hour before using. This toning bath will keep and can be replenished.[17]

An example of an acetate gold-toning bath for sepia-purple tones:

Water (distilled) 35°C/95°F .. 400 ml

Fused sodium acetate ... 10 grams

Gold chloride (1% solution) ... 10 ml

Water (distilled) .. to make 500 ml

Cool to 21°C/70°F. Wait for 1 hour before using.

A thiocyanate toner for cool blue-gray to purple tones (this toner will not keep but must be used the same day that it is made):[18]

Water (distilled) ... 400 ml

Ammonium thiocyanate ... 12.5 grams

Tartaric acid ... 1 gram

Sodium chloride .. 2.5 grams

Gold chloride (1% solution) ... 10 ml

Water (distilled) ... to make 500 ml

A gold aluminum toner for brown-red tones (this toner will keep and can be replenished when necessary with additional gold chloride):[19]

Water (distilled) ... 250 ml

Aluminum chloride .. 1.3 grams

Sodium bicarbonate ... 5.2 grams

Water (distilled) ... to make 295 ml

Mix and let the solution stand for 30 minutes. Filter. Add gold chloride (6 ml 1% solution).

Toning with most formulas will take 5–10 minutes, with constant, gentle agitation. After the print has reached the tone that you want, rinse it for 3 minutes, fix, and wash. A gold-toned print can go directly from the toning bath into the fixer; however, do not get any fixer in the toner since this will completely ruin the toner.

! Keep in mind that the print will dry down to a darker shade.

Platinum and palladium toners

The safest and easiest method for platinum or palladium toning is to purchase the premixed solutions that are used for platinum and palladium printing. Since only a small quantity will be used, the remainder of the premixed solution can be used later if you decide to try platinum or palladium printing (these solutions will keep for years, but they need replenishing with platinum or palladium from time to time). See chapter 7 for instructions on mixing platinum and palladium formulas.

! Avoid contact with the sodium chloropalladite, palladium chloride, and, particularly, potassium chloroplatinite. Wear gloves and a dust mask when handling the dry chemicals, and use gloves when working with the solution. See the chemical list in the appendix for further precautions.

A basic platinum toner:[20]

Water (distilled) ... 900 ml

Potassium chloroplatinite ... 0.5 grams

Or (but not both)

Potassium chloroplatinite (20% solution) 2.5 ml

Citric acid .. 5 grams

Sodium chloride (table salt) ... 5 grams

Water (distilled) to make ... 1 liter

A basic palladium toner:[21]

Water (distilled)	900 ml
Sodium chloropalladite (15% solution)	5 ml
Sodium chloride (table salt)	5 grams
Citric acid	5 grams
Water (distilled) to make	1 liter

Before toning with platinum or palladium, it has been suggested that you give your print a 5% sodium chloride bath for 1–2 minutes and then wash it again for 5–10 minutes.[22]

Toning will take 5–10 minutes, with constant, gentle agitation. After it has reached the tone you want, the platinum-toned print should be washed well before it is put into the fixer. After fixing, it can be put in a commercial hypo clearing bath or 1% sodium sulfite and agitated for 2–3 minutes. It can then be washed for 30–60 minutes, depending upon the thickness of the paper. Keep in mind that it will dry down to a darker shade. Be careful not to get any fixer into the toner, as this will completely ruin it.

Fixing

Fix the salted print in two 1-liter 10% sodium thiosulfate baths for 5 minutes each, with agitation. During the fixing process, the image, which consists of finely divided silver, can bleach considerably; hence, the use of a weak fixer. Making the fixer slightly alkaline by adding 2–3 grams of sodium carbonate or sodium bicarbonate, or a few milliliters of ammonia, per liter will help minimize the bleaching.[23] Because the fixer is a weak solution, it will probably be exhausted after processing eight to ten 8×10-inch prints. It's best to replace the fixer on the basis of the number of prints that have been processed rather than waiting for it to reach its capacity. After fixing, the print can be put in a commercial hypo clearing bath or 1% sodium sulfite with agitation for 3 minutes. It can then be washed for 30–60 minutes, depending upon the thickness of the paper. A simple test to determine if the print is adequately fixed can be found in the appendix.

Because the fixer is so weak, it's important not to overload its capacity. Generally, when a sodium thiosulfate fixer has 2 grams of silver per liter, it is considered exhausted.[24] An easy method of testing this is to use a commercially available hypo testing solution. If a precipitate forms when the hypo testing solution is added to the fixer, then the fixer has reached its capacity and should be replaced. A simple formula for making your own testing solution can be found in the appendix.

! Do not pour used fixer down the drain. It is not only environmentally unsound to do this but also illegal in most areas. Save it in a clearly labeled container and take it to your chemical recycling center.

Dry the print by gently blotting the surface with a paper towel and letting it air-dry, or use a hair dryer to speed up the process. As the paper dries, the image will darken to a red-brown color.

Notes

1. Reilly (1980).
2. Ibid.
3. Crawford (1979).
4. Reilly (1980).
5. Crawford (1979).
6. Reilly (1980).
7. Wall and Jordan (1976).
8. Reilly (1980).
9. Ibid.
10. Towler (1969).
11. Reilly (1980).
12. Burbank (1973).
13. Hasluck (1905).
14. Reilly (1980).
15. Ibid.
16. Crawford (1979).
17. Clerc (1930).
18. Crawford (1979).
19. Sullivan (1982b).
20. *British Journal of Photography* (1930).
21. Sullivan (1982a).
22. Wall (1945).
23. Ibid.
24. Eaton (1986).

Le Bajazzo *(© Richard Farber), salted paper.*

OPPOSITE: Timeless *(© Luc van Quickenborne), salted paper.*

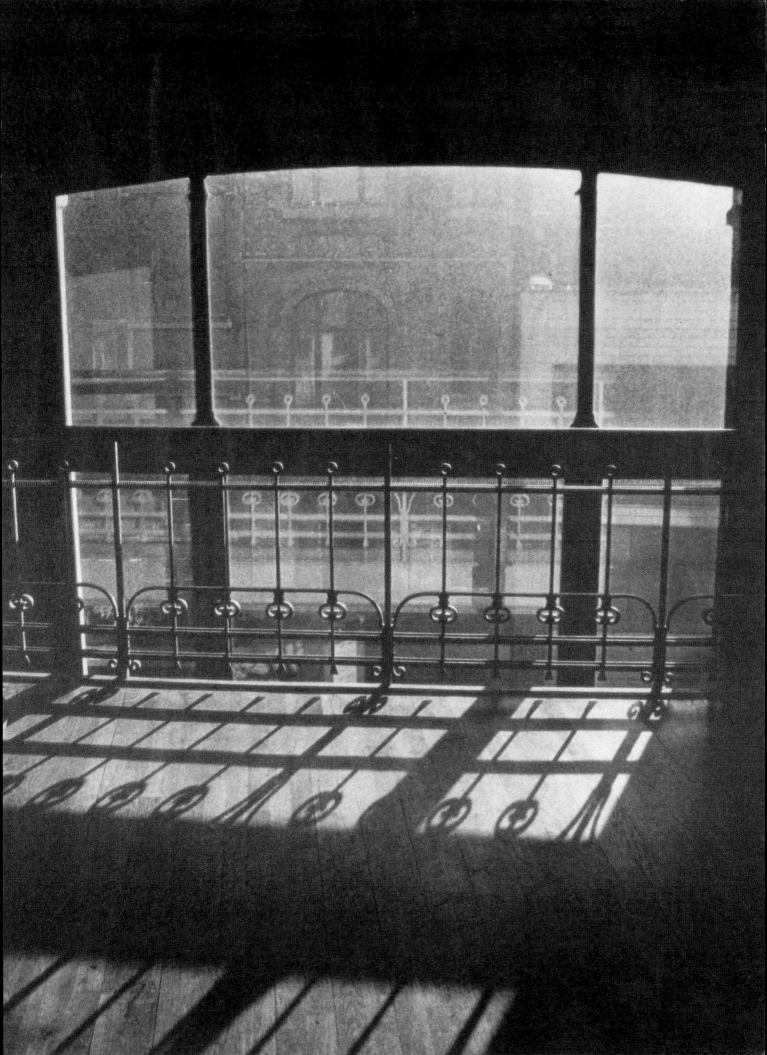

Child on Swing, *anonymous gold-toned albumen print.*

Albumen

ALBUMEN PRINTING PAPER, INTRODUCED BY LOUIS BLANQUART-EVRARD IN 1850, WAS BASED on the albumen negative process developed by Niépce de St. Victor in 1848.[1] Albumen paper had a tremendous advantage over its predecessors, the calotype and salted paper: instead of the image resting within the paper fibers themselves, there was a sensitive coating on a layer of albumen, thus permitting a greater density range on either a glossy or matte surface. More than just a sensitizer resting on an albumen base, the albumen actually combines with the silver nitrate, becoming a light-sensitive component itself: silver albumenate.[2] Albumen paper, combined with the collodion glass-plate negatives developed by Archer in 1851, made it possible to create images with very fine detail, as well as overcoming the obvious problem of having to print through the texture of a paper negative.

Albumen was one of the most popular photographic mediums in history and was used from its inception in the mid-1860s until the late 1920s. It has been estimated that the number of prints made with albumen has been exceeded only by today's ubiquitous color printing.[3] Its gradual demise was brought about by the advent of more modern methods, such as "gaslight paper" and developing-out paper.

Like salted paper, albumen has a long tonal range that benefits from a dense negative, such as one that has a density range of about 1.6—too dense to print on even a grade 0 paper.

Making the Albumen Solution

Making the albumen to coat the paper is not difficult. The egg white, or albumen, is mixed with glacial acetic acid and a chloride and then thoroughly beaten to help break down the albumen. It is then allowed to ferment for a week or so.

Begijnhof, Bruges
(© Richard Farber),
gold-toned albumen
print.

A basic formula is as follows:[4]

Albumen	500 ml
Glacial acetic acid	1 ml
Water (distilled)	15 ml
Ammonium chloride	7.5 grams

Sodium chloride (table salt) can be substituted in equal amounts for the ammonium chloride.

! Be very careful with the glacial acetic acid. The intense fumes are dangerous and the liquid can burn your skin. Wear gloves and protective glasses when handling this material, and be sure there is good ventilation in your work area. See the chemical list in the appendix for further precautions.

To some extent, the percentage of chloride in the solution can be used as a means of controlling contrast. To compensate for a thin negative, a smaller amount of chloride,

1–1.5%, can be used with a weaker silver solution, 8–9%. The best method for proper contrast, however, is to have a negative with the correct density range. A negative properly matched to albumen would use a chloride content of 1.5–2% and a stronger silver solution.[5]

The albumen, or egg white, should have no blood, yolk, or chalazae (the stringy white part) in it. The most convenient way to separate the albumen is with an egg separator, although juggling the yolk between shell halves is adequate for those with nimble fingers. Rather than take a chance on spoiling an entire container of albumen, separate each egg in a small container and then put the albumen in with the rest of the egg whites. (Save the yolks; you can make a terrific cheesecake with them!) With a rotary eggbeater or an electric mixer, put all the ingredients together and beat for several minutes, or until it's all reduced to a froth. Cover the container and let it sit in the refrigerator for 24 hours. During this time, the froth will gradually return to a liquid. After 24 hours, take the albumen mixture out of the refrigerator and let it warm up for a few hours. Filter the liquid through a layer of cheesecloth and then put it in a refrigerator for one week. *Clearly label the container!* The resulting albumen solution will keep well as long as it is refrigerated or frozen between uses. A few milliliters of a wetting agent, such as Kodak Photo-Flo, added to the albumen solution will help minimize air bubbles when the paper is floated.

Untitled gold-toned albumen print (© Evelyn Thomasson).

Coating the Paper

The paper to be albumenized usually has a smooth surface, although any surface can be used. Light- to medium-weight paper is generally used for albumen paper, although weights as heavy as one- or two-ply can also be used. The paper should be coated only on one side, which is accomplished by floating it on the albumen solution (see the section in chapter 1 on floating paper). Folding up the edges of the paper to make a "boat" works well, although the folded edges have to be trimmed off when the paper is used.

Another method involves covering the outer margins of a piece of paper with water-proof glue and attaching another paper to it. With this method, when the glue is dry, the two sheets are immersed in the albumen and the edges later trimmed to separate them.[6] If the paper is large enough, each sheet can be cut down into several smaller ones.

Regardless of the method used, the paper should be in contact with the albumen solution at room temperature for 1½–2 minutes, making sure that there are no air bubbles. After each piece of paper has been drained, hang it up to dry in a dust-free area. To minimize coating differences, you may want to hang the paper by its long side. As it dries, the excess albumen that collects on the bottom edge can be gently blotted off. After the paper has completely dried, it can be trimmed and flattened under a weight, but take care not to mar the soft surface. The paper is then ready for use or storage (it can be stored for a very long time).

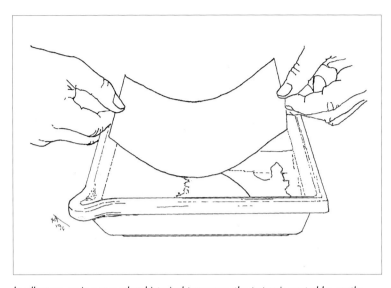

In albumen, as in some other historical processes, the paper is coated by gently laying it on the coating liquid in a tray for a few minutes to evenly absorb the liquid on one side. This simple procedure usually takes some practice to master.

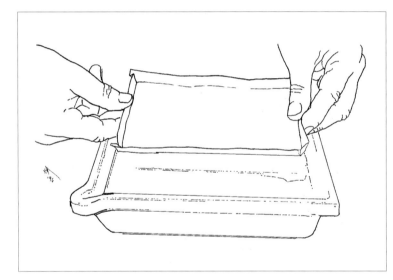

Since floating paper has a great tendency to form a tight curl when it comes in contact with the liquid, one solution is to fold up the edges a bit, making a sort of boat.

Although the paper is perfectly usable with only one coat of albumen, two coats will give more brilliance and, if the first coating was uneven, equalize the coating. However, the first coating should be coagulated or hardened before the second coat is added, or it can dissolve—partially or completely—in the second floating. It should also be noted that the thicker coating tends to make toning and fixing more difficult, as well as making the paper somewhat more prone to curling.[7] If only one

coat of albumen is used, the albumen won't require hardening since the addition of the silver sensitizer will coagulate it.

Hardening the Albumen

There are four methods for hardening the albumen coating:

1. The paper can be thoroughly steamed.
2. The coated paper can be covered with a protective paper and heated well with a hot iron—about 65°C/150°F.
3. The paper can be aged in a warm place for several months.
4. The paper can be put in a bath of 70% isopropyl alcohol for a brief time. Reilly notes that since the 70% alcohol will leach the chloride out of the albumen, the same percentage of chloride that is in the coating should be added to the alcohol.[8] That is, if the chloride content of the albumen solution is 2%, then add 2% chloride to the alcohol as well.

After the second albumen coat, hang the paper by the opposite corner to dry so that the coating will be equalized.

Matte Albumen Paper

If you prefer a less shiny surface, diluting the albumen solution with distilled water is one way to do this. Hubl suggests the following method for making matte-surfaced albumen paper:[9]

• The albumen is prepared as usual (see above), but it can be used after it's allowed to settle for 24 hours and then filtered. It does not need to stand for an additional week before use.
• The salting solution consists of 100 ml of albumen added to 100 ml of arrowroot solution (see chapter 3). The 100 ml of arrowroot solution should have 4 grams of sodium chloride (table salt) added.
• Apply the solution the same way as you would for arrowroot paper (see chapter 3).

Sensitizing

Albumen paper is generally sensitized by being floated on a silver nitrate solution, which serves to coagulate the albumen. It is also possible to brush-sensitize it, but this must be done carefully to give an even coating. The advantage of using a brush is that the sensitizer will always be the same percentage strength. This method is also more economical because it requires a much smaller amount of silver nitrate. An alternative method is to use a coating rod for sensitization.

There have been quite a few variations on the components of the sensitizing solution, such as adding ammonia or ammonium nitrate.[10] Modern sources generally use two

Untitled gold-toned
albumen print
(© Evelyn Thomasson).

methods: silver nitrate with water alone or silver nitrate with water and citric acid added. The addition of citric acid will give a more reddish color and lengthen, although perhaps not appreciably, the time that sensitized paper can be kept. It is interesting that, when combined with the silver nitrate, the citric acid itself becomes a light-sensitive substance: silver citrate.[11] Sensitized albumen paper, like salted paper, will generally keep from several hours to a day or so, depending upon the ambient conditions. From the standpoints of consistency and performance, the best practice is to sensitize only what you need and to use it as soon as possible.

The strength of the silver nitrate sensitizer is based upon the amount of chloride in the albumen coating. For the albumen coating solution given here, a 12–13% solution of silver nitrate is adequate.

Always use distilled water; tap water contains elements that will combine with and precipitate out the silver salt, giving a milky appearance to the water.

*Anonymous albumen
paper print.*

⚠ Wear gloves and goggles when mixing and handling silver nitrate. It can cause permanent blindness if it comes in contact with the eyes. It also causes dark brown-black staining of the skin. See the chemical list in the appendix for further precautions.

A float-sensitizing formula using only silver nitrate (12%):

Water (distilled)	400 ml
Silver nitrate	60 grams
Water (distilled) to make	500 ml

For brush or rod sensitizing:

Water (distilled)	100 ml
Silver nitrate	12 grams

For matte albumen paper:

Water (distilled)	100 ml
Silver nitrate	12 grams
Citric acid	1.5 grams

Weak-appearing shadows may be improved by sensitizing the paper twice (dry the paper before the second coat).[12]

Albumen paper, matte albumen paper in particular, seems to work best when it is not absolutely dry. Prior to sensitizing the paper, it is suggested that it be moistened somewhat if your ambient conditions are very dry. This can be done by putting the paper in a closed box with a shallow dish of water near it or leaving the paper for several hours in a damp basement.[13]

After the paper has absorbed some moisture, it is ready to be sensitized—under safelight conditions—either by floating or brushing. In either case, avoid getting silver nitrate on the back of the paper.

Wear gloves and protective glasses. See the chemical list in the appendix for further precautions.

If the paper is floated, leave it on the sensitizer for 2–3 minutes, removing the paper slowly when the time is up. Let the excess solution drain back into the tray and then hang the paper to dry by the same corner with which you lifted it from the tray. To avoid contaminating the floor, spread newspapers beneath the wet paper to catch the remaining drips.

The paper, albumen side up, can be attached to a piece of cardboard by taping or pinning the corners down. Brushing the sensitizer on is the easiest and most economical method of application, and disposable foam brushes work well for this. The sensitizing solution can be measured with an eyedropper into a small glass or plastic—not metal—container. A 4 × 5-inch (10 × 20.5-cm) image might take 20–25 drops. Be sure to use an adequate amount of silver nitrate and thoroughly brush it on with overlapping strokes in order to avoid mottling. The paper, which should be dried in a dark area, can be left on the cardboard to prevent it from curling.

Replenishing the Silver Nitrate Solution

If the paper is sensitized by floating, both the silver nitrate concentration and volume of the sensitizer are reduced as it is used and will need to be replenished. There are two very general methods of replenishment:

1. Add 0.5 teaspoon (2 grams) of silver nitrate for every seven 11 × 14-inch prints, and replenish the missing volume with solution that is the same percentage as the original.[14]
2. Replenish the missing volume and concentration with a silver nitrate solution that

is twice as strong as the original.[15] For example, if the volume of a 12% solution is down 15 ml, replenish it with 15 ml of a 24% solution. For precise measurements, Reilly gives directions for titration.[16]

Citric acid is replenished on the basis of what has actually been used. For example, if the volume of a 1-liter solution containing 5% citric acid (50 grams) is reduced in volume by 100 ml, or 10%, then 5 grams (10% of 50) of citric acid would be added when the volume is replenished.[17]

After the silver nitrate solution has been used for awhile, it will become darker. This is caused by an accumulation of organic matter, and if this is not corrected, the solution will become useless. An easy remedy for this is to add a teaspoon (15–20 grams) of kaolin to the container with the silver nitrate. Kaolin is a fine clay that will attract the organic matter in the solution. Shake the container a few times and let the kaolin settle to the bottom. After it has settled, the silver nitrate solution can be carefully decanted into a new container, leaving behind the kaolin and the organic matter.[18]

Exposure

! Make certain that the sensitized albumen paper is dry before using it, or the silver nitrate can permanently stain your negative.

To expose the paper, place the negative, emulsion side down, on the albumen surface—under safelight conditions—and put the negative/paper sandwich into a contact printing frame with the negative facing the glass (chapter 1). It is then exposed to a UV light source, such as the sun or a UV lamp. As noted in the directions for contrast control in chapter 1, contrast can be controlled somewhat by the type, as well as color, of the light. One method suggested for controlling contrast is to have the printing frame face the north sky for increased contrast or face the sun for reduced contrast.[19] Contrast can also be increased by laying a tissue over the printing frame glass or by increasing the distance of the frame from the light source, both of which require a longer exposure time.[20]

Periodically take the frame into a well-shaded or safelight-lit area for inspection. If your negative is *extremely* dense, then the exposure can take a very long time. Since the image will bleach back in the wash and fixer, it should appear darker than normal. Refer to chapter 1 for instructions on using a step tablet to help determine the proper exposure.

When the exposure is complete, remove the paper from the frame under safelight conditions and place it in a tray of running water. Wash the print for 5 minutes, or until there is no longer any milkiness in the water. The instructions for processing are much the same as for salted paper, but because the albumen presents a tougher surface, a stronger toner and fixer are needed.

Toning

If the print is to be toned, any of the toners listed for salted paper can be used following the same procedures. Although the same strength gold toners given for salted paper can also be used for albumen, they will be more effective if the amount of gold is doubled to 0.4–0.5 gram per liter. While in the toner, the print should be agitated constantly. After toning is completed, rinse the print for several minutes in running water before fixing it.

Fixing

Although one fixing bath may be used, it is less effective and certain than multiple baths. An effective fixing schedule for an albumen print is to use two 1-liter fixing baths of 10% sodium thiosulfate for 4–5 minutes each, with regular agitation. To minimize the silver bleaching, make the fixer slightly alkaline by adding 2–3 grams of sodium carbonate or sodium bicarbonate, or a few milliliters of ammonia per liter.[21] A simple test to determine if the print is adequately fixed appears in the appendix.

Remember, the fixer is weak, so it's important not to overload its capacity. It will probably need replacing after eight to twelve 8×10-inch (20×25-cm) prints. It is best to replace the fixer on the basis of the number of prints that have been processed rather than waiting for it to reach its capacity. Generally, when a sodium thiosulfate fixer has 2 grams of silver per liter, it is considered exhausted.[22] A simple method of testing this is to use a commercially available hypo testing solution. If a precipitate forms when the testing solution is added to the fixer, then the fixer has reached its capacity and should be replaced. A simple formula for making your own testing solution can be found in the appendix.

> **!** Do not pour used fixer down the drain. It is not only environmentally unsound, but also illegal in most areas. Save it in a clearly labeled container and take it to your chemical recycling center.

After fixing is completed, wash the print in running water for a few minutes and then put it in a hypo clearing bath, with constant agitation, for 3 minutes. Either a commercial hypo clearing bath or a 1% solution of sodium sulfite can be used. The print is then washed for 30 minutes in running water.

After the wash is completed, remove the print and let the excess water drain from it. Gently blot the surface with a paper towel and either hang it up to dry or allow it to dry flat on a sheet of newspaper.

Anonymous gold-toned albumen print.

Notes

1. *Encyclopedia of Photography* (1969).
2. Towler (1969).
3. Reilly (1980).
4. Ibid.
5. Ibid.
6. Cutler (1988).
7. Reilly (1980).
8. Ibid.
9. Hubl (1896, as quoted by Reilly 1980).
10. Towler (1969).
11. Wall (1945).
12. Reilly (1980).
13. Ibid.
14. Cutler (1988).
15. Reilly (1980)
16. Ibid.
17. Ibid.
18. Cutler (1988).
19. Burbank (1973).
20. Hasluck (1905).
21. Wall (1945).
22. Eaton (1986).

Bridge at Buchanty (© Michael Ware), type II cyanotype, made
with Michael Ware's redesigned cyanotype chemistry, the first
major change in the cyanotype in 150 years.

Cyanotype

Invented in 1842 by Sir John Herschel, the cyanotype is one of the first permanent photographic processes, and one of the oldest. Herschel made the very important discovery that ferric salts, such as ferric ammonium citrate, are reduced to a ferrous state upon exposure to light, and in that state can combine with, or *reduce*, other salts, such as potassium ferricyanide. This is the basis for ferric processes such as the cyanotype, platinum, and the kallitype. Because of this, these processes are sometimes referred to as *iron printing*.

Originally, this technique was used as a means of copying notes. It is still used in that capacity as today's familiar blueprint. Unfortunately, the blue color wasn't well suited for other subjects, such as portraits, and its popularity was limited. It had its uses though: it was used to some extent as a material for postcards and prints that amateurs could easily make at home or while on holiday. Anna Atkins,[1] regarded as the first woman photographer, made a book about her study of British algae and botanical specimens by using the then-new cyanotypes to illustrate it.

The distinctive blue color of the cyanotype is the result of ferric ammonium citrate and potassium ferricyanide being reduced by light to ferrous ammonium citrate and potassium ferrocyanide, respectively, to form ferric ferrocyanide (insoluble Prussian blue):

> Apparently a portion of the ferrous salt first formed by the reducing action of light reacts further with a portion of the Prussian blue to form the white insoluble ferrous ferrocyanide. After the print is washed thoroughly and dried, the ferrous ferrocyanide is oxidized gradually by the air to form further amounts of ferric ferrocyanide (Prussian blue). This explains why the cyanotype darkens after being subjected for a considerable period to the action of the air.[2]

Cyanotypes may be considered reasonably permanent, but they will fade if they are in contact with alkaline substances. They may also fade after extended exposure to light because of partial reduction of the Prussian blue to the white ferrous ferrocyanide. If this occurs, the cyanotype can be given a chance to "rest" in the dark, and the air will once again oxidize it back to blue ferric ferrocyanide, although perhaps not totally.[3] This regenerative ability, by the way, is unique in photography to the cyanotype.

The traditional cyanotype, also referred to here as *type I*, generally uses a negative with a density range of about 1.4, or one that would print on grade 0 paper. A less dense negative will also work, although the contrast will be weaker. A negative step tablet (see chapter 1) can be used to find the negative density range best suited to your paper. Although the best method of contrast control is to have a negative of the correct density range, it is possible to adjust the contrast to some degree.

As with related processes, the color and texture of the paper used for a cyanotype can add a great deal to the appearance of the finished print. Since cyanotypes are sensitive to alkaline conditions, it is better to avoid papers that are buffered. Most paper has an adequate amount of sizing for use with the cyanotype and can be used with no further preparation. A few papers, however, may need to be lightly sized if the sensitizer sinks in too deeply or if the final image is too flat. Sizing can add depth and brilliance to the image by keeping it closer to the surface of the paper (see chapter 1).

Some papers may reproduce a shorter range of tones than others, making it difficult to use the recommended negative density range in some cases. The only way to determine if a paper will be adequate for your purposes is to test it. You may find that different types of paper require different exposure times and also vary somewhat in the intensity of the blue coloration of the print.

Cyanotypes can be used in many creative ways, both alone and in combination with other materials. For a more graphic appearance, try a high-contrast negative from an enlargement made on paper or from overhead transparency material made with a computer printer or copy machine. These can then be used to produce a high-contrast or continuous-tone image. Multiple printing in combination with other media or handcoloring with watercolors or similar materials can provide a striking appearance. The support for the cyanotype can be a material other than paper: it can be printed on cloth and wood as well. Possibilities for printing on cloth include using the material for decorative pillows, clothing, wall hangings, or three-dimensional figures.

Contrast Control

If the light-density values appear weak after the initial printing and developing, they can usually be corrected by simply extending the exposure time on the next attempt, overexposing until the highlight is printed through. The paper must also be capable of reproducing the desired density range for this to be completely successful. Overexposure reduces the tonal separation in the deepest values, adding to the shadow contrast, although it will not alter the maximum density. It should be understood that once the

maximum density of a particular sensitizer-paper combination has been reached, further exposure will not increase it, but will tend to slide the tonal values forward. This effect isn't necessarily unwanted; it can add mood and character to an otherwise ordinary image.

It's possible to adjust the contrast to some degree for a negative with a shorter density range by adding 1–2 drops of a 1% (1 gram per 100 ml) ammonium or potassium dichromate solution to the sensitizer solution. Due to the hazardous nature of dichromate, this alternative is best avoided if possible.

> **!** Dichromate is a carcinogen. Handle it with care. Wear gloves and protective glasses, and avoid inhalation of the dry material.

The processing method giving the shortest density range with the type I cyanotype is the traditional water bath. Combined with a paper that delivers differing density ranges, this can be a useful control, particularly for a negative with a shorter density range. If the negative range exceeds that of the paper-processing bath combination, or the print is underexposed, it can result in an unhappy sight familiar to many beginners when some, or most, of the highlights float gracefully down the drain during processing. As noted above, this is usually corrected with a longer exposure time.

Dichromate is usually suggested when the sensitizer needs to be adjusted for a thinner negative—one with a smaller density range. There is also a method for adjusting the sensitizer for a longer density range. Certain weak acidic solutions, such as acetic or citric acid, can significantly increase the number and density of steps reproduced beyond that of plain water processing, without lengthening the exposure time. The increase in density range depends upon the paper type and the type and strength of the acid, but it can be a more effective means of contrast control than overexposure alone. This method tends to reduce the tonal separation in the very deepest values without reducing the maximum density. Different dilutions of acid may increase this effect, sometimes disproportionately, in both the light and dark ends of the scale.

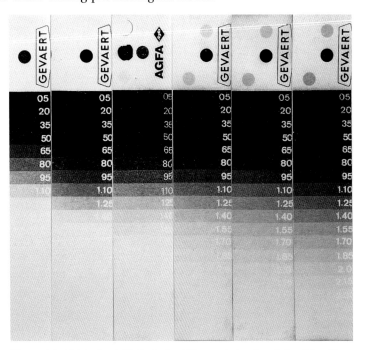

These step tablets clearly illustrate the difference in tonal scale possible with acetic acid development. The solutions were made using a stock solution of 8% acetic acid. The two on the left were exposed for 6 and 11 minutes, respectively, and developed in plain water. The remainder from left to right were exposed for 6 minutes and developed in acetic acid diluted with water 1:5, 1:2, 1:1, and in the undiluted stock solution of 8% acetic acid, respectively (© Richard Farber).

> **!** Deadly cyanide gas can be generated when acids are added to potassium ferricyanide. Make certain that all potassium ferricyanide, whether in solution or dry, is

OPPOSITE AND ABOVE: Postcards from Rome (© *Carolyn Strand), a quilted, reversible garment made with a collage of cyanotypes, front view showing decorative stitching.*

safely put away so that there is no danger of accidentally adding acid to it. Be sure to use standard safety procedures and protection when using any of these materials. It's best to avoid the use of glacial acetic acid (99%) or hydrochloric acid in a developer. See the chemical list in the appendix for further precautions.

Remember that different kinds of paper may give different results; the following suggestions are general reference points for you to try with your brand of paper and under your working conditions.

The type I cyanotype requires eyedroppers, two containers for the sensitizer, a small mixing container, and a brush (or rod) for applying the solution. The type II cyanotype requires only one container for the sensitizer.

Ordinary white vinegar, a very dilute form of acetic acid (about 5%), can be used full strength or in various dilutions for manipulating the density range. Using vinegar without dilution has the strongest effect and may add two stops of high-value density; a dilution of 1:2 (one part vinegar to two parts water) may add one stop. Although vinegar is inexpensive, the odor can be strong and offensive. You may be able to find an 8% solution of acetic acid, designed for cleaning coffeemakers, at your supermarket. As well as adding even more scale than vinegar, the 8% solution is easily diluted and has a markedly reduced odor. A 1% solution of citric acid (10 grams per liter) will provide about the same improvement as vinegar diluted 1:2. Not as inexpensive as vinegar, citric acid has the advantage of being odorless. There is some suspicion that the use of citric acid may cause the cyanotype to be more susceptible to (reversible) light-induced fading.[4]

Ordinary *nonindicator* stop bath made with either citric acid or acetic acid can also be used at various dilutions for this purpose. If the percentage of the solution is known, the amount of water to add for other percentages is easily determined with the crisscross method shown in the appendix.

In summary, controls for contrast include exposure, the negative density range, the type of paper used, and the type of developing agent used.

Sensitizing

There are two solutions for sensitizing: one of ferric ammonium citrate and the other of potassium ferricyanide. The solutions can be kept reasonably well in a cool, dark area if separate; however, once mixed together, they will not keep.

There are many formulas for sensitizers, differing only slightly from each other, but it should be noted that too much potassium ferricyanide will lower the printing speed; too little may cause the blue color to bleed into lighter areas.[5] Ferric ammonium citrate is

available in either brown or green crystals, but the green, which is more sensitive, is the preferred form.

! Do not combine acid, such as stop bath, with potassium ferricyanide. This will generate highly toxic hydrogen cyanide gas. When disposing of potassium ferricyanide, be careful that it isn't combined with other elements, especially acids, that may react with it. See the chemical list in the appendix for further precautions.

The following is a formula for cyanotype:

SOLUTION A

Water at 24°C/75°F	100 ml
Ferric ammonium citrate (green)	25 grams

SOLUTION B

Water at 24°C/75°F	100 ml
Potassium ferricyanide	10 grams

The paper can be coated with sensitizer under either a weak tungsten light or yellow light. To prepare the sensitizer, add equal amounts of solutions A and B into a small container, taking care not to contaminate the solutions by returning droppers or caps to the wrong containers. A 4 × 5-inch (10 × 12.5-cm) image might take 6–8 drops of each solution; if a coating rod is used, even less solution is necessary. The prepared and mixed solution is then coated on the paper support with a brush or with a coating rod. A foam brush is excellent for this purpose.

Once coated, the paper can be air-dried in a darkened area or dried with heat, as with a hair dryer. If heat-drying, it is best to let the paper sit several minutes before drying; otherwise, rapid drying may prevent the paper from absorbing the solution adequately. When dry, the sensitized paper will appear yellow-green. It will keep for several hours to two days, depending upon the ambient conditions. If the paper turns blue or green during or after coating, it should be discarded.

Exposing

The contact frame with the negative and sensitized paper can be exposed to the sun or to an artificial UV light source. The printing time will take from 3–30 minutes, depending upon your negative density and the type of light source you are using.

Periodically check the exposure in a shaded area (if you are using the sun) or away from the light source (if you are using artificial light inside) by unfastening one part of the hinged back of the contact frame and noting the appearance of the print. As the exposure progresses, a faint provisional image will become visible. The highlights will bronze over, while other parts will be greenish in color when fully exposed. Be careful not to move the negative out of position during this process. A more accurate measure of exposure may be found by using a step wedge (see chapter 1).

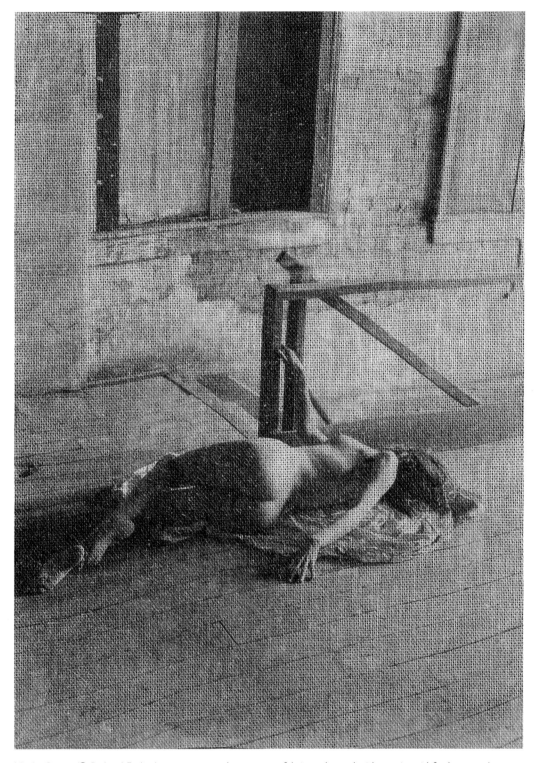

Nude, Stairs *(© Richard Farber), cyanotype made on cotton fabric and toned with tannic acid for brown color.*

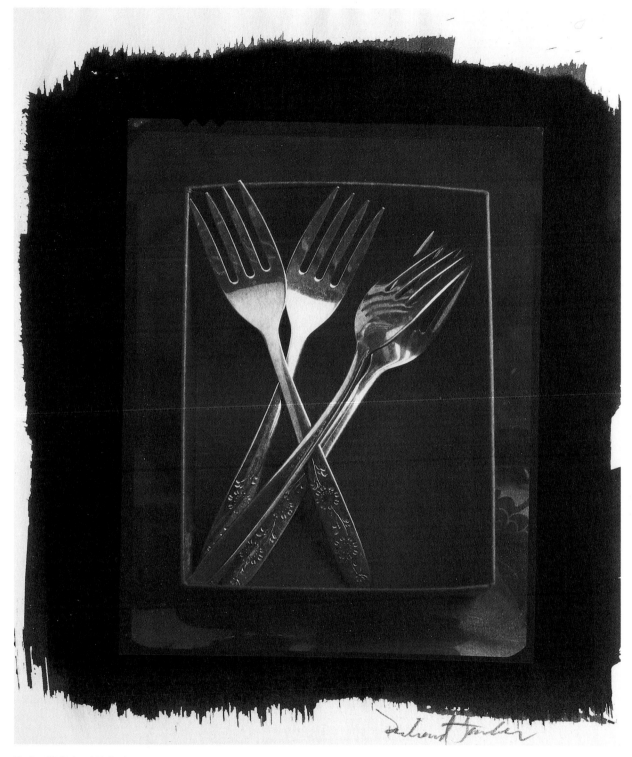

Forks *(© Richard Farber), cyanotype.*

Processing

Processing the cyanotype is one of the simplest methods ever devised. Simply slip the paper into a tray of water. The bright blue image will appear almost instantly, while the yellow ferricyanide stain washes away. Be sure to brush away air bubbles. Allow the print to wash for 10–20 minutes, making sure that the yellow ferricyanide stain is gone.

If the print is washed for too short a time, soluble ferric salts will remain in the paper, which can cause fading when the image is exposed to light.[6] Prolonged washing can cause some loss of delicate highlight tones, particularly in water that is alkaline or *hard* (having a high mineral level, usually calcium).

Processing with an acidic solution is done in the same manner, except that the exposed print is first slipped into a tray of the acidic solution for 1–3 minutes and gently moved around. Be sure to use an adequate amount of solution and to keep the print moving to avoid staining the lighter areas. Afterwards, it should also be washed for 10–20 minutes.

Remember that water processing will give the shortest density range; putting the print in a weak acidic solution first will lengthen it to some extent.

As mentioned above, you may find some or most of your image swirling away in a blue cloud during the processing bath. This is usually caused by underexposure and is easily corrected with a longer exposure. Heat-drying the paper directly after coating can also have this effect. Another possible cause is that the paper is unable to match the negative density range.

If the print has been overprinted, it can be reduced in a weak alkaline solution, such as 0.5–1% sodium carbonate (5–10 grams per liter of water), a few milliliters of household ammonia added to the wash water, a 1% solution of ammonium chloride, or even a very weak solution of hypo clearing agent. Because of its susceptibility to alkalinity, the cyanotype can be quickly bleached; it's best to use as weak a solution as possible so that the amount of reduction can be monitored and controlled. Wearing gloves or using tongs, remove the print and then thoroughly rewash it when the highlights are corrected.

After the wash, if you want to see the final color right away, place the print in a tray with a 10% household hydrogen peroxide solution, which will oxidize it to the same shade it will be when it is dry. Since there seems to be some confusion about this technique, it should be emphasized that this will not affect the final color of the print—the color when dry will be the same whether peroxide is used or not.

The wet print can be gently blotted and left to air-dry on a line or newspaper. It can also be dried with moderate heat. It will dry down to the familiar dark blue tone. Some papers, however, may take some time to fully dry down to the final color, even with heat.

Toning

Although the cyanotype is best known for its distinctive blue color, it can be toned to another color. Most toning processes seem to be less than successful over time, but one of the better methods is a two-part toner using tannic acid and an alkali such as ammonia, which gives from brown to purple-brown tones.

One such toning formula is:

SOLUTION A

 Ammonia .. 10 ml

 Water .. 1000 ml

SOLUTION B

 Tannic acid ... 20–50 grams

 Water .. 1000 ml

Slip the cyanotype into solution A until the blue color has bleached away, then wash it for a few minutes. Slip the bleached print into the tannic acid solution until the color reaches the density desired.

Toning with tannic acid has its problems, particularly with staining of the paper base and highlights. This can be partly avoided by not toning too heavily. Because the image is bleached in the alkaline bath, there's an unavoidable loss of some density. This can be compensated for by printing the cyanotype somewhat darker than desired for the finished image.

The Ware Type II Cyanotype

There have been no major changes to the traditional, or type I, cyanotype since its introduction by Herschel over 150 years ago. Michael Ware, an innovative English photographer and distinguished chemist, has recently designed an elegant new method of making cyanotypes. The information in this section is based on Ware's material.[7] Sometimes called the "new cyanotype," it will be referred to here as the *Ware type II cyanotype,* or simply, the *type II cyanotype.*

The type I cyanotype generally works very well; after all, it's been used essentially unchanged for over one hundred years. Like any process, however, it has a few drawbacks. Typically, a cyanotype bleeds heavily during processing, which can stain highlights. It can also require a long exposure time, depending upon the light source.

The type II cyanotype neatly addresses these drawbacks. It bleeds very little and is considerably more sensitive to light, making for much shorter exposures. Its density range is longer, but like the type I cyanotype, this can be modified shorter or longer to some extent. It is also capable of a very dark maximum density, approaching black. And instead of two separate solutions, it uses a single solution, which keeps very well, reportedly up to one year.

The type II cyanotype uses a long-scale negative, longer than that of the traditional cyanotype. A suitable negative density range is about 1.8, but the range that can be accommodated can be increased to 2.6 by adding citric acid to the sensitizer. This would be a negative that you would be unable to print on the lowest grade of paper. The contrast can be reduced by adding 1–2 drops of ammonium dichromate to the sensitizer.

As with most improvements, there is a cost. Of the three chemicals used in this process, two are more hazardous than those used for the type I and one can be difficult to find.

The procedure to make the solution is also more difficult, requiring more laboratory skill and presenting greater hazards.

Since kits are now being offered for the type II cyanotype, they are strongly recommended as a safer and more convenient alternative to preparing your own chemicals. Sources for kits can be found at the end of this chapter.

Directions are given below for those who wish to prepare their own sensitizer.[8]

! Do not attempt to prepare your own sensitizer if you are not familiar with the techniques of safely handling chemicals and with their potential hazards. Remember that all of these chemicals are toxic! Wear gloves and eye protection. Be sure that you have adequate ventilation. See the chemical list in the appendix for further precautions.

Preparation should take place under tungsten light, not fluorescent or daylight.

Sensitizer chemicals needed:

Ferric ammonium oxalate (ammonium iron III oxalate) 30 grams
Potassium ferricyanide .. 10 grams
Ammonium dichromate (25% solution) 0.5 ml
Water (distilled) to make ... 100 ml

1. Using a mortar and pestle, finely powder 10 grams of potassium ferricyanide, crushing all the red crystals to a yellow powder.

! This should be done under a fume hood or in a glove box (see chapter 2). In addition to other protective gear, wear a dust mask and avoid inhalation of the powder.

2. Heat about 30 ml of distilled water to 50°C/122°F and dissolve 30 grams of ferric ammonium oxalate (ammonium iron III oxalate).
3. Add 0.5 ml of 25% ammonium dichromate solution (previously prepared by dissolving 5 grams of the solid in distilled water and making up to a final volume of 20 ml) to the hot solution from step 2. Mix thoroughly.
4. While it's still hot, add to the solution the 10 grams of finely ground potassium ferricyanide in small portions with vigorous stirring; few (or preferably no) red crystals should be seen, and green crystals should begin to appear. Set the solution aside in a dark place to cool and crystallize overnight.
5. Separate most of the liquid from the green crystals by filtration. A coffee filter in a funnel will work fine (do not use a funnel used for making coffee or for any use other than in the darkroom). The green solid (ferric potassium oxalate, or potassium iron III oxalate) should be disposed of safely (it is poisonous!). The volume of liquid extracted should be about 30–33 ml.
6. Prepare the olive-colored solution with distilled water to make a final volume of 100 ml. The sensitizer can be made more dilute (up to 200 ml); it will be faster to print, but yields a less intense blue.
7. Filter the sensitizer solution, label the container clearly, and store it in a cool, dark area. Its shelf life is estimated to be about 1 year.

! This solution is toxic. Make sure it is well out of the reach of children and pets. See the chemical list in
 the appendix for further precautions.

The directions for coating, exposing, and processing the paper are the same as for the traditional cyanotype.

Type II cyanotype kits can be obtained from Bostick and Sullivan and from Luminos Photo Corp. Artcraft Chemicals will make kits to order. See the appendix for full contact information.

Michael Ware has plans to publish a book on the cyanotype in the near future.

Notes

1. Atkins (1985).
2. O'Hara and Osterburg (1951).
3. Ibid.
4. Ware (personal communication, Feb. 1996).
5. Crawford (1979).
6. Luna (1992).
7. Ware (1997a).
8. Ware (1996).

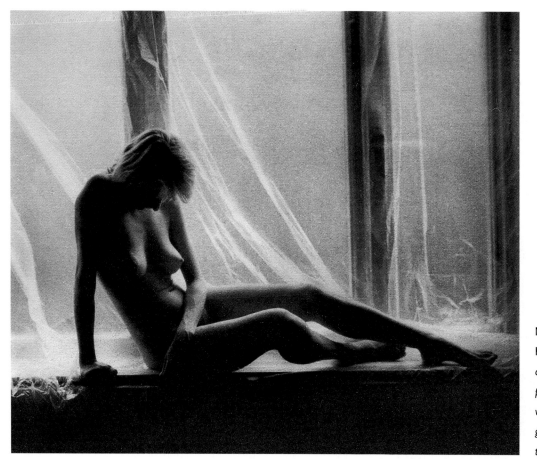

Nude at Window, Den Haag (© Richard Farber), acid-developed cyanotype print made from a negative with a density range greater than normal for type I cyanotype printing.

Scheveningen Landscape (© Richard Farber),
kallitype developed in sodium acetate.

6

Kallitype

THE KALLITYPE, NOT TO BE CONFUSED WITH THE *CALOTYPE,* WAS INTRODUCED IN 1889 BY W. W. Nichols. It is based, as is the closely related process of platinum, on Herschel's discovery that upon exposure to light, certain ferric substances, such as ferric oxalate, become ferrous and, in a suitable solvent, can then reduce metallic salts, such as silver nitrate, to a metallic state. Unlike other iron-based printing processes, which need only a clearing bath to remove the remaining ferric salts, the kallitype also needs a fixing bath to remove unexposed silver salts. Unfortunately, the kallitype was originally fixed in ammonia, and it quickly earned a reputation for fading. Although Nichols changed the fixing procedure to include the proven fixer, sodium thiosulfate, the kallitype failed to lose its reputation of impermanence.

Magazines, like the influential *Photo Miniature,* helped to keep interest in the kallitype alive by publishing articles and formulas for the process. If not for the interest of those who continued to use and experiment with it, the process would probably have disappeared into photographic oblivion. As it is, the kallitype has remained available only as a handmade item, although when platinum came into short supply during the First World War, a platinum and silver kallitype paper called Satista was produced.[1] Contrary to its early reputation of fading, a kallitype should be as permanent as any related silver process if properly processed. And as with other silver processes, toning greatly increases its life span.

Perhaps more than any other silver process, the kallitype is capable of producing color variations based solely on the composition of the developer. The possible color range includes black, brown, sepia, slate blue, and a reddish hue—all without toning. When toned with platinum or palladium, the kallitype can be very difficult to distinguish visually from a genuine platinotype or palladium print. Although there were doubtless many kallitypes made, there seem to be few on the vintage collectible market. An interesting

speculation is that some collections may include kallitypes incorrectly identified as platinum or palladium.[2]

Since the kallitype has a fairly long scale, a negative with a density range of 1.2–1.4, or one that would print on grade 1 or 0 paper, is the most suitable. However, negatives with a shorter density range can also be accommodated because the kallitype contrast can be altered by the addition of dichromate to the developer.

As with the other historic processes, the texture, color, and general appearance of the paper support is an important component of the kallitype. When selecting a paper, remember that paper can look quite different after it has been thoroughly wet and then dried. Another point to keep in mind is that because of the long wet time, some papers can literally fall apart. The tint or color of the paper can have a strong effect upon the apparent visual contrast: a bright white base appearing more contrasty than an off-white base. Any buffering agents or materials within the paper can also have a definite effect upon the final outcome (see chapter 1). To see this for yourself, print the same negative on two different paper types and compare the prints. There will very likely be a visual difference in color and/or contrast, ranging from subtle to impressive. This is one reason you should compare as many papers as possible.

Some papers, such as Rives BFK, may have to be sized to keep the sensitizer from falling too deeply into the paper fibers and giving a sunken appearance. The temperature will have some bearing on this as well; warmer temperatures seem to make the sensitizer sink in at a greater rate than cool temperatures.[3] Different materials, such as starch (even spray starch), dextrin, and gelatin, have been recommended as sizing agents. Dextrin and starch will wash out, leaving the original surface clear, but too heavy a coat of gelatin can obscure the texture of the paper. Hot-pressed papers are usually easier to use, as well as papers that are reasonably well sized at the factory. Ultimately, the only way to find out whether or not a paper will work for you without additional sizing is to try it. Some papers that seem to work well with the kallitype are Fabriano Artistico and Schoellerhammer Durex and 3G. Others, such as Arches Platine, Cranes Platinotype, and Buxton, are designed for the iron processes and have been reported to work well.

Like the cyanotype, the sensitizer can also be applied to fabric. Consider going beyond the constraints of a frame. Some possibilities include wall hangings, pillows, and mixed media.

The materials for making a kallitype are:

- silver nitrate (10% solution)
- a clearing agent (see section on clearing, below)
- ferric oxalate
- sodium thiosulfate
- developer (see section on developing, below)
- a foam brush or coating rod
- a contact printing frame, preferably with a hinged back
- a yellow safelight
- trays larger than the print size

Restorante Sardegna (© Richard Farber), kallitype developed in sodium acetate.

- a UV light source
- suitable paper to sensitize
- gloves and protective glasses
- distilled water
- potassium, ammonium, or sodium dichromate
- an alkalizing agent to add to the fixer: household ammonia, sodium carbonate, or sodium bicarbonate

The processing steps for the kallitype are as follows:
- developing
- clearing the print in three sequential baths
- toning, if desired
- fixing the print in two to three sequential fixing baths
- clearing the print in a hypo clearing bath
- giving the print a final 30-minute wash

Sensitizing Solution

There have been many formulas published for the kallitype, some of them quite complex. The sensitizer given below is a good place to start, since it's easy to mix and gives initially good results. It's best kept as two solutions and mixed just before use. Once mixed together, the solution will not keep well.

> Be careful handling the silver nitrate. Wear gloves and goggles. Avoid inhalation of the dry material. See the chemical list in the appendix for further precautions.

Solution A: 10% silver nitrate solution

Water (distilled)	20 ml
Silver nitrate	3 grams
Water (distilled) to make	30 ml

Solution B: 20% ferric oxalate solution from powder (The commercially prepared 20% solution is recommended.)

Water (distilled)	40 ml
Ferric oxalate powder	10 grams
Water (distilled) to make	50 ml

> Ferric oxalate is a toxic substance. Wear gloves and protective glasses when handling it. Be very careful to avoid inhalation of the powder. See the chemical list in the appendix for further precautions. Because excellent-quality ferric oxalate is available commercially, a premeasured or premixed 20% ferric oxalate solution is highly recommended as the safest and easiest method. Although it's safer and easier to buy the commercially prepared product, the appendix contains directions for making your own ferric oxalate.

Sensitizing the Paper

To sensitize the paper, choose a piece larger than the negative. Place the negative on the paper and make light pencil marks at its corners or edges as a guide for sensitizing. Pin or tape down the edges of the paper. You can mask the paper with tape or use an opaque mask, such as black paper or a graphic arts material called Amberlith or Rubylith, if you do not want to have brush marks in the margins.

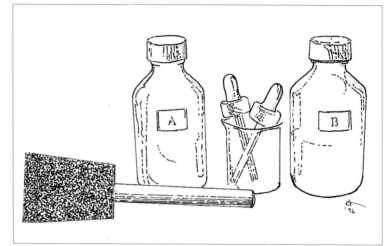

Under safelight conditions, wearing gloves, add equal amounts of solutions A and B into a small plastic or glass—but not metal—container. Use enough solution to adequately cover the area of the negative without flooding it. For a 4 × 5-inch (10 × 12.5-cm) print, 7–8 drops each of part A and B will be a good starting point. A larger print, such as 8 × 10 inches (20 × 25 cm), will require four times the quantities of solutions A and B.

Apply the sensitizer to the paper. Using either a brush or coating rod, spread it to the marks indicating the margins of the negative. The paper can then be air-dried in a dark place. Although it can also be dried under gentle heat, the use of a hair dryer or other

The kallitype requires eyedroppers, two containers for the sensitizer, a brush (or rod) for spreading the solution, and a small mixing container. The Vandyke requires only one container for the sensitizer.

type of forced air is discouraged because of the added risk of introducing oxalate particles into the air. Generally, the paper will air-dry in 15–20 minutes.

A foam brush is highly recommended for coating. Once a brush has been used, it's best to dedicate it solely for the application of that chemical; this helps avoid contamination problems, as will washing it when you're finished with it. If you're using a fairly smooth paper, a coating rod will also work well and is easy to clean.

Exposure

Under safelight conditions, when the paper is completely dry, place the negative, emulsion side down, on the sensitized surface of the paper. Put the paper and negative into the contact printer with the negative facing the glass.

! If the paper is not completely dry, it can permanently stain the negative.

The exposure can then be made with your choice of UV light. There will be a provisional exposure that can be periodically checked in a shaded area or under a safelight. The exposure can also be monitored with a gray scale (see chapter 1). The best method, however, is to judge the exposure by time.

Black Mountain, Roots and Stream (© Richard Farber), kallitype developed in sodium acetate and palladium toned.

If the exposure is long enough, the darker parts may exhibit a phenomenon known as *solarizing*, or a reversal in tone from dark to light, which will remain as a permanent part of the image. Rather than discarding the image if this occurs, you might want to keep it for its interesting tonal structure. Toning will generally correct for solarized shadows. Adding an additional amount of silver (solution A) may also help eliminate solarizing.[4]

Contrast Control

Contrast is controlled with the addition of dichromate to the developer, which adds a great deal of flexibility to the kallitype process. It doesn't seem to matter which of the three dichromates (ammonium, potassium, or sodium) is used; however, the concentration that you choose does matter.

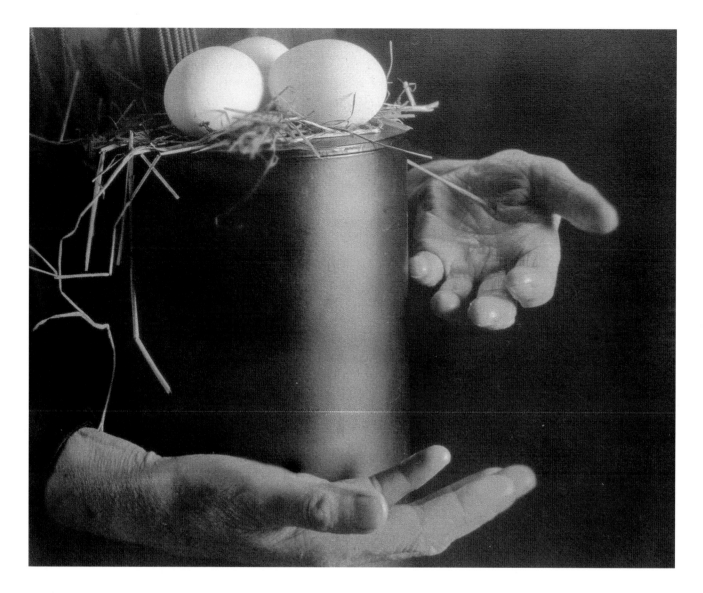

Dichromates are known carcinogens. Avoid inhalation and contact. Wear protective glasses and gloves. See the chemical list in the appendix for further precautions.

Untitled gold-toned Vandyke print (© Pieter Tjepkema).

In equal amounts, a more concentrated solution of dichromate will give a stronger restraining effect than a weaker solution. A concentration between 3–5% should be of adequate strength to provide for reasonable steps of contrast adjustment. It's difficult to state a specific amount of dichromate to add for a specific negative density range because of the variation in developers and different types of exposing light sources. The effects of various amounts of dichromate in the developer can be easily tested with a step tablet to find which amounts will work best for your conditions (see chapter 1).

Adding 3–4 ml of a 5% dichromate solution per liter of developer is a good starting point for a negative with a density range of about 1.10–1.20, or one that would print on about a grade 2 paper. Each new addition of 2 ml will further shorten the scale about 0.15, or one density step, which can be seen as a loss of steps on a step tablet. More

dichromate in the developer generally requires a slightly longer printing time. A denser negative, of course, requires less dichromate in the developer. These amounts are just starting points—add more or less to fit your conditions.

If negatives with different density ranges are to be printed, it can be worthwhile to make separate developing solutions, each with a different amount of dichromate in it to provide the appropriate contrast. With use, the dichromate will gradually need to be replenished. The degree of change can be monitored by exposing a sample of paper with a step tablet and developing it at the beginning of the printing session. If the contrast seems to be falling off, expose another step tablet and test-develop it. It will be evident when the level of contrast is lessening, since more exposure steps will be visible.

Although dichromate is the primary in controlling contrast, it's worth repeating that the type of light used also has a bearing on the contrast. The use of daylight fluorescent tubes alone or in combination with UV tubes may add an additional means of fine-tuning the contrast (see chapter 1).

Developing

When the exposure is complete, take the exposed paper out of the contact printer under safelight conditions. Slip it quickly and evenly into the developer and brush off any air bubbles; the image will appear almost instantly. Leave it in the developer for 5–10 minutes with little or no agitation.

The developer, which is a solvent of the ferrous oxalate produced during exposure, also helps dissolve some of the iron compounds. This is the main reason for the extended development. In theory, unless the image is fogged, it can't be overdeveloped.[5] It's been suggested that as long as there is enough of a suitable acid, such as tartaric or citric acid, in the developer, the formation of a yellow ferric stain can be largely avoided.[6] This can be ensured by adding 2–3 grams of tartaric acid to the developer initially and then a few milliliters of a 10% tartaric acid solution (10 grams of tartaric acid in 100 ml of water) after each print or two to keep the acid replenished at an effective level.

There are many formulas for developers. Each of the examples listed below gives different image tones. Many more formulas, generally variations of the ones that follow, can be found in the texts listed in the bibliography. The solutions will last for quite a while; replace them when they no longer work well or start staining prints.

> ! Don't pour used developer down the drain; save it in a clearly labeled container and take it to your chemical recycling center.

Formulas for developers

In spite of what may be suggested for some formulas, it's important to remember that there is a limit to how much borax (or any chemical) can be added to a solution before it becomes saturated. For example, if you're trying to mix or use a developer and some borax

remains undissolved despite much stirring, the solution has reached its saturation point and will hold no more borax at that temperature. At 25°C/77°F, 6.25 grams of borax in its hydrated[7] form can be dissolved in 100 ml of water.[8] Although warmer water can hold more of a chemical, when the temperature falls to a lower point, less can be held and the excess amount will usually drop out.

Note that tartaric acid has been added to each formula. The purpose, as noted above, is to help prevent a yellow stain.

Brown tone[9]

Water 49°C/120°F	750 ml
Borax (sodium borate)	100 grams
Rochelle salts (sodium potassium tartrate)	75 grams
Tartaric acid	3 grams
Water to make	1 liter

This formula is variable: if the amount of Rochelle salts is increased or the amount of borax decreased, the image tone will become warmer. As noted above, unless you intend to use your developer at a fairly warm temperature, this amount of borax will not stay in solution at a normal room temperature of 25°C/77°F.

Sepia brown tone

Water 49°C/120°F	750 ml
Rochelle salts	50 grams
Tartaric acid	3 grams
Water to make	1 liter

Slate blue tone[10]

Water 49°C/120°F	750 ml
Rochelle salts	40 grams
Sodium formate	42 grams
Tartaric acid	3 grams
Water to make	1 liter

Maroon[11]

Water 49°C/120°F	750 ml
Rochelle salts	40 grams
Sodium tungstate	58 grams
Tartaric acid	3 grams
Water to make	1 liter

Neutral gray-black tones

Water 38°C/100°F	750 ml
Sodium acetate	125 grams
Tartaric acid	3 grams
Water to make	1 liter

Many prefer this type of developer for ease of preparation and use.

Ammonium or sodium citrate can also be used at the same dilutions as called for in the platinum formulas. Each gives a very warm red-brown color to the print unless toned. To avoid cross-contamination, do not use the same developer solution for both kallitype and platinum printing.

Clearing

After developing, the print must be cleared of excess ferric salts, or, as mentioned above, a permanent yellow iron stain of insoluble ferric compounds will result.

Clearing the print requires three clearing baths, in which the iron compounds are soluble, used in sequence, with regular agitation for 5 minutes each. Take the paper out of the developer with tongs or gloves, let the excess fluid drip off, and put the print in the clearing bath for 5 minutes with regular agitation. Repeat this for each of the three clearing baths. If the print is rinsed off before being placed in the clearing bath, the bath will last longer. The clearing baths can be used until they no longer clear the yellow stain from the highlights of the print.

After the first bath is exhausted, exchange the second bath for the first and the third bath for the second one. A new third clearing bath can then be added. It's best to examine for evidence of incomplete clearing in daylight, since the yellow stain will not be very noticeable under a yellow safelight. A test to check if clearing is adequate can be found in the appendix.

Unlike the process used for platinum, a dilute hydrochloric acid clearing bath can't be used for kallitypes, since the acid would dissolve the silver. There have been many suggestions for clearing baths, some of them, such as potassium oxalate, are quite toxic. The ones given below are relatively safe and effective to use. They will, like the developer, become contaminated with sensitizing chemicals as they are used.

- EDTA is a very effective, easy-to-use clearing agent.

EDTA solution

Water	1 liter
EDTA	25–30 grams

It can be kept until it no longer clears properly.

- Kodak Hypo Clearing Agent seems to be an effective clearing bath for the kallitype. Although the formula is proprietary, it's known to include EDTA, sodium citrate, and

sodium metabisulfite. Try starting with the recommended dilution for film and paper before using more concentrated solutions. It should be noted that a working solution of Kodak Hypo Clearing Agent has a stated life span of 24 hours. The clearing agent can be made in small amounts from the powder, but, unfortunately, the components of dry chemical mixtures will not be evenly distributed throughout the product.

- A very effective combination is to use EDTA for the first two clearing baths and Kodak Hypo Clearing Agent for the third.
- A clearing bath containing sodium citrate and citric acid can also be used, but it causes a warm color shift unless toned.[12]

Windmill, Leiden
(© Richard Farber), Vandyke print.

Sodium citrate/citric acid clearing bath

Water	800 ml
Sodium citrate	30 grams
Citric acid	5 grams
Water to make	1 liter

Toning

If you choose to tone the print, it is generally done prior to fixing. Any of the POP toning formulas, such as the ones for salted paper, will work for the kallitype. The palladium and platinum formulas produce especially nice tones, ranging from brownish to black. Remember to handle the print with gloves or tongs. Before toning, rinse the print for a few minutes in running water to avoid chemical carryover to the toner. It has been suggested that prior to platinum or palladium toning, the print should be washed for a few minutes, put in a 5% sodium chloride (table salt) bath, and then washed again for 5–10 minutes.[13]

There's no definite time for the toning step, because the print is toned until it has the desired appearance. Remember that the print will dry down to a darker shade. After toning, rinse the print for a few minutes, fix, and wash as usual.

Fixing

Like a conventional silver print, the kallitype needs to cleared of unexposed silver salts with a fixer. After it has been cleared, remove the print from the clearing bath with tongs or gloves. Let the excess fluid drip off, and slip the print into the first fixing bath.

Because a strong, or acid, bath would severely bleach the finely divided silver, a relatively weak fixer (with a correspondingly limited capacity) made of 3–5% sodium thiosulfate is used.

Fixing is the Achilles' heel of the kallitype. It must be done properly if the image is to be permanent, but there is still the risk of significant bleaching, even in weak fixer. Making the fixer slightly alkaline by adding 2–3 grams of sodium carbonate or sodium bicarbonate, or a few milliliters of household ammonia per liter, helps minimize the silver bleaching.[14] If you choose to use ammonia, make certain that there is adequate ventilation in your workspace. See the chemical list in the appendix for further precautions.

Another way to cope with bleaching, as with salted paper, is to overprint the image, which will then give the desired density after fixing (see chapter 1). Toning will also greatly alleviate, if not eliminate, the problem of bleaching and will also add to the permanence of the print. It will, however, alter the color of the print.

One fixing bath of 5% hypo (sodium thiosulfate) can be used, but its capacity will be limited to about six to eight 4 × 5-inch (10 × 12.5 cm) prints. Since only one fixing bath would soon be exhausted, the two-bath fixing system is strongly recommended to ensure complete fixation.[15] Since most of the work is done by the first bath, the second, which

removes any remaining silver compounds, stays fairly fresh. An alternative suggestion from Stevens is that each bath should be 2.5% hypo, or half strength, and should include 2 ml of ammonia.[16] After the first bath is exhausted, exchange the second bath for the first and add a new second bath. Stevens further suggests that three 1-liter fixing baths of 3% sodium thiosulfate can be effectively used for 2 minutes each. When the first bath is exhausted after eight to ten prints, the second is exchanged for the first, the third bath for the second, and a new third bath is prepared.

It's difficult to give a precise time for fixing the image. After 10 minutes, the hypo, which is strongly attracted to paper, can be extremely difficult to wash out of the fibers.[17] If fresh fixer and multiple baths are used with regular print agitation, then a total fixing time of 6 minutes can be considered the minimum fixing time, and 10 minutes, the maximum. A simple test to determine if the print is adequately fixed can be found in the appendix.

It should be stressed that because the fixer is so weak, it's important not to overload its capacity. Generally, when a sodium thiosulfate fixer has 2 grams of silver per liter, it is considered exhausted.[18] A simple method of testing this is to use a commercially available hypo testing solution. If it forms a precipitate when added to the fixer, then the fixer has reached its capacity and should be replaced. A simple formula for making your own testing solution can be found in the appendix.

> ! Do not pour used fixer down the drain. This is not only environmentally unsound, but also illegal in most areas. Save used fixer in a clearly labeled container and take it to your chemical recycling center.

Keep in mind that because the fixer is very weak, its capacity is soon exhausted, so keep track of the number of prints fixed. After the print has been fixed, rinse it for 1 minute in running water, put it into either a commercial hypo clearing bath or 1% sodium sulfite for 3 minutes with agitation, and then wash it for 30 minutes.

When the washing is complete, the print can be gently blotted with a paper towel and hung, or placed on newsprint, to dry. It can also be dried with gentle heat.

Vandyke Print

The Vandyke, or brown, print is a simpler variant of the more complex kallitype. Unlike the regular kallitype, it doesn't require a clearing bath, needing only water for a developer and a fixing bath. It will yield an image that is an attractive dark brown color, which can also be toned for added permanence. If a brown print and cyanotype are to be used in combination, print the cyanotype first, or the brown print will be bleached.

The negative should have a density range of about 1.4, which could be printed on a grade 0 paper.

Consider going beyond an image on paper; the Vandyke can also be made on fabric and other porous material. Wall hangings, pillows, and other creations are possible. The brown print can also be enhanced by handcoloring with different media, such as watercolors and acrylics.

Sensitizer

The sensitizer relies on ferric ammonium citrate to reduce the silver salts to a metallic state. There are two types of ferric ammonium citrate available: green crystals and brown crystals. The green form, which is more sensitive to light, is the preferred type.

> **!** Be careful handling the silver nitrate. Wear gloves and goggles. Avoid inhalation of the dry material. See the chemical list in the appendix for further precautions.

One formula for the sensitizer is as follows (mix in the order given):

SOLUTION 1

Water (distilled)	35 ml
Ferric ammonium citrate	10 grams

Stir well until dissolved.

SOLUTION 2

Water (distilled)	35 ml
Tartaric acid	1.5 grams

Stir well until dissolved.

SOLUTION 3

Water (distilled)	35 ml
Silver nitrate	4 grams

Stir well until dissolved.

Add solution 2 to solution 1. Stir well. Add solution 3. Stir well. Add water (distilled) to make 100 ml.

This is enough solution to make nearly one hundred 4×5-inch (10×12.5-cm) prints. The solution will last for a month or two if kept in a cool, dark place.

Under a safelight, measure enough sensitizer to cover the negative size to be used, and brush it on with a foam or bristle brush, or use a rod for coating. Let the paper dry in a dark area; it can also be dried with gentle heat.

Exposure

Under a safelight, when the sensitized paper is dry, put the negative, emulsion side down, on it and put the paper and negative in a contact printing frame with the negative facing the glass. It can be exposed with the sun or an artificial UV light source. Depending upon the density of the negative and the type of light used, the exposure will be approximately 3–8 minutes. Because it will bleach back in the fixer, expose the paper until the provisional image appears darker than you want the finished print to be. Refer to chapter 1 for a more accurate method, using a step tablet.

Processing

Under a safelight, take the exposed print out of the contact printing frame. Slip the print, image side up, into a tray of gently running water. Like the salted paper, there will be a milky cloud in the water until the unexposed silver salts are washed away. Wash for 1–2 minutes, or until the milkiness is gone. The color will change to an orangish brown while it's washing.

Stonecutter's Hut
(© Michael Ware), an example of Michael Ware's recently developed argyrotype process.

Fixing

Take the print out of the developing water and let the excess water drip off. Slip it into a tray of weak sodium thiosulfate, 3–5% (30–50 grams per liter), for 5–8 minutes with gentle

agitation. Since one fixing bath will soon be exhausted, a two-bath fixing system is strongly recommended to ensure complete fixation.[19] Fix the print for 3–4 minutes with regular agitation in each fixing bath. After five to eight prints have been fixed, exchange the second bath for the first, discard the first, and add a new second bath. Since most of the work is done by the first bath, the second remains fairly fresh to remove any remaining silver compounds.

Even with the weak fixer solution, there will still be a fair amount of bleaching. Making the fixer slightly alkaline by adding 2–3 grams of sodium carbonate or sodium bicarbonate, or a few milliliters of household ammonia per liter, will help minimize the silver bleaching.[20] If you choose to use ammonia, make certain that there is adequate ventilation. The color will change to a darker brown in the fixer.

After fixing, rinse the print off and put it into a commercial hypo clearing bath or 1% sodium sulfite for 3 minutes with constant agitation. Afterwards, wash it for 30 minutes. Gently blot away the excess water with a paper towel and dry the print. It can be air- or blow-dried with gentle heat. The print will dry down to a distinctive dark brown color.

Toning

Toning deepens the color to an attractive dark brown and adds greater permanence. Unlike the other POP processes, the Vandyke is best toned *after* fixing to guard against staining.[21] Make certain the print is well washed before toning, since residual fixer will make the toner useless. The Vandyke can be toned in any of the POP toners given in this text, but the image should be printed darker than normal to allow for slight bleaching if a gold toner is used. Wash for 30 minutes after toning.

Argyrotype

The argyrotype, developed by Michael Ware, is an alternative to the kallitype process. Utilizing silver oxide rather than the traditional silver nitrate in the sensitizer, it's more resistant to fading, which is the weakness of kallitypes. The material presented in this section is adapted from Ware's Web site.[22]

The argyrotype process produces a rich brown color, which can be changed with heat (using an ordinary clothes iron or a dry-mount press) to a darker brown-black color. With humidification, the color can be changed to a purplish gray. While not having the color range of the traditional kallitype, the argyrotype yields a broader range than the Vandyke.

Argyrotype works best using a negative with a density range of about 1.8 (0.2 to 2.0), or one that would be difficult to print on a grade 0 paper. The contrast can be modified to some degree to compensate for a less dense negative.

Your choice of paper, as with all hand-coated processes, is a major factor that should be carefully considered for both aesthetic and physical characteristics. Some papers that seem to work well with the argyrotype are Saunders Waterford, Rives BFK, and Whatman watercolor paper. There are many others, such as Fabriano Artistico, which may work

equally well. It's worth repeating that the only real way to know how a paper will respond for your needs is to try it yourself.

You can prepare the argyrotype solution or purchase it in kit form. Although instructions for preparing the sensitizer are given below, the kit is highly recommended as being both safer and more convenient.

The exposure can easily be judged by the print-out image, but remember that the highlights will develop more density during processing and the dark areas will become denser as the image is dried (known as *dry-down*).

The following materials are needed to make an argyrotype:

A heat-resistant glass container

Sulfamic acid ..7 grams

Silver (I) oxide (Ag_2O) ..7 grams

Ferric ammonium citrate ..22 grams

Wetting agent (optional) ..0.2 ml

Water (distilled) to make ...100 ml

! Do note combine silver oxide with ammonia; the combination can be highly explosive. This sensitizer is best prepared under a fume hood. Wear protective goggles and gloves and avoid skin contact when mixing or handling it. See the chemical list in the appendix for further precautions.

Under tungsten lighting:

1. Dissolve the sulfamic acid in 70 ml of distilled water at a temperature of about 50°C/122°F. Note that adding an extra gram of sulfamic acid will increase the contrast, enabling less dense negatives to be used.

2. Add the powdered silver (I) oxide to the warm water in small amounts with constant stirring until it is dissolved.

3. Add the ferric ammonium citrate in small amounts to the solution, stirring until it is dissolved.

4. A wetting agent, such as Tween 20, is optional, but it aids absorption by the paper fibers. You may want to try the sensitizer first without a wetting agent; it can be added later if you find excessive bleeding of color during processing.

5. Add distilled water at room temperature to make a final volume of 100 ml. The solution will be olive green in color.

6. Filter the solution to remove any remaining solids.

The solution, which will keep for several months, should be stored in a clearly labeled dark bottle in a dark, cool place.

Coating, exposure, and processing

Other than the exceptions noted below, making an argyrotype is basically the same as a Vandyke (see the section on the Vandyke, above).

The color can be changed from brown to a purplish gray by attaching the dry sensitized paper facedown to a lid over a container of water for 30 minutes prior to exposure. The paper should not touch the water! If you use humidified paper, place a thin piece of clear polyester between the negative and the sensitized paper to prevent possible damage to the negative.

If the exposed print is humidified for 10 minutes after exposure, the highlight gradation can be increased.

The print should be fixed in a 2% solution of sodium thiosulfate (20 grams per liter of water) for 3 minutes with gentle agitation. A 1-liter fixing bath has a maximum capacity of ten 8×10-inch (20×25-cm) prints. A few grams of sodium bicarbonate or sodium carbonate can be added to preserve delicate highlight values.

After a thorough washing, the argyrotype can be toned if desired, or simply air-dried.

Notes

Kits for the kallitype are available from Photographers Formulary. Calumet Photographic carries an argyrotype kit. Artcraft Chemicals will make up kits for both the kallitype and the argyrotype.

1. Neblette (1952).
2. Sullivan (1982a).
3. Sullivan (1982b).
4. Stevens (1993).
5. Hall (1903).
6. Stevens (1993).
7. A hydrated form of a chemical has one or more water molecules attached, while the anhydrous or desiccated form doesn't. Because it doesn't have the added weight of the extra water, a smaller amount of the anhydrous form will be needed to make the same concentration in a solution.
8. Merck & Co. (1996).
9. *British Journal of Photography* (1930).
10. Stevens (1993).
11. Ibid.
12. *British Journal of Photography* (1930).
13. Wall (1945).
14. Ibid.
15. Eaton (1986).
16. Stevens (1993).
17. Reilly (1980).
18. Eaton (1986).
19. Ibid.
20. Wall (1945).
21. Stevens (1993).
22. Ware (1997b)

Reclining Nude *(© Richard Farber), platinum/palladium print.*

Platinum/Palladium

THE PLATINUM/PALLADIUM PROCESS WAS INVENTED IN 1873 BY WILLIAM WILLIS. AS mentioned in the chapter on the cyanotype, it has its roots, as do several related processes, in the discovery by Sir John Herschel that certain ferric substances, such as ferric oxalate, become ferrous when exposed to light and, in a suitable solvent, can reduce metallic salts to a metallic state. Only a clearing bath is necessary to remove the remaining ferric salts. The image coloration depends upon the metals used, the developer, the temperature of the developer, and, to some extent, the color of the paper.

Pure platinum images tend to be neutral brown to black, depending upon the developer used. Palladium images are warmer in tone, ranging from brown to brown-black.

The platinum print is regarded by some as the most beautiful of all photographic processes. It is certainly one of the most permanent; the relatively inert platinum can be considered as permanent as the paper in which it rests. The story is told of platinum prints safely recovered from a ship that had been sunk for several years.[1] Palladium, also very nonreactive, even under adverse conditions, doesn't lag far behind in permanence. Platinum and palladium images consist of finely divided metal particles resting *in* the paper fibers rather than on the surface, which gives the image a rich, almost velvety appearance. With ammonium citrate as a developer, a palladium print can look very much like a platinum image.

The negative for hand-coated platinum should have a density range of about 1.4, or the equivalent of a grade 0 paper. It is also possible to use a negative with less density since the contrast can be adjusted to some degree.

Going beyond the regular platinum print, an effective and interesting means of enhancement is to overprint it with gum dichromate, although this will change the velvety appearance of the image. This process requires a registration system (see chapter 1).

Paper and Sizing

Since the final appearance of the print is heavily dependent upon the support paper, the importance of the paper cannot be overemphasized. As you can imagine, the texture and general appearance of the paper support is an important component of the platinotype and related processes. The tint or color of the paper can have a strong effect on the apparent visual contrast, a bright white base appearing more contrasty than an off-white base. By trying many papers, you can compare how different papers will work under your conditions.

Some papers, especially with the changes in manufacture that have been made trying to meet today's environmental concerns, will not work well at all, even though they previously may have been excellent platinum papers. Any buffering agents or materials within the paper can have a definite effect upon the final outcome of the process (see chapter 1).

Currently, there are papers available that are made specifically for platinum printing. Arches has a paper called Platine, especially designed for platinum; Cranes has a paper designed for platinum, which is carried by Bostick and Sullivan; the Fine Print Studio in Germany also has a paper well suited to platinum. Although much more difficult to obtain, Buxton paper from England is also specifically designed for iron-based or other historic processes. With a little searching, you can find other papers, such as Schoellerhammer Durex and 3G, Strathmore, and Rising, that will also work well with this process. To see for yourself how much variation in quality there can be with different papers, try printing a step tablet or the same image on two or three different papers; the difference in maximum density (the darkest tones) and the overall appearance can be substantial. If you're disappointed with the results of your platinum/palladium printing, or if there's a problem clearing the print, try another type of paper before doing anything else.

Since paper can look quite different after it has been thoroughly wet and then dried, first appearances can be deceptive. Another point to keep in mind is that because of the long wet time required in these processes, some papers can literally fall apart, and some others, such as Rives BFK, may have to be sized to keep the sensitizer from falling too deeply into the paper and giving a sunken appearance. The temperature has some bearing on this as well: warmer temperatures seem to make the sensitizer sink in at a greater rate than cool temperatures.[2]

The majority of factory-sized papers do not need extra sizing. Hot-pressed papers are usually easier to use in this regard, as well as papers that are factory gelatin-sized. For papers that do require sizing, different materials, such as starch—even spray starch—dextrin, and gelatin, have been recommended as sizing agents (see chapter 1 on general applications), but there are drawbacks to each. Too heavy a coat of gelatin can obscure the texture of the paper, and dextrin and starch will wash out, leaving the original surface clear. Ultimately, the only way to really determine if a paper will work for you without additional sizing is to try it.

Self-Portrait for Elz (© Siebe Swart), palladio print.

Once you find a paper that works well for you, it might be wise to buy it in quantity. There is always the possibility that it will change, making it unsuitable for future use.

Sensitizing Solutions

Platinum and palladium papers should be sensitized and handled under either a weak tungsten light or a yellow safelight, kept at a reasonable distance. Remember that like the other historic processes, it's easy to fog the image with a light that's too close or too bright.

The chemicals used for the platinum and palladium sensitizer are (1) ferric oxalate, (2) potassium chlorate, (3) platinum chloroplatinite, and (4) sodium chloropalladite or palladium chloride.

! See the chemical list in the appendix for precautions in using these chemicals.

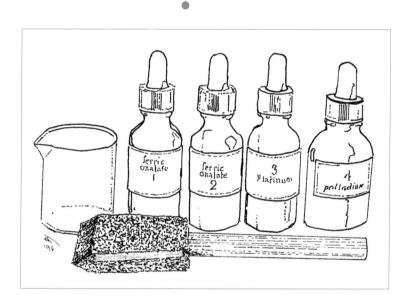

The conventional platinum/palladium process requires three containers for the sensitizer if you are doing palladium or platinum alone and four if you are combining platinum and palladium. You will need bottles with eyedroppers, a small mixing container, and a brush (or rod) for spreading the solution.

Ferric oxalate is the most important component in this process. In order to achieve good results, the strength of the solution should be correct and it should contain little or no ferrous material. Ferric oxalate can be purchased in liquid form or as a powder. It should be noted that, in either form, it has a definite life span, eventually becoming useless for sensitizing. The Drypack® powdered ferric oxalate, introduced by Bostick and Sullivan,[3] appears to keep an unusually long time until mixed. Since excellent-quality ferric oxalate is commercially available, it is not recommended that you make your own solution, but it is also possible (refer to the appendix for details).

The chemicals are generally mixed and kept in separate containers, measured for sensitizing by proportional amounts, sometimes with an eyedropper (known as the *drop method*) for small prints. Dedicate a separate dropper for each solution to avoid potential contamination. Use the same *type* of eyedropper for all solutions, since different types can have different-sized drops. For larger prints, a pipette may be used.

! DO NOT, under any circumstances, use your mouth to draw any solution up in a pipette. Rubber bulbs are available for this purpose. Remember, these solutions are highly toxic if ingested.

Considering the toxicity of these components, it is well worth purchasing them already prepared or as premeasured powders and simply adding distilled water—the added expense, if any, is small. Suppliers for prepared solutions and for separate chemicals are listed in the appendix.

Another point in favor of premeasured components is that you don't have to worry about the accuracy of your measurements. For example, if you were to measure the potassium chlorate on a scale with an accuracy of 0.1 gram, a measure of 0.3 gram could be off by ±0.1 gram, or 30%, which is not acceptable. And potassium chlorate is very unstable: it can cause a fire if it comes in contact with flammable substances and it can also explode if it comes in contact with certain organic materials.[4]

However, if you wish to compound your own sensitizing solutions, the formulas for the sensitizers are given as follows:

SOLUTION 1: Ferric oxalate

Water 49°C/120°F	55 ml
Oxalic acid	1 gram
Ferric oxalate	15 grams

SOLUTION 2: Potassium chlorate

The amount of potassium chlorate specified is for platinum printing. Palladium printing requires twice the amount of potassium chlorate shown.

Water 49°C/120°F	55 ml
Oxalic acid	1 gram
Ferric oxalate 1	5 grams
Potassium chlorate	0.3 grams

OR (but not both)

Because the amount of potassium chlorate is so small, it will be easier and far more accurate to make a 5% solution (5 grams in 100 ml of water), which will have 0.05 gram of chlorate per milliliter.

Water 49°C/120°F	49 ml
Oxalic acid	1 gram
Ferric oxalate	15 grams
Potassium chlorate (5% solution)	6 ml

SOLUTION 3: Palladium salt

Water 38°C/100°F	60 ml
Sodium tetrachloropalladate (also called sodium chloropalladite)	9 grams

OR (but not both)

Water 38°C/100°F	55 ml
Palladium chloride	5 grams
Sodium chloride	3.5 grams

SOLUTION 4: Platinum salt
You don't need this solution if you only intend to make palladium prints.

Water 38°C/100°F .. 25 ml
Potassium chloroplatinite ... 5 grams

The platinum solution may be used alone or mixed with the palladium solution for an image that becomes warmer as the proportion of palladium increases. Alternatively, the palladium solution may be used alone or mixed with the platinum solution for an image that becomes cooler and more contrasty as the proportion of platinum increases. Since platinum costs about four times as much as palladium, it's also more economical to mix the two or simply use palladium alone. Adding platinum to the palladium will also help prevent *solarizing*, which is a reversal in tone from dark to light. Properly processed, platinum and palladium can appear very much alike.

Contrast Control

A negative with the proper density range does not need contrast control, except for artistic interpretation, but negatives, like many things in life, are rarely perfect and generally require some means of adjusting the contrast. In traditional practice, solutions 1 and 2 are used in varying ratios to control contrast: more of solution 2 for greater contrast or more of solution 1 for less contrast.

It is the potassium chlorate in solution 2 that provides contrast. It will eventually deteriorate, leaving solutions 1 and 2 essentially the same.

Although not a primary means of contrast control, even a small amount of platinum added to a palladium sensitizer solution will increase the contrast level to some degree, as well as making the color cooler.

As mentioned in chapter 1, the type of exposing light used may also influence contrast to some extent. Preliminary tests with a (European) Philips 33 fluorescent tube indicate that it delivers slightly higher contrast by lessening the highlight response at the end of the scale with little effect on the middle density areas and virtually none in the maximum density. This daylight tube has a usable portion in the range of 440 nm. Used alone or in conjunction with UV tubes, it can be a useful means of fine-tuning contrast. North American tubes are not directly equivalent, so a suggested start is the GE daylight tube GE F20 (or F40) T12 SP65. Certain fluorescent tubes specifically designed for aquariums may help to control contrast, as may the use of colored filters.

Another method of contrast control is to use varying amounts of household-strength hydrogen peroxide in the developer. This is the same strength hydrogen peroxide (3%) that is kept in the house to put on minor cuts. With this method, solution 2, which contains the potassium chlorate, will not be necessary, so only solutions 1, 3, and/or 4 would be needed. Adding 10–12 ml of hydrogen peroxide per liter of sodium citrate or

ammonium citrate will decrease the number of steps shown on a step tablet by three to four steps. It will also reduce the speed, so the exposure time will have to be increased. Smaller amounts of peroxide have less of an effect on contrast and require less exposure compensation.

There are a few problems associated with this method.

- Although it is recommended as a method of contrast control for the commercially produced Palladio paper, it doesn't seem to offer a large range of control for hand-coated paper.
- The developer must be reasonably concentrated because each addition of peroxide will further dilute it.
- Because the peroxide is a fairly volatile material, after a day or so only water will be left and the peroxide will have to be replaced. This, of course, also means that if you

Gritstone Blocks
(© Michael Ware), an example of Michael Ware's innovative platinum print-out paper process.

don't care to use the peroxide method any longer, or no longer need to use a specific amount of peroxide, the developer will be left as it was before peroxide was added (only more dilute). For this method to work properly, with consistent results, fresh peroxide must be used. It is inexpensive; replace it regularly.

> ! A final warning: do *not* get or use concentrated hydrogen peroxide. It is a powerful oxidizer that can cause severe burns and can be a fire hazard if it comes in contact with organic material.

An alternative method that might work for you is to use a tiny amount of hydrogen peroxide in the sensitizer.[5] This is done by adding no more peroxide than 10% of the total amount of sensitizer. Because the amounts are very small, the best way to measure the peroxide is with a micropipette or a 1-ml syringe; both will be marked in hundredths of a milliliter. A starting point might be 0.05 ml of peroxide per milliliter of sensitizer.

Using this method, solution 2, which contains the potassium chlorate, will not be necessary, so only solutions 1, 3, and/or 4 would be needed; solution 1 being used in equal proportion to the total of 3 and/or 4. The peroxide must be added just before the sensitizer is to be used, and the paper must be air-dried or dried with heat. Although this technique was designed with potassium oxalate as a developer, it should also be effective with citrate-based developers.

Although specifically not recommended because of its severe health hazards (see the chemical list in the appendix for detailed cautions), dichromate can also be added to the developer to control contrast. With this method, solution 2 will not be necessary, so only solutions 1, 3, and/or 4 would be needed. Care should be taken if this is used with palladium alone because the dichromate may cause bleaching. The action of the dichromate lessens with use, requiring replenishment from time to time. It is difficult to state a given amount of dichromate to add for a specific negative density range because of the variation in developers and different types of exposing light sources. The effects of various amounts of dichromate in the developer can be easily tested for your working conditions with a step tablet (see chapter 1). As a general guideline, using a 10% solution of dichromate, 20–30 drops per liter, might be expected to reduce the number of steps visible on a step tablet by one and one-half to two steps. Greater or lesser amounts of dichromate would have, respectively, larger or smaller effects.

> ! Dichromate is a known carcinogen. Avoid inhalation of the dry form. Mix solutions under a fume hood. Wear gloves and protective glasses when handling it. See the chemical list in the appendix for further precautions.

Humidity Control

Recent findings have suggested that, contrary to what was previously thought, moisture is not detrimental to platinum/palladium-sensitized paper and a certain amount may

actually be necessary to achieve the maximum possible density.[6] Sullivan mentions that humidifying the paper before it's coated, drying it, and then humidifying it before it's exposed has been successful.[7] Unless your climate is a dry one, simply allowing the paper to air-dry for several hours after being coated may permit enough moisture to be absorbed. A simple test can help determine if humidifying the sensitized paper will be useful for you.

Under safelight conditions, sensitize a sheet of paper and allow it to air-dry. When it's dry, cut it into five strips, each large enough to cover a step tablet, and number them 1 to 5 with a pencil. Strip number 1 will be a control; expose and process it immediately. Take strip number 2 and put the sensitized but unexposed paper in a cardboard box along with, but not in, a small tray of water. Close the lid of the box and leave it for 5 minutes. At the end of that time, under a safelight, take the humidified paper out, expose it under a step tablet, and process as usual. Following this same procedure, humidify strip number 3 for 10 minutes, expose and process it. Humidify strip number 4 for 15 minutes, expose and process it. Wait several hours to allow ambient moisture to humidify strip number 5 before exposing and processing it. After all the strips have been washed and dried, compare them under good light.

If all the test strips appear the same, then there is no advantage to humidifying your paper. If one of the humidified strips appears to have a better density range, then try an exposure test with a regular negative. To avoid the possibility of permanently staining the negative with the humidified paper, it is a good idea to use a very thin piece of plastic between the negative and the paper or to use a duplicate negative that can be replaced if it's damaged. Sensitize two pieces of the same type of paper with equivalent amounts of sensitizer and let them dry. Label them as number 1 and 2 with a pencil. Humidify the sensitized paper labeled number 1 for the time indicated by the test strip, and then expose and process it. Expose and process the other piece of sensitized paper with no additional humidity. When they are dry, compare them under good light.

Sensitizing

To sensitize your paper, under safelight conditions add the appropriate number of drops from each solution to a small plastic mixing cup (do *not* use metal). Use a separate dropper for each solution and replace each one as you use it to avoid mixing them up. The prepared sensitizer is coated on the paper support with a brush. Avoid overbrushing, since this can abrade the surface of the paper. Be certain to wash the brush when you are finished.

A drop schedule for an 8 × 10-inch (20 × 25-cm) print for adjusting the sensitizer contrast is given below.[8]

! Solution 3 can be palladium, platinum, or a mixture of the two.

For soft prints:

Solution 1 ... 22 drops

Solution 2 ... 0 drops

Solution 3 ... 24 drops

For prints between soft and average:

Solution 1 ... 18 drops

Solution 2 ... 4 drops

Solution 3 ... 24 drops

For average prints:

Solution 1 ... 14 drops

Solution 2 ... 8 drops

Solution 3 ... 24 drops

For prints between average and contrasty:

Solution 1 ... 10 drops

Solution 2 ... 12 drops

Solution 3 ... 24 drops

For contrasty prints:

Solution 1 ... 0 drops

Solution 2 ... 22 drops

Solution 3 ... 24 drops

The drop schedule can be adjusted for contrast ranges in between those shown by varying the number of drops of solutions 1 and 2.

Smaller-format prints, such as 4×5 inches (10×12.5 cm) would use about one-quarter of the amount shown. Solutions 1 and 2 would add up to 5 drops in all cases, and solution 3 and/or solution 4 would be equal to 6 drops.

It is safest and easiest to let the sensitized paper air-dry in a dark place, which takes about 20 minutes. Although not recommended, it can also be gently dried with a hair dryer, taking care not to overheat the sensitive coating. The risk in using a hair dryer is that tiny amounts of oxalate get blown into the air and can be inhaled.

Exposure

To expose the sensitized paper, under safelight conditions place the negative, emulsion side down, on the sensitized paper and place the two in the contact printing frame with the negative facing the glass. Either an artificial source of UV light or the sun can be used

Tulip and Colander (© Richard Farber), platinum/palladium print.

(see chapter 1). Although there will be a provisional image, it is not very easy to determine correct exposure visually; it is best determined by time.

If the exposure is long enough, the darker parts of a palladium print may exhibit the phenomenon known as solarization, or a reversal in tone from dark to light that will remain a permanent part of the image. As already mentioned, adding platinum to the palladium helps prevent this. Solarization isn't necessarily bad; it produces an interesting tonal structure and can result in a rather unique image.

Developers

There are many developers for the platinotype. Some, such as the historically recommended potassium oxalate, reputedly last indefinitely. Unfortunately, potassium oxalate is a highly toxic material, requiring very careful handling. (This is not to imply, however, that the other sensitizer components or recommended developers are not without hazards of their own. See the chemical list in the appendix for precautions regarding other chemicals.)

The colors of the image can be varied with different developers or additives, such as mercuric chloride and uranium compounds. Their use, however, is questionable at best, considering their extreme toxicity. Mercuric chloride, in particular, is so highly poisonous that there is no reason for it to be on your shelf at all.

Because there are safer alternatives, the use of the developers and additives mentioned above will not be discussed. Should you want more information about them, it can easily be found in most older texts. The citrates, such as sodium citrate and ammonium citrate, are a much safer developer choice, with sodium citrate giving warmer tones, especially with palladium, and ammonium citrate giving cooler tones.

! Even the most benign developer will be toxic after it has been used, since it will then have platinum and/or palladium salts dissolved in it. Because of this, the developer should always be handled with caution.

To mix a citrate developer, add 300 grams of ammonium or sodium citrate to a container with 1 liter of warm distilled water, and stir until it's dissolved. It will keep best in a cool, dark place. Citrate developers can be used at room temperature.

At some point, the solution will contain enough impurities that it may stain prints or cause difficulties with clearing the ferrous salts from the paper. At this stage, it is easier to replace it with fresh developer and consign the old developer to the proper chemical disposal for your community.

Processing

At the end of the exposure, remove the paper from the contact frame under a safelight and slip it into the developer. The entire print should be placed in the developer as quickly

as possible; otherwise, there may be visible development lines. The image will appear almost instantly, changing very little during the time that it's in the developer. Leave it in the developer with little or no agitation for 4–5 minutes, taking care to brush off air bubbles on the surface. Remove the print with gloves or tongs, and allow excess solution to drip back into the tray. The paper can then be transferred to the clearing bath. Rinsing the print off after developing will help the clearing bath last much longer.

Clearing

The clearing bath is necessary to remove unexposed ferric or iron salts, which will, in time, yellow the image. One recommended clearing bath (mentioned above) is a weak solution of hydrochloric acid (1:200, or 5 ml of acid per liter of water). This works well with platinum, which is relatively unaffected by the acid, but some care has to be used with palladium, which can be attacked by the acid. It doesn't seem unreasonable to think that the paper itself may also be affected to some degree by hydrochloric acid. Good ventilation, gloves, and goggles are necessary when you are handling hydrochloric acid. Because there are safer alternatives that inflict little or no damage to the image and paper, hydrochloric acid will not be discussed in detail. If you would like more information on this or other clearing agents, such as phosphoric acid, many of the books in the bibliography can be of help. Some effective clearing agents include the following:

1. EDTA

Water	800 ml
EDTA	30 grams
Water to make	1 liter

2. Kodak Hypo Clearing Agent

This is a proprietary formula, which contains EDTA, sodium citrate, and sodium metabisulfite. It seems to clear quite well. Try using it at the recommended dilution for film and paper before trying a more concentrated solution. Use three clearing baths, 5 minutes each, with agitation. After the first one has become discolored, it can be discarded. The second and third baths will then become the new first and second baths, respectively, and a new third bath can be added. The working solution will not keep more than 24 hours.

Rather than preparing a stock solution, you can mix the powdered chemicals directly, in the same proportions given for EDTA (above). Note that the chemical components will not be evenly distributed within the package. For use here, however, this will probably have little effect. But for a packaged developer, it could result in inconsistent results.

3. A very effective combination is to use EDTA for the first two clearing baths and Kodak Hypo Clearing Agent for the third.

4. Citric acid

Citric acid doesn't seem to work well with all papers and can take a very long time to clear. If it works for your particular combination of materials, it's certainly worth considering.

Water	800 ml
Citric acid	5–50 grams
Water to make	1 liter

After the last clearing bath, the print can be washed for 30–60 minutes, depending upon the thickness of the paper.

After washing, blot the print gently with a paper towel. It can then be air- or blow-dried. Retouching can generally be done with watercolors on a nearly dry brush. Ivory black seems to blend in very well.

Toning

Although not necessary for permanence, platinum prints can be toned for color and/or intensification. Recently, Sullivan developed a gold-toning formula that is fairly economical to use.[9] This toner gives blue-gray to black tones with platinum, and rose or plum-colored tones with a mixture of platinum and palladium. It doesn't appear to have any effect on pure palladium. If you have a somewhat weak print, this may improve it significantly.

! Once this toner has been mixed, it has a working life span of about 15 minutes.

The formula is as follows:

PART A: TONER

Gold chloride solution (1%)	5 ml
Sodium formate solution (5%)	10 ml
Water (distilled) to make	200 ml

PART B: CLEARING BATH

Water (distilled)	500 ml
Kodak HC110 developer (concentrate)	10 ml

Other paper developers, such as Dektol or the equivalent, should also work.

The print must be well cleared and washed, otherwise any remaining ferric salts will cause a stain when they come in contact with the toner. Because the toner acts as an intensifier, a print with slightly weaker shadows will work best.

Birch Trees, Voorschoten (© Richard Farber), platinum/palladium print.

! Wear gloves and protective glasses when using this toner.

Use a flat-bottomed tray if you can, since that will need less solution. Because of the toner's very short life span, slip the print into the tray and begin toning as soon as the toner has been mixed. Agitate the print gently for 2–10 minutes. The shadows will be most affected, but if the image is left in the toner for too long, the highlights may become stained: if the solution color begins to appear purple, stop toning.

When the print has been toned to the desired level, take it out of the toner and immediately slip it into the clearing bath. The purpose of the developer is to prevent residual gold from later staining the print. Leave it in the clearing bath for 2 minutes. Afterwards, wash the print for 20–30 minutes.

Print-out Platinum/Palladium Processes

The conventional platinum/palladium process has a faint provisional image visible after exposure, but it requires a developer to make the entire image visible. Test strips or good guesswork are necessary to determine the correct exposure. A POP (print-out paper) platinum/palladium process would make the entire image visible after exposure, which would also make it easy to judge the exposure by simply taking a look at it from time to time. A POP version of the platinum process was developed in 1887 by Pizzighelli, but it required some moisture in the sensitized paper, which made it difficult to use. It wasn't well accepted, especially since more reliable, conventionally prepared platinum paper was readily available.

In 1986, Michael Ware, in collaboration with Pradip Malde, announced a POP platinum/palladium process that was both reliable and consistent.[10] Similar to Pizzighelli's system, this process requires the sensitized paper to have a certain amount of humidity. Unlike the earlier version, however, this process has improved chemistry as well as controllable humidification of the sensitized paper. After Ware's monograph[11] was published, it set off a wave of experimentation humidifying conventionally sensitized paper. Although controlled humidification is effective and necessary for Ware's process, there's less agreement about whether it should be used for conventional sensitizing. As mentioned in the earlier section on platinum/palladium sensitizing, the best way to find out if extra humidification will be of benefit to you with the traditional process is to try it yourself.

The Ware process can be used with platinum, palladium, or a mixture of both, and controlled humidification yields a versatile range of colors, from neutral black to sepia and Vandyke brown.

The negative used for this process requires a density range of about 1.5 for platinum (or one that would print on a grade 0 paper) and about 2.0 for palladium (which would be difficult to print on even the lowest grade of silver gelatin paper). Other densities can be used, but the results may be less than ideal.

Paper

As with the traditional process, the color, surface, and characteristics of the paper are very important to the final appearance and life span of the print. Refer to the section on paper at the beginning of this chapter.

Sensitizing solutions

The sensitizer solutions aren't yet available in kits, so you will have to prepare your own. The directions are given below.[12]

> ❗ Wear gloves and protective glasses and work in an adequately ventilated area when handling these chemicals. Refer to chapter 2 for appropriate safety measures, and see the chemical list in the appendix for further precautions.

FERRIC AMMONIUM OXALATE SOLUTION

Ferric ammonium oxalate ... 27 grams

Water (distilled) to make ... 50 ml

Dissolve the crystals in 30 ml of warm distilled water (40–50°C/104–122°F) with constant stirring. Add distilled water to make up a final volume of 50 ml.

PLATINUM SOLUTION

Ammonium tetrachloroplatinate (II) ... 5 grams

Water (distilled) to make ... 20 ml

Dissolve the crystals in 15 ml of distilled water at room temperature with constant stirring. Make up a final volume of 20 ml with distilled water. This solution should be made up at least 24 hours before use. It has a shelf life of up to one year, but may be less depending upon the conditions of storage.

PALLADIUM SOLUTION

Two methods of preparing this solution are given. Only slightly more expensive, the first method is recommended since it's more convenient to mix and presents less risk of chemical exposure in preparation. The shelf life of the palladium solution is considerably longer than that of the platinum solution.

Ammonium tetrachloropaladate (II) ... 5 grams

Water (distilled) to make ... 25 ml

Dissolve the crystals in 20 ml of distilled water at room temperature with constant stirring. Make a final volume of 25 ml. The palladium solution can be used immediately.

OR *(but not both)*

The palladium solution can also be made in the following way:

Palladium(II) chloride ... 3 grams

Ammonium chloride .. 1.8 grams

Water (distilled) to make ... 25 ml

Dissolve the ammonium chloride in hot distilled water (70–80°C/158–176°F). Add the palladium(II)

chloride. Maintain the temperature and stir until all the crystals have dissolved. This process can take an hour. The palladium solution can be used when cooled to room temperature.

Sensitizing

The paper is coated and dried in the same manner as the traditional platinum/palladium process described earlier in this chapter. The room should be lit with a yellow safelight or a dim tungsten light; do not use fluorescent lights. The total number of drops of platinum and/or palladium should equal the number of drops of ferric ammonium oxalate. Platinum and platinum/palladium solutions should stand for 1 hour before use; palladium can be used without a waiting period. When determining exposure, remember that palladium is about twice as fast as platinum.

Contrast

The composition of the sensitizer will largely determine the color and contrast of the image, with palladium yielding the warmest tones and longest exposure scale, and platinum, cooler tones and the shortest scale. The two solutions can be combined in different ratios to produce subtle changes in color and contrast. The amount of humidification will also play a role in color and contrast. As mentioned above, a negative with the correct density range will give the best results.

As noted in chapter 1, different light sources may also affect contrast control.

Humidifying

After the paper has been dried, the next step is to humidify it. To avoid fogging the paper, make sure to work under a safelight and keep the paper from being exposed to any light.

Along with the amounts of platinum and palladium used, controlled humidification is an important factor in determining color and contrast. Lower relative humidity produces a warmer color and somewhat shorter exposure range; higher relative humidity produces cooler tones and a slightly longer exposure range. If you live in a area with a high enough relative humidity, the paper can simply be allowed to absorb the moisture from the air for 1 or 2 hours (in the dark); otherwise, the sensitized paper can be placed in a closed container that is partly filled with a solution that provides a constant relative humidity (see below). The paper is taped or held with magnets to the underside of the top of the container, the sensitized portion facing, but *not touching* the liquid. Some solutions and the relative humidity (RH) they provide are as follows:

- Calcium chloride: RH 32%
- Calcium nitrate: RH 55%
- Ammonium nitrate: RH 80%
- Water: RH 100%

The solutions should be saturated and should contain excess solids in suspension. For solutions 1, 2, or 3, the paper should be left in the container for 30 minutes to several hours; the tones will not vary with time. Plain water, however, will produce warm tones in 5–20 minutes and colder tones in 20–40 minutes. Exceeding this time with plain water is not recommended since the paper can absorb too much moisture, which may weaken the image, cause clearing problems, and possibly damage the negative.

Exposure

After being humidified, the sensitized paper is put into a contact printer, emulsion to emulsion with a negative, and the negative next to the glass. A thin sheet of plastic or rubber should be put under the paper to help prevent it from drying out. Although it's always safer to use a duplicate negative, a very thin piece of Mylar can be placed between the negative and paper to prevent possible damage to the negative.

Expose the paper to a UV light source, periodically taking it into a safelit area to check the density by carefully unhinging one part of the printer back. Don't leave the back open more than necessary since that could cause an unequal exposure. When the density appears correct, take the paper into the darkroom for processing.

The processing sequence

Note that no developer is necessary because the image has already been printed out. The visible image only requires clearing and washing. The processing sequence is as follows:

! Do not allow the processing solutions to come in contact with your skin; use print tongs and gloves.
● See the chemical list in the appendix for further precautions.

1. EDTA disodium (5% *w/v*) .. 5 minutes
2. Rinse in water.. 30 seconds
3. Kodak Hypo Clearing Agent (1:2 from stock) 15 minutes
4. Rinse in water.. 30 seconds
5. EDTA tetrasodium (5% *w/v*) or *(but not both)* EDTA disodium (5% *w/v*) 15 minutes
6. Wash in running water ... minimum 30 minutes

Clearing the print can be carried out under ordinary tungsten lighting; its purpose is chiefly to remove excess chemicals and reaction products. The capacity of bath number 1 is about fifty 8×10-inch (20×25-cm) prints.

! When the EDTA-based baths have reached their capacity, do not pour them down the drain. They
● should be put into clearly labeled containers and placed out of the reach of children until they can be taken to the appropriate recycling center.

You can judge the success of the wet-processing by examining the print under a bluish light for any yellow, residual iron stain of regions of unexposed sensitizer, which may cause the paper base to become brittle later. If no yellow stain is perceptible, clearing has been adequate.

A bath of Kodak Hypo Clearing Agent (1:2 from the stock solution) can be used as a third bath if a yellow stain persists, particularly with palladium.

After washing, the print can be left to air-dry, face up, or it can be dried with mild heat, such as from a hair dryer.

Ziatype

Richard Sullivan[13] announced a palladium and gold POP (and developing-out) process in 1996 called the *Ziatype*.[14] Lithium chloropalladite is used for cool tones and the addition of sodium tungstate gives warm brown to sepia tones.

A variable color range is possible with the Ziatype, including neutral black, brown-black, sepia, and possible split tones. Gold chloride can be used in place of part of the lithium chloropalladite sensitizer to produce prints with colors that range from purple-brown overtones to an overall lavender color.

Like the Ware/Malde technique, the Ziatype process depends on sensitizer chemistry that can utilize controlled humidification. It is interesting that the Ziatype also works as a traditional developing-out system, giving differing tones depending upon the developer and sensitizer used. Similar to the traditional process, the Ziatype uses two solutions of ferric ammonium oxalate—one with potassium chlorate—to control contrast.

The Ziatype offers several advantages over traditional palladium printing. It's more convenient to use because a developer isn't necessary unless desired. Test strips aren't necessary because the exposure can be judged by taking a look at the print from time to time. And, finally, it offers a choice of colors.

The Ziatype is available as premixed solutions,[15] which are both safer and more convenient to use than mixing your own. The use of premixed solutions is also recommended for the traditional platinum/palladium process. Although small amounts of potassium chloroplatinite can be added to the lithium palladium chloride sensitizer, it's more economical and safer not to do so. Platinum is nearly four times the cost of palladium and can induce severe allergic reactions (this is not the case with the solid metal or the finished print). The instructions for the Ziatype can be obtained from Bostick and Sullivan.[16]

> ! Wear gloves and protective glasses when handling these chemicals. See the chemical list in the appendix for further precautions.

The premixed solutions are as follows:
- *Solution 1:* ferric ammonium oxalate
- *Solution 2:* ferric ammonium oxalate with potassium chlorate to control contrast

- *Solution 3:* lithium chloropalladite for cold tones
- *Solution 4:* sodium tungstate additive for warm tones

Note that only very small amounts are needed for color changes. One drop will add considerable warmth to an 8×10-inch (20×25-cm) print. To achieve the same result for a smaller image size, dilute the solution.

- *Solution 5:* potassium chlorate (8%) for additional contrast enhancement

! See the chemical listings in the appendix for cautions on potassium chlorate.

- *Solution 6:* gold chloride (5%) for gray/blue/purple tones

Gold chloride can be substituted for up to 80% of the lithium palladium chloride. Using 1–2 drops out of 8 will give a burgundy to purple color shift; more will tend towards lavender. Split tones are possible with gold chloride but not always predictable.

Although it's recommended that you avoid preparing your own solutions in favor of premixed ones, the components of each solution are given below as a point of interest.

! Do not attempt to prepare your own sensitizer if you're not familiar with the techniques of safely handling chemicals and their potential hazards (see chapter 2 for appropriate safety measures). Wear gloves and protective glasses. Avoid inhaling the chemicals and work in an adequately ventilated area when handling them. See the chemical list in the appendix for further precautions.

SOLUTION 1

Ferric ammonium oxalate	10 grams
Water (distilled) to make	25 ml

SOLUTION 2

Ferric ammonium oxalate	10 grams
Potassium chlorate	0.9 grams
Water (distilled) to make	25 ml

SOLUTION 3

Palladium chloride	2.3 grams
Lithium chloride	1.7 grams
Water (distilled) to make	25 ml

SOLUTION 4

Sodium tungstate	4 grams
Water (distilled) to make	25 ml

SOLUTION 5

Potassium chlorate .. 2 grams

Water (distilled) to make ... 25 ml

Paper

As with the traditional process, the color, surface, and characteristics of the paper are very important to the final appearance and life span of the print. Refer to the section on paper at the beginning of this chapter.

Sensitizing

The room should be lit with a yellow safelight or a dim tungsten light; do not use fluorescent lights. The paper is sensitized with the drop method in the same manner as the traditional process. Different amounts of solution 2 are used to control the contrast. Although the addition of solution 2 usually provides adequate contrast control, 1 drop or more of a 4% potassium chlorate solution can boost the contrast. Carefully note the cautions for potassium chlorate in the chemical section of the appendix.

The number of drops of solutions 1 and 2 together should equal the number of drops of solution 3. Refer to the sensitizing section on platinum/palladium in this chapter for more information about using the drop method. For a 4 × 5-inch (10 × 12.5-cm) print, a total of 6 drops of solutions 1 and 2 and 6 drops of solution 3 should be adequate if it's brushed on. If a rod is used for coating, less may be used. Avoid excessive amounts of coating since that may cause tiny particles to flake off. The paper can be air- or blow-dried. Since oxalate particles can be blown into the air by a hair dryer, air-drying is preferable.

After the paper has been dried, it needs to be humidified (under safelit conditions) before it's exposed. The method recommended by Sullivan is to steam the sensitized paper for about 30 seconds. He notes that a steam humidifier or vaporizer works well for this purpose.[17] Be sure to move the paper around to make certain it's evenly steamed. Simply pouring boiling water into a suitable container and holding the paper facedown above it for 30–60 seconds also works well.

A passive humidification method might be preferable since it's difficult to avoid inhaling the steam, not to mention humidifying your darkroom. Although it takes quite a bit longer, the passive method uses the Ware/Malde technique of placing the sensitized paper in an enclosed container with a solution such as plain water or a saturated solution of ammonium chloride (see section on humidifying, above). (If ammonium chloride is used, there should be excess solid in the solution.) This process will provide a constant relative humidity of 100% for water or 80% for ammonium chloride. A shallow plastic container can be partly filled with the solution and covered with a piece of plastic or glass. The paper is taped or held with magnets to the underside of the top, the sensitized portion facing, but not touching, the liquid. It's then left in a dark area for 20–40 minutes.

Newborn, Georgia
(© Richard Farber),
palladium print.

Regardless of which method you choose, once the paper has been humidified, it's ready for exposure. Remember, it's always a good idea to use duplicate negatives rather than an irreplaceable original negative. Under safelight conditions, place the negative, emulsion side down, on the face of the sensitized paper, and place the paper and negative, negative side down, on the glass of the contact printer. To protect the negative from possible damage, it can have a piece of 3-mil Mylar between it and the paper. Put a piece of plastic, acetate, or rubber slightly smaller than the print frame over the paper to retain the moisture. If the paper is placed in a Mylar negative sleeve, it will serve the dual purpose of protecting the negative and keeping the moisture in.[18] After the back of the contact printer has been closed, it's ready to be exposed to your UV light source.

Exposure

Periodically take the contact printer into a shaded or safelit area to check the exposure by opening part of the hinged back. Since the process is self-masking, you can make the

exposure longer to print in the highlights without greatly affecting the deep shadow values. *Self-masking* means that as the tones grow darker with exposure, they will mask further exposure in the area when they reach a certain level of density.

When the exposure looks about right to you, take the contact printing frame into the darkroom and remove the exposed paper for processing.

If the exposed paper wasn't steamed prior to exposure, there will be little or no print-out image, so the print will have to be timed for the proper exposure. If this is the case, the paper can be steamed after exposure and the image will appear, although it will be a sepia color. If the paper has dried out a little, or has been insufficiently humidified, the image color will be closer to a traditional palladium image rather than a neutral black. If the print is partially humidified and processed with a platinum/palladium developer, then it's possible to have split tones or coloration between sepia and neutral black.

Resteaming can also be done to intensify an image after exposure and before processing. This increases the density of the darker values and will be visible as it occurs.

Processing

Wearing gloves and using tongs, process the exposed paper under safelight conditions.

Place the print face up in running water and wash it for 5 minutes. Or, the print can be processed with a standard platinum/palladium developer, which will give a brown or sepia tone.

If there's a yellow tint still visible, wash the print in Kodak Hypo Clearing Agent or another platinum clearing agent, such as EDTA, for 5 more minutes. After the last clearing bath, wash the print for 5 minutes under running water. An alternative to this method of processing is to use the method devised by Ware, given above (p. 108) for the POP process.

Print clearing can be carried out in ordinary tungsten lighting; its purpose is chiefly to remove excess chemicals and reaction products.

After the print has been washed, remove it from the water and gently blot the excess water with a paper towel. The print can be air-dried or dried with gentle heat from a hair dryer.

Notes

It is also recommended that you refer to Arentz (1990), Nadeau (1989), Rice (1994), and Weese (1997) for more information on these processes.

1. Clerc (1930).
2. Sullivan (1985).
3. See the section on sources of supplies for North America in the appendix.
4. Shaw and Rossol (1991).
5. Rudiak (1994).
6. Ware (1986).
7. Sullivan (1994).

Untitled platinum/palladium print (© Richard Farber).

8. Wall and Jordan (1976).

9. Sullivan (1996).

10. Ware (1986).

11. See also the article by Pradip Malde (1994), which is essentially the same as Ware's article.

12. Based on Ware (1997c).

13. See Bostick and Sullivan in the section on sources of supplies for North America in the appendix.

14. The name *Ziatype* comes from the ancient Anasazi Indian symbol for the sun.

15. See Bostick and Sullivan in the section on sources of supplies for North America in the appendix.

16. See Bostick and Sullivan in the section on sources of supplies for North America in the appendix and Sullivan (1996).

17. Sullivan (1996).

18. Ibid.

Doves (© Hans Nohlberg), duotone carbon print created using two differently pigmented, self-made carbon tissues, one with lampblack and the other with burnt umber.

Carbon/Carbro

CARBON PRINTING, THE FIRST TRULY PERMANENT PROCESS, WAS A UNIQUE ACHIEVEMENT based on decades of discovery. Carbon prints can be one of the most elegant and permanent of processes, essentially as permanent as the pigment and paper base, and subject only to possible gelatin damage. They are capable of resolving a great amount of fine detail in the gelatin relief and can even have a visible image relief. This is a versatile process, which can have a beautiful tonal scale with a surface that can be glossy or matte in nearly any color, on almost any paper.

A brief sketch of the history of carbon printing will provide some insight to its development. In 1832, Gustav Suckow noted that dichromates were light sensitive; several years later, in 1839, Mungo Ponton discovered that paper coated with dichromate was light sensitive. Soon after, Alexandre Edmond Becquerel discovered that the sensitivity of dichromates was dependant upon organic matter, such as starch or gelatin, which was in the paper Ponton had used. William Henry Fox Talbot, in 1852, made the very important discovery that colloids, such as gum arabic and gelatin, became insoluble after being combined with dichromate and exposed to light. In 1855, Alphonse Poitevin, building on Talbot's discovery, made the first carbon process by adding carbon black—hence, the name *carbon*—to the dichromated mixture of gelatin. Unfortunately, the lighter tones tended to wash away with this process. The problem was solved by LaBorde, who noted that there were two actual surfaces to the gelatin layer—top and bottom—and the insolubility went only part way down in the lighter tones. Because the bottom part of the gelatin layer was still soluble in the light areas, it was dissolved in the warm water. Various methods to remedy this problem were tried, including exposure from the back of the tissue, but none of these attempts was ever a complete success.

Adolphe Fargier made the first successful carbon-print transfer with a full tonal range in 1860 by coating the exposed tissue with collodion and transferring the final image to

a support. Although it worked well, the process was also very complex, which worked against its general use. In 1864, Joseph Swan, who had unsuccessfully tried to expose the tissue from the back several years earlier, invented a carbon tissue and transfer procedure that could easily by used, and which was introduced commercially in 1866. In 1868, the Autotype Company was formed in London, and it became the dominant, although not the only supplier of carbon supplies. It also produced carbon prints, which is why carbon prints were frequently referred to as *Autotypes*.

Carbon tissue is actually not a thin tissue, but rather a thick coat of pigmented gelatin on a paper backing. Unfortunately, carbon tissue has not been commercially made for several years and the remaining stocks are now in short supply. The stocks that currently exist will not be replenished unless a new manufacturer is found, and since the demand is low, that isn't likely. Although it's still possible to obtain the tissue from the suppliers listed in the appendix, specific kinds of tissue may be difficult to locate or, more likely, may no longer be usable.

Over time, the gelatin's surface will present an increasingly heavy fog level, eventually making it unusable. How soon this will occur depends on a number of variables: whether the tissue has been stored frozen, the color and type of pigmenting material, and the manner in which it has been stored. Considering the current age and cost of stocked tissues, it would be prudent not to purchase without a money-back guarantee that the tissue is still usable.

There are two simple tests that can be used to check the solubility and fog level of carbon tissue.[1] To determine the solubility of the tissue, agitate a small piece of tissue in hot water (40°C/104°F) for 3–4 minutes. The pigment should either all dissolve or leave only a very small amount of pigment. If this isn't the case, then it has become too insoluble to be used. The amount of fog in carbon tissue can be determined by processing a small piece as you normally would but without sensitizing it. The amount of density or pigment left on the paper is the level of fog.

> When handling or cutting carbon tissue, be careful not to get oil from your fingers on the gelatin surface or to crack or bend the tissue. As mentioned above, carbon tissue will keep longest if it's frozen. It will keep least well in hot, humid conditions. A final note of warning: exposure to formalin fumes will harden the gelatin, making it insoluble. Other fumes, such as those from paint, can also fog or harden the tissue.

Carbon Tissue

The situation is not as bad as it appears because it's not very difficult to make your own tissue. The three main components are gelatin, pigment, and a paper support.

Gelatin, an animal product, is a very complex material. There are actually many types of gelatin, the quality and individual characteristics of which vary from that used for cooking to pharmaceutical purity. It also varies in hardness, which is described in units of measure called *bloom strength*. Uniform hardness of gelatin, such as that found in U.S. pharmaceutical (USP) quality, is best to avoid blotchy, mottled tones.[2] Compared with

cooking gelatin, the pharmaceutical-quality gelatin has a somewhat higher melting temperature, as well as more resistance to tearing when wet. This is only a brief overview, as a complete discussion of gelatin would easily make a complete book.

For the vegetarians who prefer to avoid animal products, there really isn't a satisfactory vegetable substitute for making carbon tissue. Perhaps it will help to know that gelatin is a by-product from animals not bred for this sole purpose.

A negative for carbon printing should have a density range of about 1.4, or the equivalent of a grade 0 paper. The sensitizer can be adjusted for differing negative densities, but the most satisfying images will have ample shadow and highlight density.

Paper negatives on RC (resin-coated) paper with the proper density range can work surprisingly well. Although negatives made from paper positives don't work well unless very thin paper is used, a slide taken of a finished enlargement can be used to produce a negative on RC photographic paper. The slide can be color reversal film, a black-and-white film slide from Agfa Scala, black-and-white negative film processed with a reversal kit, or a Polaroid slide.

Supplies

To make a carbon print, you will need the following supplies:
- carbon tissue
- transfer paper (optional)
- final support material
- clearing agent for dichromate stain (potassium metabisulfite)
- formalin (3% solution) or glyoxal (1% solution)
- gelatin
- a yellow safelight
- a squeegee
- glass or plastic—2 pieces: (1) one larger than the tissue used and (2) one larger than the final support
- bulldog-type clips
- a fan (optional)
- distilled water

Pigments

Many pigments can be used, although it is easier to use a tube watercolor or ink, such as *sumi* ink. The better grades of watercolor generally have more pigment and a correspondingly higher density. Like paper, the better quality paints unfortunately tend to be more expensive.

Sumi ink gives a warm black to brown-black color with excellent permanence. The Winsor & Newton *nonpermanent* liquid Indian ink will also work well. Permanent inks are usually not suitable because they contain agents that will harden the gelatin.[3]

Lily Pads (© Richard Farber), carbon print made with self-made tissue with ivory black watercolor pigment.

Powdered pigments can be used, but they are more difficult to mix thoroughly with the gelatin and may need to be reground if they are too coarse. Care should be taken not to inhale the dust generated when grinding pigments.[4] For those willing to put up with the extra work and potential health risk, powdered pigments can produce extremely fine, accurate colors and can have a greater pigment density than tube colors.

Some pigments, including some tube watercolors, may harden the gelatin, or make it insoluble, and cannot be used.[5]

! Some colors or pigments, such as cobalt blue and cadmium yellow, are carcinogenic or otherwise toxic and should be handled with care or avoided.[6] Care should be taken not to inhale the dust generated by grinding pigments or measuring the powder. If you're not familiar with pigments and paints, check with someone who is, or consult one of the texts listed in the references before experimenting with colors. Refer also to the appendix for notes on the health risks of pigments.

Support Material for Carbon Tissue

The paper used for the carbon tissue support can be any smooth-surfaced paper, as long as it has reasonable wet strength. The minimum weight for this purpose is 150-gram paper. It is also possible to use certain plastics as a support. They have the advantage of being reusable, but nonporous materials take quite a bit longer to dry than a paper support, and some may not stay attached to the dried gelatin. Plastics with a hint of tooth, or texture, are the best choices. Plastic used for drafting has one or two lightly frosted surfaces that work very well for this purpose.

Making Carbon Tissue

To prepare carbon tissue, add gelatin to cool water and allow it to swell, or bloom, for about 15 minutes. Then melt it in a hot-water bath. Pigment, a wetting agent to keep down bubbles, and usually a plasticizer are then added. Stir the ingredients together well and then apply the mixture to the paper or other support material and allow it to dry.

The tissue is not light sensitive until it has been sensitized with dichromate, so unless you are making presensitized tissue, the tissue can be made in full light. If you are making presensitized tissue, the process will need to be done under a yellow or dim tungsten light, since even wet dichromated tissue is sensitive to light to some degree.[7]

Since formulas for the gelatin content of carbon tissue range from 10 to 20%, a good starting point is 10% (10 grams per 100 ml water). Glycerin or sugar, which acts as a plasticizer, is generally added in amounts of 1–5% per liter to keep the gelatin supple after it has dried. To help keep air bubbles at a minimum, a wetting agent that reduces surface tension, such as grain alcohol or a commercial preparation, such as Kodak Photo-Flo, is very useful. Gelatin melts at a relatively low temperature, so the container of gelatin and distilled water can be put into a hot-water bath at no more than 49°C/120°F to melt the gelatin. (Note that it is detrimental to the setting properties of the gelatin if it is made too hot.) The pigment can be gently mixed into the distilled water either prior to adding the gelatin or after the gelatin has been melted.

If you are using a liquid pigment such as *sumi* ink, a good starting point might be 4% of the volume (4 ml per 100 ml solution) and perhaps twice that amount for increased contrast. The more pigment used, the higher the contrast; decreasing the pigment will result in lower contrast. The amount of pigment needed will vary from color to color. For example, it would take a smaller amount of black than of a more transparent pigment for a given density.

Depending upon how thick the coating is to be, a 5 × 6-inch (12.5 × 15-cm) tissue will usually take 15–20 ml of solution, an 8 × 10-inch (20 × 25-cm) area will take four times as much, and so forth; 500 ml of solution, for example, will cover seven to fourteen 8 × 10-inch (20 × 25-cm) tissues.

Presensitized Tissue

It's possible to add the dichromate sensitizer directly to the gelatin solution before it is coated on the support material. The advantage of doing this is that the additional step of tray sensitizing becomes unnecessary because the tissue is ready for exposure as soon as the gelatin-coated paper is dry. Also, unlike tray sensitizing, the amount of dichromate in each piece of tissue will be uniform and consistent.

The disadvantage of presensitized tissue is that it must be used soon after manufacture (see chapter 1) because a certain amount of fogging will take place over time in the tissue, whether sensitized or unsensitized. It's a good idea, for the sake of consistency, to make and use only what you need over a short time period. However, there are reports that presensitized tissue can be frozen indefinitely in a deep freeze.[8] If it's frozen, care must be taken to wrap the carbon tissue well to avoid problems with condensation when it's thawed out.

The amount and type of dichromate will determine the contrast of the tissue. Ammonium dichromate is more sensitive than potassium dichromate: a 2.5% solution of ammonium dichromate has the same speed, contrast, and keeping quality as a 3.5% solution of potassium dichromate. Note that a greater percentage of dichromate will lower contrast and a smaller percentage will raise it. A starting point for presensitized tissue might be 1.4% ammonium dichromate (1.4 grams per 100 ml of gelatin) or 2% of potassium dichromate (2 grams per 100 ml of gelatin).

> **!** All dichromates are considered carcinogens and should be handled carefully, with full protective gear. Mix the dichromate stock solution under local ventilation or outside, wearing a dust mask. Wear gloves and wash your hands well after removing the gloves. Ammonium dichromate has the added risk of being flammable. See the chemical list in the appendix for further precautions.

Formulas for Carbon Tissue

These sample formulas should give you a good start. Note that they can be modified with other pigments and different amounts of sugar, glycerin, and gelatin.

FORMULA 1

Gelatin	10 grams
Water (distilled)	100 ml
Sugar	6 grams

Sample Pigments

Sumi ink (liquid)	4 ml

OR (but not both)

Indian red (tube watercolor)	2 grams
Venetian red (tube watercolor)	1 gram
Lampblack (tube watercolor)	0.2 grams

1. Measure 100 ml of distilled water into a container.

2. Add the sugar and stir until dissolved.

3. Add the gelatin (10 grams per 100 ml) and let it sit for 15 minutes until it has fully absorbed the water.

4. Add 1–2 ml of grain alcohol. This acts to reduce the surface tension and helps eliminate bubbles.

5. Heat the container of gelatin to 43–49°C/110–120°F, *but no higher*, in a hot-water bath for 45–60 minutes. This will melt the gelatin and allow the trapped air to rise to the surface.

6a. If you're using *sumi* ink, gently stir it in, trying not to stir in air bubbles.

6b. If you're using tube watercolor pigment, pour a little of the hot gelatin into a small container with the pigment and mix well. As soon as it's mixed, add it back into the container with the hot gelatin.

Note that if the amount of *sumi* ink is increased to 12–14% (12–14 ml per 100 ml) of the gelatin solution, the results can be uniquely beautiful with rich blacks and a fine- to medium-grained effect that's quite striking.

FORMULA 2

This formula is derived from one by Pollmeier.[9]

Water (distilled)	350 ml
Glycerin	18 ml
Gelatin	10 grams
Wetting agent	0.6 ml

Let the gelatin swell for 15 minutes in cool water. Heat the container of gelatin solution to 46–49°C/115–120°F in a water bath. Add the following:

Water (distilled)	20 ml
Lampblack (tube watercolor)	8.4 grams
Quinacridone violet (tube watercolor)	3.6 grams

Mix the watercolor and water before stirring it into the melted gelatin solution.

FORMULA 3

This formula is for a presensitized tissue.[10] Note that once the dichromate has been added to the gelatin solution, it can't be saved for future use unless it is frozen (see above).

Water (distilled)	50 ml
Gelatin	8 grams
Sugar	10 grams

Let the gelatin bloom for 30 minutes in cool water. Heat the container of gelatin solution to 46–49°C/115–120°F in a water bath. Add the following:

Water (distilled)	25 ml
Wetting agent (Photo-Flo)	0.125 ml
Ivory black (tube watercolor)	8 grams
Carmine red (tube watercolor)	1.5 grams
Caput mortuum violet (tube watercolor)	2 grams

Tree and Canal (© Richard
Farber), carbon print made
with self-made carbon
tissue with ivory black
watercolor pigment.

Mix well before stirring into the melted gelatin solution. Note that a good starting point would be about one-half this amount of pigment. Add:

Potassium dichromate (5% solution) .. 25 ml

Make the tissue as soon as possible after mixing this solution.

Coating the Gelatin on the Support

Level a flat waterproof surface, such as glass or a plastic-coated board. One method for leveling is to use small pieces of clay under each corner and check the level with a bubble balance.[11] An alternative method is to use a plastic-laminated board with three small adjustable bolts to act as feet; two are placed at corners at one end of the board and the third is placed at the other end in the center. With this arrangement the board is easily leveled. A third method is to simply use several plastic or rubber doorstops to adjust the level.

A four-way density test is a convenient way of determining exposure for a bromide print to be used for carbro printing. This image demonstrates the double image that results from moving the carbon tissue once it has been applied to the bromide.

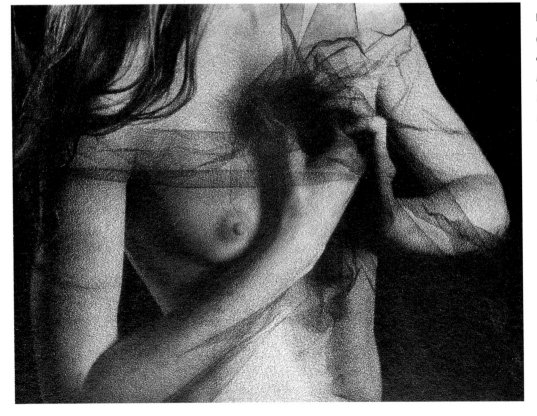

Nude with Gauze (© Richard Farber), a carbro print with a mezzotint-like grain pattern resulting from using self-made carbon tissue with a 12% sumi ink content.

Unless you are using a plastic support for the gelatin, take the paper to be coated and immerse it in hot water for 1–2 minutes. Squeegee it onto the flat, leveled surface, making sure that no drops of water remain on it and that there are no bubbles under it.

After squeegeeing down the wet support paper and wiping the edges with a paper towel, put a strip of masking tape around all edges. This will prevent the hot gelatin from seeping under and making part of the paper rise up, causing the still-liquid gelatin to run and sag.

Gently stir the pigmented gelatin solution, which has been heated to 49°C/120°F in a water bath, skimming any air bubbles from the surface. Before pouring the gelatin, wipe any water drops from the bottom of the container to prevent it from dripping onto the gelatin. Hold or fasten a piece of stocking around the pouring lip of the container to help catch bubbles and pour the hot gelatin close to the surface on the center of the support. It will take about 80 ml to cover an 8 × 10-inch (20 × 25-cm) area. Using an ordinary plastic pocket comb, spread the hot gelatin from the center outward to the edges. Spread it as quickly as possible, because it will soon form a skin as it cools. Remove any air bubbles before the gelatin sets.

The gelatin should be firm enough in 5 minutes to allow the paper to be picked up by an edge, clipped, and hung to dry. If the paper is picked up too soon, the gelatin will sag or run and will have to be discarded. If the gelatin feels firm and not sticky to a finger gently touching it, then it's ready.

To minimize curling, the wet support should have weights, such as spring clips (sometimes called *bulldog clips*), attached to the bottom edge when it is hung up to dry. If the clips are metal, they should either be dipped in liquid rubber, varnished, or painted with polyurethane to prevent rusting. If the clips aren't wide enough, a thin strip of painted wood or plastic can be attached to each side of the clip to lengthen it. Although it will take longer to dry because both sides won't be exposed to the air, the support can also be pinned to a large piece of board or cardboard.

The drying gelatin will be a virtual dust magnet, so try to dry it in a still, dust-free area. The tissue will normally dry in 12–15 hours. If the area is heated, drying time will be accelerated. Tissue on plastic supports will take quite a bit longer to dry. As mentioned above, the wet gelatin is very sticky, so the use of a fan to speed drying is not recommended.

Final Support Paper

The color and texture of the final support material will greatly influence the appearance of the carbon image. The final support paper for the carbon or carbro print can either be gelatin-sized and hardened paper or photographic paper that has been fixed and thoroughly washed. Fixed-out photographic paper is worth considering as a final support. There's no health risk from formalin since it doesn't need to be hardened; it's easily available, convenient to use, and comes in several surface textures and tones.

Since either the emulsion side or the back side of resin-coated (RC) paper can be used,

don't throw away your reject prints on RC photographic paper—save them for testing carbon prints. Note that the gelatin-sized final support paper does not have to be hardened if you are using a double-transfer system or carbro, although hardening will do no harm.[12] For test purposes, using a sheet of plastic for the final support will help conserve paper. The plastic can also be reused if you wash the gelatin image off with hot water.

Double Transfer System

It is possible to transfer the tissue to a temporary support, attaching it at a later date to a final support. Different materials have been used for this in the past, many requiring waxing so that the gelatin image on them can be released onto the final support. Some modern materials, such as plastic, can be used without waxing or other preparation. Plastic drawing or drafting film that is lightly frosted will work well for this purpose and is inexpensive. Another advantage of plastic is that it doesn't retain chemicals, so the dichromate will be washed out during processing rather than being retained in the paper fibers.[13]

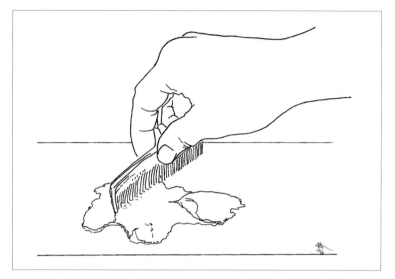

After the paper that will form the carbon tissue backing has been taped down, the hot pigmented gelatin is poured upon the center of the paper and spread quickly to the edges with an ordinary comb, taking care that air bubbles are removed. After 5 minutes or so, the gelatin will be firm enough for the tissue to be hung up to dry.

One advantage of using a system like this is that final support paper, which is time-consuming to make, will not be wasted on images that aren't wanted.

! If you use a temporary support, the image will be reversed unless you reverse the negative.

To use plastic film as a temporary support, simply use plastic film instead of the final support paper and follow the steps given above for support paper. Make certain to use the frosted side of the plastic for the side to mate with the tissue, since the gelatin may not adhere to the slick side of the plastic.

The transfer of the image from the temporary support to the final support is accomplished by soaking a gelatin-coated final support paper for 15–20 minutes. The temporary plastic support should be soaked for a few minutes with the final support, placed gelatin to gelatin, brought carefully out of the water to avoid air bubbles, placed on a piece of plastic, or glass, and squeegeed a few times. The sandwich is then covered with a piece of newspaper and a piece of glass and weighed down for about 20 minutes. After this, the plastic/paper sandwich is hung up to dry. As it dries, the plastic will release from the paper, leaving the image on the final support.

Once the image is on the temporary support, it's no longer sensitive to light. This means that the temporary plastic support can be visually or pin registered, enabling multiple printing in the same or different colors. This is also the basis of three-color carbon printing, although that procedure is more complex. The image can be transferred to the final support at a later date in normal room light.

Sensitizing

Contrast is determined by several different variables:

- *The length of time the tissue is immersed in the dichromate:* the longer the immersion time in the sensitizer, the lower the contrast; the shorter the time, the higher the contrast.
- *The strength of the dichromate sensitizer:* sensitizer concentration can be varied from less than 1% for higher contrast to 6% for lower contrast, with 3–4% being about average contrast.[14] In equal amounts, ammonium dichromate is more sensitive than potassium dichromate, but a 2.5% solution of ammonium dichromate is equal in speed and contrast to a 3.5% solution of potassium dichromate.[15] It should also be noted that as the dichromate concentration is increased, so is the printing speed.
- *The amount and color of the pigment in the tissue:* the greater the amount of pigment, the greater the contrast.
- *The type of exposing light source:* different types of light can have an effect upon the contrast, although the dichromate strength can be adjusted to modify this effect (see chapter 1).

Cut a piece of carbon tissue slightly larger than the negative. The temperature of the sensitizer solution shouldn't be higher than 15–18°C/59–64°F and the room temperature should be about 20°C/68°F. Sensitize the tissue under safelight conditions with dichromate. This can be done either by immersing the tissue in a tray of potassium dichromate for 1–3 minutes or immersing it for about 1–2 minutes in ammonium dichromate. Keep the tissue under the surface of the dichromate and brush off any air bubbles.

> All dichromates are considered carcinogens and should be handled carefully with full protective gear. Wear gloves and wash your hands well after removing the gloves. Ammonium dichromate has the added risk of being flammable. See the chemical list in the appendix for further precautions.

Remember, if the tissue is allowed to stay too long in the sensitizer bath, it will absorb more dichromate, resulting in lower contrast, which is the same effect as using a higher concentration solution. Also note that for consistency, the dichromate solution should be at the same temperature for sensitizing all your images, since gelatin has different rates of absorption at different temperatures.[16]

After the tissue has been sensitized, it can be removed from the sensitizer and

squeegeed to minimize further absorption of dichromate. You can also simply let the excess fluid drip back into the tray. Whichever method you choose, use it consistently for repeatable results.

An alternative method worth considering is to pin down the edges of the dry carbon tissue and brush on a measured amount of solution with a foam brush. For example, 15–20 ml would be enough to adequately cover a 4 × 5-inch (10 × 12.5-cm) area. The merits of this method are that because the solution is "one shot," it's always the expected strength, and this method eliminates the chance of a spill when a large amount of dichromate is poured from the tray back into the container. However, unless you brush quickly, with strokes crossing in both directions, it's possible to end up with streaks from unevenly sensitized tissue, especially with larger image sizes.

The dichromate can be kept and reused, but it should be filtered between each use. Eventually, as the dichromate is used up or the solution becomes contaminated with

Picture, 1929 (František Drtikol, © Ervina Boková-Drtikolová), a carbon print reproduction made by Klaus Pollmeier from the original glass-plate negative (courtesy of Klaus Pollmeier and © Suzanne Pastor).

organic matter from the tissue, the solution will become weaker and, at some point, will have to be discarded.

> ! Do not pour the used dichromate down the drain. It is illegal in most, if not all, areas to dispose of it in
> ● any fashion except at a chemical recycling center.

Spirit sensitizing

A more rapid method of sensitizing, called *spirit sensitizing,* uses an ammonium dichromate solution dissolved in acetone, an alcohol (such as isopropyl), or potassium dichromate dissolved in acetone.[17]

Make the concentration of ammonium dichromate two to three times stronger than needed and dilute it 1:2 with the alcohol or acetone. This will dry very rapidly as the alcohol evaporates.

Potassium dichromate is not soluble in alcohol, but it can be mixed with acetone for use as a spirit sensitizer. Make the concentration of potassium dichromate twice as strong as needed and dilute it with an equal amount of acetone. Pin or tape down the tissue and brush on the spirit sensitizer—a foam brush works well. Make the brushstrokes as even as possible to ensure an even coating.

> ! Use alcohol and, particularly, acetone with caution. They are very flammable and have a strong odor.
> ● Use good ventilation. Wear gloves and protective glasses. See the chemical list in the appendix for further
> precautions.

Regardless of the method used to sensitize the tissue, it needs to be dried after it is removed from the sensitizer. Remove it from the sensitizing bath, place clips on the top and bottom of the tissue, and hang it to dry in a dark area. Spread newspaper on the floor to catch any drips. If the tissue is simply left to air-dry, it can take over a full day, depending upon the ambient moisture and temperature conditions. You can also use a small fan to blow gently on the tissue, which will reduce the drying time to 1–2 hours.

Once the tissue is sensitized, it will gradually gain in speed (unless frozen), a phenomenon known as the *dark effect.* Exposed but undeveloped tissue exhibits what is known as the *continuing effect,* which is also a gain in speed. Exposed tissue held 6 hours prior to processing will appear the same as tissue exposed 15–20% longer and processed at once.[18] When the tissue has been sensitized, it is best to use it as soon as possible and to process it promptly after exposure.

Exposure

Make a small pencil mark on the back, or nongelatin, side of the final transfer paper; when it's wet, both sides will look the same. Soak the final transfer paper in a tray of cool water

for 15 minutes before the exposure. RC paper needs to be soaked only 4–5 minutes. If you are using a plastic transfer support, this step can be eliminated and the plastic immersed just after the exposure.

Since tap water usually contains air, it will contribute to the formation of air bubbles between the support and the tissue. This will result in tiny shiny specks on the finished print. The best way to avoid this is to use water that has been aged or allowed to sit for a day or two, or to use boiled water.

There is nothing as disconcerting as watching the gelatin film slowly floating off the support and slipping away into the water. To prevent this, the negative should have a safe-edge of an inactinic material, one that will not pass light, on all sides. This can be done by carefully masking the unexposed negative edges with red or black litho tape or by using a black paper mask to cover the film edge. If this isn't done, the tissue in contact with the clear negative edges will be overexposed and will frill, or lift off, from the transfer paper during development, possibly taking the image with it. If the negative has clear shadow areas that go to the edge, it might be a good idea to use a translucent material, such as white paper, for an edge mask. This allows some exposure to the edge and prevents the clear areas from frilling during development.[19]

Under a safelight, lay the negative, emulsion side up, on the sensitized tissue, or the image will be reversed on the final support. Place this combination in a contact frame with the negative facing the glass and make the exposure. The light source can be the sun or an artificial UV light source. The use of daylight fluorescent lights (Phillips No. 33 in Europe and General Electric GE F20 [or F40] T12 SP65 in North America) is recommended as a highly effective and inexpensive alternative to a UV light source. They work extremely well with the carbon process. There will be virtually no provisional image, so the exposure must be done by time rather than visual inspection. Make certain that the tissue is dry or it can become literally glued to the surface of the negative. A 1-mil (0.001-inch or 0.025-mm) piece of plastic between the negative and tissue can be used to prevent this.

A trial exposure might be 3–5 minutes, depending on the light source. After the exposure, remove the tissue from the printing frame under safelight conditions.

Attaching the Exposed Tissue to the Support

Slip a piece of glass or plastic larger than the support into the bottom of the tray of water where the support paper is. (A plastic tub is a good choice for soaking the tissue and support in cold water since it has higher sides than a tray. This will enable you to turn the tissue over easily under the water without danger of trapping air bubbles.) If you use glass as a support, make sure to sand the edges smooth with sandpaper so that you won't cut yourself. Under a safelight, take the exposed tissue and put it in the cool water over the support tissue, pigment side up, for 2–3 minutes, *until it is limp*, brushing off air bubbles and keeping the exposed tissue completely immersed.

> ! If you soak the tissue too long, it won't adhere to the support. Under water, reverse the tissue so that the pigment side is facing the front of the final transfer paper (the side without the pencil mark). Bring the tissue and the support up together on the glass, avoiding air bubbles, with the carbon tissue on top.

Note that the commonly accepted method of soaking and bringing up the tissue/support sandwich is to bring them up together and *then* place them on a piece of glass or plastic. Use whichever method is most comfortable and successful for you.

Firmly squeegee the sandwich several times from the center outwards—first vertically and then horizontally—to eliminate air bubbles. Then lay a few layers of newspaper over it. Place a piece of glass or stiff plastic—larger than the carbon tissue—over the newspaper. Finally, put a weight, such as a liter container filled with water, on top. Leave it for about 20 minutes in a dark or safelit area. A little longer or shorter time generally won't do any harm. However, remember to be consistent in whatever method you use.

The room temperature should be fairly cool, about 18°C/64°F. If this isn't possible, an alternative is to fill a tray with ice water, or water and frozen ice packs, and place it on the glass or plastic that's covering the tissue/support sandwich for the extended waiting period.

If plastic is used as a support, it will not have to be soaked to be attached to the exposed tissue; just put it in the water at the same time the tissue is put in. The length of time that the tissue and plastic are dried together under a weight can be reduced to 3–5 minutes.[20] It can then be developed normally and dried.

Processing

Fill a tray with warm water (39–41°C/103–105°F). Remove the weight and carefully transfer the sandwich, tissue side up, into the hot water. Hold it under the water 1–2 minutes until the gelatin is softened; you will see gelatin oozing from the sides of the tissue. Brush off air bubbles as they form on the top of the tissue. Gently, but evenly, under water, pull the tissue from the transfer paper by a corner. If the tissue resists being removed, let it wait a little longer or the gelatin will tear. This resistance can be caused by overexposure or by not waiting long enough to remove the tissue. Throw the used support paper away.

At first there will only be a dark gelatinous mass visible on the paper. Gently move the support paper under water with tongs or with your gloved fingers and the image will begin to become distinct. Be *very* gentle with the agitation of the paper, since the edges of the image may frill. It's even possible for entire portions of the image to float away with harsh movement. You can, from time to time, pick the support up by one edge, let it drain and then gently slide it back into the water. To keep development even, this is best done by picking up alternate edges. If you do this, be careful not to leave it out of the water too long or the tissue will harden in the cool air and will not develop fully.

> ! The wet gelatin is easily damaged; do not touch its surface.

Because the water will become dark with the dissolved pigment, you may want to place the developing image in a fresh tray of water, at the same temperature, to finish developing. Note that the safelight can be turned off midway through development and you can proceed under ordinary light.

There are several methods that can help control development:

- A small cup or beaker can be used to pour water gently over areas that need more clearing. Pour from a low height to avoid damaging the delicate gelatin.
- Keep a tray of cool water next to the developing tray. If the print is developing too rapidly because it was undertimed, place the print in the cool water to slow down the process until you can add cool water to the developing tray for slower development.
- Add hot water to increase development, but be careful not to get it too hot or the surface will blister.

When the image has developed to the proper density, remove the support from the

Leaf and Steps (© Richard Farber), a carbro print with a mezzotint-like grain pattern resulting from using self-made carbon tissue with 12% sumi ink content.

hot water with tongs or gloves and put it in a tray of cold water for a few minutes to firm the gelatin. Remove it from the water and hang it to dry with light areas up to avoid color bleeding into a light area.

When the image is dry, any yellow dichromate stain remaining can be removed by a 5-minute soak in a print-strength solution of Kodak Hypo Clearing Agent or a 5% solution of potassium metabisulfite (50 grams/liter), followed by a 10-minute wash in water.

> ❗ Do not allow water to fall on the delicate gelatin surface, or it can be damaged. After the wash, hang the print up to dry.

If multiple exposures are to be made, wait until all the exposures are finished before clearing.

Although not absolutely necessary, since the gelatin will dry to a fairly tough surface, it can be further hardened by soaking it in a 3% solution of formalin or a 1% solution of glyoxal for 3–5 minutes. Follow this with a 5-minute wash. Then hang the paper up to dry in a well-ventilated area, preferably outside.

> ❗ Wear gloves and protective glasses when using either formalin or glyoxal. Do this either outside or under a fume hood inside. See the chemical list in the appendix for further precautions.

Multiple Printing

Multiple printing can be used to add density to shadows and to enable the use of multiple colors. Cut the carbon tissues that are to be used to the same size. Make a black or white paper mask for the edges of the negative and make a pencil mark on the vertical and horizontal edges. When the tissue is put down on the negative in the printing frame, hold it firmly and make corresponding marks on the back of the tissue. After the tissue and support have soaked in the cool water and been squeegeed together, make marks on the support corresponding to those on the tissue. Be sure to make the pencil marks immediately after squeegeeing the tissue to the support since the support paper will change dimensionally as it dries. Process the print normally and let it dry completely. Place the next sensitized tissue on the mask, make corresponding pencil marks on the back, and carefully close the printing frame. After the tissue and support have soaked in the cool water and been removed, align the marks on the tissue with those previously made on the support. Holding the tissue firmly, carefully squeegee the tissue and process normally.

Carbro

The carbro (*car*bon *bro*mide) process is closely related to the carbon process. In 1873, A. Marion found that if he placed a piece of carbon tissue saturated with certain chemicals in contact with paper that had been coated with dichromate and exposed to a negative,

the carbon tissue would become insoluble. The *ozotype*, invented by Thomas Manly in 1899, utilized this concept and is the direct forerunner of the present-day carbro process. A similar process, little known today, called the *gum ozotype*, was also developed for the gum process. In 1905, Manly found another method, called the *ozobrome process*, which used a bromide print as the basis for the image, making it possible to make an enlargement on photographic paper instead of having to make a contact print with a large negative. In 1919, H. F. Farmer made improvements to this process. It was called the carbro process, and materials for it were carried by the Autotype Company.

Before the advent of computers, the carbro process was routinely used for three-color separation printing, with some rather handsome results. Unfortunately, the colored tissue for the separations is no longer commercially available, so the only way to make a three- or four-color carbon or carbro print now is to make your own colored tissues. There are a few people doing this, but it's a difficult job to find suitable lightfast pigments and to color-balance them correctly.

Carbro has some significant advantages over carbon printing. As mentioned above, a large-format negative is not required for the carbro process, since it uses a bromide print to transfer the image, and the image doesn't need to be reversed as it does with carbon. It's much easier to burn and dodge a bromide print than a negative and to see the effect on the positive bromide image. A carbon print will continue to lose density as it's developed, while the carbro print will generally develop to a certain point and not much further.[21] Because the transfer of the image to the carbon tissue is a chemical process, no exposing light is necessary, nor is there any danger to the negative from heat or intense light.

There are, however, some disadvantages to contend with in the carbro process. A carbro print may not be quite as sharp as a carbon print. With carbon printing, the negative will provide a consistent basis for an unlimited number of prints, while carbro is limited to three to five prints from each bromide, which gain in contrast after each use, and there will be some trouble finding a suitable bromide paper.

Carbro, even more than carbon, is a picky process. Hopefully, the suggestions given here will permit you to find a combination suitable for your conditions and materials.

Bromide paper

Carbro depends on a chemical process, rather than UV light, to make the carbon tissue insoluble. Nonsupercoated[22] bromide paper was designed to be used with the carbro process to enable intimate chemical contact between the paper emulsion and the sensitized carbon tissue. Unfortunately, with only a few exceptions, virtually all modern photographic paper is now supercoated. Luminos, which makes many types of enlarging paper, currently has one of the only nonsupercoated papers available, Classic SW-Art single-weight photographic paper. The document art and tinted RC papers by Kentmere have also been said to be nonsupercoated. Chen-Fu photographic paper from Chen-Fu Products has recently been introduced and may be a good choice. The Fine Print Studio in Germany is also planning to introduce a paper soon.

A semimatte surface was customarily recommended for a good transfer, but Symmes found that some papers with a glossy surface seem to work just as well.[23]

Although more difficult to use, many modern photographic papers can still be very suitable, even with the supercoating. Because photographic papers are frequently modified by the manufacturer, it's difficult to make a reliable recommendation. Good results have been reported with Ilford Multigrade FB and RC papers, Agfa's Classic paper, Kodak Polycontrast III RC "N" surface, as well as Kodak Fine Grain Release Film. A few test exposures will easily determine the suitability of available papers.

A major problem with current supercoated papers is that highlights have a tendency to be washed away after the tissue has been transferred. If you run into this problem, first make certain that the cause isn't an improperly exposed bromide. The negative must be matched to the proper grade of paper for good results. You will probably find that a bromide print that looks somewhat flat, with good highlight values, will work the best. Making a test print with differently exposed strips or a step tablet will graphically demonstrate the contrast range available to you. The bromide print to be used should have a white border of at least ⅜ inch (1 cm) to avoid the carbon tissue frilling during processing.

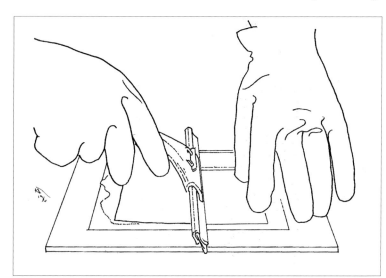

A piece of carbon tissue is shown being squeegeed onto the surface of a bromide print for a carbro print. The squeegee is an essential tool for carbon/carbro printing. It's used to help eliminate air bubbles and ensure intimate contact between the carbon tissue and the gelatin surface to which it's attached.

To avoid hardening the gelatin, the use of amidol as a paper developer is frequently recommended. It's been suggested that amidol developers, which contain no carbonates, are superior because developers with carbonate amounts in excess of 2.5% of the total volume tend to have a hardening effect on the emulsion.[24] Although amidol currently has somewhat of a cult following, it has its drawbacks, which include toxicity, a fairly limited tray life, staining of skin, and expense. Many, but not all, paper developers, such as D-72 (Dektol), Ethol LPD, and Ilford Phenidone-based developers, can be used successfully. If you suspect that your developer is causing problems, you might want to try Kodak D-52 since it has a very low carbonate content. A nonhardening fixer, such as plain sodium thiosulfate, or a rapid fixer without the hardener is a necessity.

It has also been suggested that hard water (water with a high mineral content) can cause problems maintaining highlights. All solutions should be prepared with distilled water, which will, with the exception of the wash, eliminate this possibility. If you're using RC paper, then technology is on your side; RC paper has a fiber core that's protected on both sides by a plastic film. The emulsion, contrary to popular belief, is not under the

plastic, but on top of it, which means that washing is very efficient and fast because only the emulsion has to be washed, not the paper fibers.

Sensitizing solution for carbro

There are several sensitizing solutions that can be used for carbro: single- or two-bath solutions. Two-bath solutions are considered more flexible than single baths, but they require precise timing for each sensitizing solution, particularly the second one.

Although single-bath sensitizers contain dichromate, a known carcinogen, two-bath sensitizers also contain chromic acid, chrome alum, or large amounts of formaldehyde—all of which are toxic and/or carcinogenic. For this reason, two-solution sensitizers will not be discussed here. Formulas for both types of sensitizers can be easily found in the literature.

The following is a common formula that works well:

Potassium dichromate	12 grams
Potassium ferricyanide	16 grams
Potassium bromide	8 grams
Succinic acid	2.5 grams
Potassium alum	1.0 gram
Water (distilled) to make	1 liter

Note that 1 liter of water is for normal contrast. Contrast can be adjusted lower by substituting 750 ml of water for the volume recommended in the formula, or higher by adding 250 ml of water to the 1 liter recommended in the formula.

The contrast is determined not only by the dilution of the sensitizer, as indicated above, but also by the length of time that the tissue is in the sensitizer and by the pigment content of the carbon tissue.

The sensitizer solution is toxic, and potassium dichromate is a known carcinogen. Wear gloves and eye protection when handling the solution. When it's time to dispose of the sensitizer, don't pour it down the drain. It's illegal in most, if not all, areas to dispose of it in this manner. Before disposal of the sensitizer or its components, contact your local waste-treatment plant for its requirements, or take it to your local chemical or hazardous-waste recycling center. See the chemical list in the appendix for further precautions.

The solution should be filtered after each use, or the organic matter from the tissue will eventually make it useless. One liter will sensitize about eight 8 × 10-inch (20 × 25-cm) prints. The sensitizer should be stored in a cool, dark area or refrigerated if you have a refrigerator dedicated only to photographic materials.

When using carbon tissue with the carbon/carbro processes, it's necessary for the

room, water bath, and, particularly, the sensitizer to be fairly cool (about 18°C/64°F) to prevent the swollen gelatin from melting, reticulating,[25] or, in the case of carbro, preventing transfer by adhering permanently to the bromide print.[26]

Experiments by Symmes using tissues with different melting points strongly indicated that the usable temperature was limited by the type, or melting point, of the gelatin that made up the tissue. He found that the processing temperature could be higher than normal as long as the sensitizing time was reduced and the gelatin on the tissue came cleanly away from the bromide.[27] It should be noted that Symmes was using commercially made tissue, which probably had characteristics different from those of your tissue if you are making your own.

Procedure for carbro printing

1. Cut a piece of carbon tissue slightly larger than the size of the bromide image. Make certain that the bromide has an adequate white border.
2. Before sensitizing the tissue, place the bromide in cool water for 10–15 minutes if it is fiber based or for 2–3 minutes if it is resin coated. Also place the final transfer paper in cool water for 15–30 minutes. As with carbon printing, the use of aged, distilled, or boiled water will dramatically reduce problems with air bubbles.
3. Soak the tissue in cool water for 2 minutes. Remove it from the water and squeegee it.
4. Squeegee the bromide (image side up) to a piece of glass or plastic.
5. Cover the image area of the bromide with a pool of water, preferably distilled. The water helps keep out air and also makes it easier to align the tissue later.
6. Under ordinary room light, place the wet tissue in the sensitizing bath for 2 minutes at a temperature of about 18°C/64°F.

> The time in the bath is important, because the tissue will gain contrast with longer sensitization up to about 3 minutes. Remove the tissue from the sensitizer and let the excess fluid drip back into the tray. Don't forget to count this as part of the total sensitizing time.

7. Carefully lay the tissue gelatin side down and squeegee it onto the bromide image. Since this is a chemical-transfer process, a few light strokes will be sufficient. You must be very careful doing this, since moving the tissue once it has made contact with the bromide will cause a double image. One good method is to roll the tissue while holding one edge firmly down and then carefully squeegeeing it (while still carefully holding the edge down). The room temperature should be fairly cool, about 18°C/64°F. If this is not possible, fill a tray with ice water, or water and frozen ice packs, and place it on the glass or plastic covering the tissue/bromide sandwich for the extended waiting period.
8. Place a layer of newspaper over the sandwich and lay a light weight over that.
9. After 15 minutes, remove the weight, carefully pick up the bromide/tissue sandwich

and place it in a tray of cool water along with the final transfer paper. Remove the tissue from the bromide by gently peeling it off under water. Put the bromide aside. The bromide can be reused several times, gaining contrast with each use. To reuse it, rinse it off for 5 minutes and redevelop it in a nonhardening developer. No fixing is necessary. Wash the bromide print for 10 minutes and then dry it.

10. The instructions from this point are exactly the same as for carbon printing, with the exception that ordinary room lights may be used instead of a safelight.

Nontransfer carbro

An alternative method worth consideration is to develop the tissue directly on the bromide print instead of transferring it. This method is much easier because the tissue doesn't have to be transferred to a final support material. It has the added advantage that you won't have to gelatin-size the final support paper. If you decide to process the tissue this way, use a slightly heavier weight on the tissue.

For this process, instead of removing the tissue in the cold-water tray, process it in hot water in exactly the way described for processing a carbon print. The silver in the bromide print must be redeveloped or bleached

With the carbro process, the carbon tissue must be applied to the bromide print very carefully to avoid air bubbles or a double image. As shown here, one edge is held firmly to the bromide as the sensitized tissue is gently laid down on a pool of water.

after the carbon image has been developed. This will result in an image under the carbon, providing unique possibilities for its appearance.

If the print is redeveloped in regular photographic-paper developer, the silver image can strengthen or enhance the carbon image. This is particularly effective if the carbon image is a dark tone, such as from *sumi* ink. Since the carbon image can be nearly any color, this technique can also be used to give a unique split-toned effect.

Although usually not mentioned in the literature, the redeveloped silver image is as vulnerable to deterioration as a normal silver gelatin print. After the print has been redeveloped and dried, it can be toned for permanence in selenium toner 1:31 for 3–8 minutes and then given a 15–20-minute wash. Depending on the paper, the dilution of the selenium, and the length of toning time, selenium toner can strengthen darker values and, in some papers, change the color.

> Make sure there is good ventilation in your work area and wear gloves and eye protection when using selenium toner. Do not attempt to mix your own selenium toner from powder; it is very toxic. Instead, use a premixed solution such as Kodak Rapid Selenium Toner. See the chemical list in the appendix for further precautions.

Another possibility is to tone the redeveloped silver image in different color variations, including red, green, or blue, with various toners. A look through the literature will reveal many toning formulas. It's possible to do the redevelopment or bleaching immediately after processing the carbon image, but you risk damaging the image. There is much less risk to the image if the print is permitted to dry completely before being redeveloped and/ or toned. If you aren't sure whether to redevelop or bleach, go ahead and redevelop the image. If you don't care for the appearance of the redeveloped image, the silver can always be bleached away with no harm to the carbon image; however, once the silver has been bleached, the effect is permanent. Only the carbon image will be left.

> Be very careful choosing and using toners. Many of them contain chemicals that are toxic and/or carcinogenic, and all require good ventilation. Gloves and eye protection are also necessary when mixing and using toners. Use the resources given in this book to find information about safety and use. Before disposal of a toner, contact your local waste-treatment plant for its requirements or take it to your local chemical or hazardous-waste recycling center.

Gelabrome

An interesting variation of the carbro process is called *gelabrome*.[28] With gelabrome, which has the same appearance as a nontransfer carbro (see the section on carbro, above), the pigmented gelatin is prepared directly on the surface of the bromide print rather than the carbon tissue being separately prepared, sensitized, and applied as it is in the conventional carbro process. Like the carbro process, neither an enlarged negative nor a UV light source is necessary since the image is chemically derived from a bromide enlargement.

Gelabrome has several advantages over nontransfer carbro:
- The carbon tissue doesn't have to be made as a separate step.
- There is no risk of a blurred image because carbon tissue doesn't have to be carefully placed and squeegeed onto the bromide.
- There's no risk of air bubbles forming between the carbon tissue and the bromide.
- You won't have to prepare a gelatin-sized final support paper.

One disadvantage shared with carbro is that there's not as large a choice of a final support surface as there is with carbon because the carbon image must be on the photographic paper.

Pigments and image tone

Any of the pigments or inks used for tissue making can be used, giving a wide range of possible colors (see the section on pigments, p. 121).

Water Meter (© Richard Farber), gelabrome image demonstrating the difference in color that results from redeveloping a carbro or gelabrome print; the darker-colored portion has been redeveloped. The red color is from watercolor-pigmented gelatin. With a dark pigment, the results of redevelopment are more subtle.

The bromide print

Follow the same directions for making a bromide print as for a regular carbro print. Fiber-based or resin-coated paper can be used, although the former seems more in keeping with the historical nature of the process. Individual printing preferences will vary, but you might want to begin with a slightly flat print with full information in the shadows and highlights. A print divided into strips of different contrast and/or densities can be used to determine the final appearance after the gelabrome has been processed. The print should have a nonimage white margin of at least ⅜ inch (1 cm) to avoid frilling of the gelatin. Be sure to use a nonhardening developer. Fix the print in plain hypo or rapid fixer (ammonium thiosulfate) with no hardener added, and wash it well.

Coating the bromide with pigmented gelatin

Essentially, the same steps for making carbon tissue are followed, except that the bromide print takes the place of the support paper (see the section on making carbon tissue, p. 123). Since the tissue isn't light sensitive at this point, this step can be done in regular light.

If you use a dry print, it should be soaked for 4–6 minutes; otherwise, you can take the print directly from the wash. The wet print is squeegeed to a piece of glass or waterproof board and placed on a level area. The melted gelatin with pigment added is then carefully poured onto the squeegeed bromide print. The gelatin is quickly spread to the edges, including the white margin, with a comb or glass rod, making sure air bubbles are removed. After processing, the gelatin will not remain on the margins, leaving them clear.

Although the squeegeed print should remain flat long enough to complete this step, the edges can also be taped to the glass or board to help prevent the paper from buckling. Make sure to leave at least ⅜ inch (1 cm) of unexposed paper margin free of tape on all sides. After the gelatin has set, the print can be hung up to dry in the same manner as carbon tissue, with weights, such as clips, on the bottom to prevent curling, or the edges can be taped and it can be left on the glass or board. It's important to make sure that the gelatin has firmly set before it's moved; otherwise, it will sag and the coating will be useless. The gelatin will take 8–12 hours to dry if the print is hung up and longer if it remains taped to the glass or board. As with carbon tissue, drying with a fan is not recommended.

Sensitizing

This step can take place in incandescent room light, but not under fluorescent light. After the gelatin has completely dried, the bromide is soaked for 4–8 minutes in a tray of cold water (15–18°C/59–64°F) or until it becomes completely limp. Since tap water tends to

Figure, Snow, Trees (© Richard Farber), gelabrome made using sumi ink as the pigment.

contain air bubbles, potential problems can be minimized by using water that has been boiled, distilled, or allowed to sit or age at least 24 hours.

The gelabrome is sensitized by being immersed for 2 minutes at the same temperature in carbro sensitizer (see the section on carbro, above) with gentle agitation. The capacity of the sensitizer is the same as for carbro. *Note:* Wear gloves and eye protection when sensitizing the tissue. The sensitizer contains potassium dichromate, a known carcinogen. And remember, don't pour used sensitizer down the drain. See the chemical list in the appendix for further precautions.

Like carbro, the amount of time in the sensitizer, the paper contrast, and the amount of pigment used are the main determinants of contrast. A longer period of immersion in the sensitizer produces less contrast and a shorter one increases contrast. Alternative suggestions for contrast control are to change the amount of potassium bromide used in the sensitizer[29] or to alter the amount of succinic acid in the sensitizer—less succinic acid giving greater contrast and more succinic acid resulting in less contrast.[30] Initially, it will be easier and more convenient to limit contrast controls to pigment amount, paper contrast, and the time of immersion in the sensitizer.

After the sensitizing time has elapsed, the drained, *not squeegeed*, print is placed on a piece of glass or board and allowed to sit for 20 minutes. If the room is warmer than 18°C/64°F, the gelabrome can be put on a piece of glass or plastic that is placed over a tray with ice or several ice packs in it and covered with another tray for the 20-minute waiting period.[31] A slightly longer or shorter period of time makes no difference. Although the carbro process of selectively hardening the gelatin is based on chemical reactions, rather than depending upon exposure to UV light, it's probably best to protect the dichromated gelatin/bromide from fog in a dimly lit or dark area during this extended time. Unlike carbro, it's important *not* to put a weight or glass on top of the gelatin, since this would stick to, or otherwise spoil, the soft exposed gelatin surface.

Processing

The print then follows the same processing steps as carbon, beginning with the hot-water soak (see the steps given for carbon, p. 134) to dissolve the unhardened gelatin.

As with nontransfer carbro, to prevent the remaining silver from eventually discoloring, the finished print should either be redeveloped to strengthen the image, or the silver image should be completely bleached away with Farmer's Reducer and afterward given a 5–10-minute wash. This final step of redevelopment or bleaching is best done after the gelabrome has been dried. Remember not to let water fall directly upon the wet, swollen gelatin.

A formula for Farmer's Reducer to use for bleaching is as follows:

SOLUTION A

Potassium ferricyanide	10 grams
Water (distilled) to make	100 ml

Untitled gelabrome print
(© David Lewis).

SOLUTION B

Sodium thiosulfate (hypo) ... 20 grams

Water (distilled) to make ... 100 ml

Add one part of solution A to five parts of solution B (1:5) and add 30 parts of water. For example, add 10 ml of solution A to 50 ml of solution B and add 300 ml of water. Note that once mixed together, this reducer has a life span of about 15 minutes.

Wear gloves and eye protection when using these chemicals. Before disposal of this, or any other reducer, contact your local authorities for their regulations, or take the material to your local chemical or hazardous waste recycling center. See the chemical list in the appendix for further precautions.

Notes

An additional book about contemporary carbon printing written by S. Carl King may be available in 1998.

1. Nadeau (1986).
2. Matus (1983).
3. Nadeau (1986).
4. Shaw and Rossol (1991).
5. Clerc (1930).
6. Shaw and Rossol (1991).
7. Nadeau (1986).
8. Ibid.
9. Klaus Pollmeier (personal communication, 1994).
10. Ibid.
11. Matus (1983).
12. Nadeau (1986).
13. Ibid.
14. Clerc (1930).
15. Kosar (1965).
16. Matus (1983).
17. Crawford (1979).
18. Kosar (1965).
19. Crawford (1979).
20. Nadeau (1986).
21. Ibid.
22. Supercoating is a hardened gelatin layer added over the print emulsion as protection against stress marks and handling.
23. Symmes (1947).
24. Wall (1945).
25. Clerc (1930).

26. Symmes (1947).
27. Ibid.
28. Nadeau (1986) and Procter-Gregg (1978).
29. Lewis (personal communication, 1996).
30. Nadeau (1986).
31. This is based in part on personal communication with David Lewis.

Bike Path, Voorschoten (© Richard Farber). The finished image, multiple printed with three coatings of ivory black watercolor (see p. 155).

Gum Bichromate

Gum PRINTING, ONE OF THE DICHROMATED COLLOID PROCESSES, MAY BE ONE OF THE MOST expressive and flexible photographic mediums ever devised. As with carbon printing, gum dichromate (formerly called gum bichromate) is based on the 1839 discovery by Mungo Ponton that dichromates are light sensitive. During his tireless investigations, William Henry Fox Talbot later discovered that normally water-soluble colloids, such as gelatin and gum arabic, become insoluble when mixed with a dichromate and exposed to light. He later used this principle with gelatin for a photomechanical printing process called *photoglyphy*. In 1855, Alphonse Poitevin added carbon pigment to colloids such as gelatin and gum arabic for the first carbon process. And in 1858, John Pouncy further defined what we now call gum printing by perfecting the use of dichromated gum arabic with a pigment.

The principle of gum printing is basically the same as carbon printing: i.e., a dichromated colloid, upon exposure to light, is hardened in proportion to the amount of light passing through the negative. Unlike the method used in carbon printing, however, the exposed colloid isn't reversed front to back for processing, nor is it transferred to another support. After exposure, the print is processed in a tray of water where the soluble, unexposed gum arabic is washed away, while the hardened gum remains. Although sometimes thought of as being somewhat soft, or pictorial, a gum print can also be sharp enough to maintain surprisingly good detail.

The great attraction of the gum print is that it can be manipulated with a brush or stream of water while it is wet. Add to this the possibility of multiple printing with the same or different colors, and it becomes easy to see the tremendous flexibility and potential of this process.[1]

To make a gum print you will need the following supplies:

- potassium, ammonium, or sodium dichromate

- gum arabic
- watercolor pigment—tube or powder (see cautions about pigments in the appendix)
- a safelight (a 40-watt yellow "bug" light is fine)
- gelatin for sizing the paper
- a 3% solution of formalin or a 1% solution of glyoxal for hardening the gelatin sizing
- one or two good-quality brushes
- a tray larger than the paper being used
- a 5% solution of potassium metabisulfite to clear the print
- paper
- a contact printing frame
- a UV light source

The Negative

The negative for a gum print, unlike those required for many of the related processes, does not need to have a great density range. One that would print well on grade 2 or 3 paper (a density range of about 0.9 to 1.2) will work well. Litho film can be used for a more graphic appearance; it can also be processed in a more dilute developer for a continuous tone. Other possibilities include transparencies and paper negatives made from copy machines and computer printers.[2]

Paper and Sizing

The paper, as an integral part of the image, should be carefully chosen for color and appearance and the ability to withstand long periods of soaking. Due to the nature of this process, the paper should have some "tooth" for the gum arabic to hold onto. With a very smooth paper, there is nothing to keep the image from washing off of the surface.

The paper generally has to be sized to prevent staining, particularly if you will be doing multiple printing. The traditional sizing is gelatin that has been hardened to prevent it from washing away under multiple exposures and subsequent processing (see chapter 1).

Before sizing, particularly if multiple printing is planned, the paper should be soaked in hot water to help prevent dimensional changes (see chapter 1). This is of special concern for prints 8 × 10 inches (20 × 25 cm) and larger.

Another method of sizing, although less convenient, is to add a coat of gelatin for each printing. Although more time-consuming, the advantage of this is that you can avoid the use of less-desirable chemical hardeners such as formalin, since the gelatin will be replaced each time a print is made. Follow the instructions in chapter 1 for applying a coat of warm gelatin to the completely dry paper and then thoroughly drying it between each print. A hair dryer can be used to speed up drying or the print can be air-dried. It is also possible to spray the paper with a coat of spray starch for each printing. After spraying the paper, gently wipe off the excess starch with a sponge and let the paper air-dry or dry it with heat.

Davis describes another method of sizing, which involves coating the paper with equal amounts of gum arabic and dichromate, allowing it to dry, and then, with no negative, exposing it to UV light until it just turns light brown. The paper is then "developed" like a regular gum print by floating it on cool water for 20–30 minutes and drying it, leaving a hardened coat of gum.[3] This method provides reasonable sizing. It leaves a slight dichromate stain, but this shouldn't be a problem since the finished gum print will be given a clearing bath to eliminate the normal dichromate stain.

Pigments

Many types of pigments can be used for gum printing. Oils and acrylics, however, are not suitable because they are not soluble after they have dried. Some prime considerations include the permanence of the pigment, its toxicity, and how easy it is to mix. If a pigment has a tendency to fade over time or with exposure to light, then it is considered *fugitive*. Most major manufacturers have charts indicating the relative permanence of their pigments. As a general rule, however, blacks, such as ivory black (which is a very good choice to start out with) and lampblack, and other darker earth colors may generally be considered very permanent. Powdered pigments are more troublesome and hazardous to mix, so it is suggested that you begin with tube watercolors. If you are not familiar with pigments and paints, it might be wise to check with someone who is, or consult a reference text before experimenting with colors.

> ! Some colors, or pigments, such as cobalt blue and cadmium yellow, are carcinogenic and/or toxic and should be handled with care or avoided.[4] Note the warnings about pigments in the appendix.

A further consideration is the amount of pigment contained in a tube of watercolor. As a general rule, more expensive paints tend to contain a greater amount of pigment, which means a richer color. This doesn't necessarily mean that you must purchase the most expensive watercolor; less expensive watercolors can also give good results, particularly the blacks and browns. A comparison of the same color from two different manufacturers will demonstrate that the different samples are not the same, which can be an unexpected bonus since it means more choices are available to you. To avoid surprises, you can make a color chart on a piece of watercolor paper. Select the colors you are interested in using and spread a small amount of each on the paper with a brush or palette knife. Grade each sample from dark to light, to give an idea of its color range.

The type of pigment, such as watercolor or gouache, is also important: watercolors have a translucent appearance and are the traditional pigment used in gum, while gouache is more opaque, giving less of a tonal range. If you plan on doing multiple printing, which is the best way to build an image, then gouache would not be a good choice. For a single coating, however, gouache can work quite well with its added covering power.

Measuring the pigment doesn't have to be overly precise, but it should be consistent so that it can be repeated accurately in future work. Tube watercolors can be measured

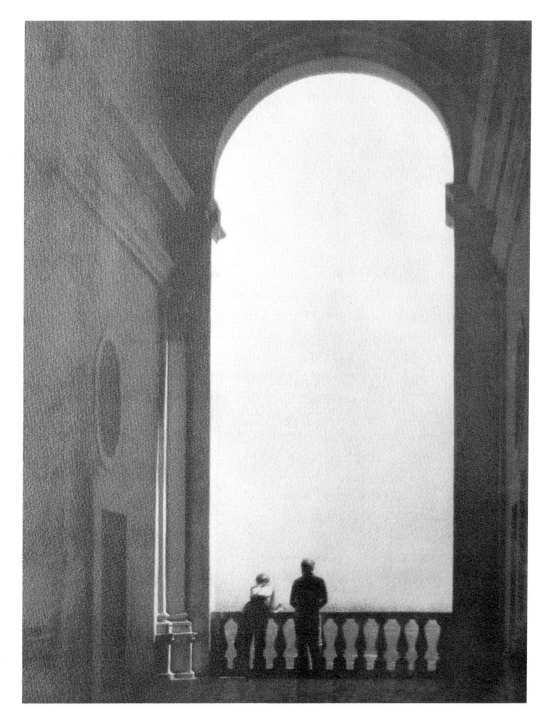

Blue Balustrade
(© Michiel Sonius), gum
print made with multiple
printings.

Opposite: Bike Path,
Voorschoten (© Richard
Farber), printed from a
pinhole-camera negative.
The left side was coated
once and the right coated
twice, illustrating the
difference in density that
multiple printing makes.

for use by squeezing out a "worm" of a specific length, i.e., 1 inch (2.5 cm). Using informal measurements, a 1-inch (2.5-cm) worm from a small 3-ml tube of ivory black weighs about 0.5 gram. The weight of a 1-inch (2.5-cm) worm from a larger 18-ml tube is about 1 gram.

Another method is to put the container in which you're going to mix the gum and pigment on a scale and carefully add pigment until you have the desired amount.

Once you have some experience doing this, you may choose to dispense with the

weighing altogether and just mix in small amounts of pigment to the gum solution until it "looks" right. Don't discount this technique, the human eye is capable of accurately discerning very fine differences in shade.

As mentioned above, powdered watercolors are more difficult to mix and represent a greater health risk, but in some cases they are less expensive and can deliver a more saturated color because more pigment can be added to the solution. They can be measured by sight (for example, a certain amount on the end of a palette knife), by weight, or by volume (such as a half-teaspoonful).

> Care should be taken not to inhale the dust generated by grinding pigment or measuring the powder (see the appendix for notes on the health risks of using pigments).[5]

Gum Arabic

Gum arabic, which is derived from the acacia tree, is available in several forms: as a powder, granulated, in small pieces sometimes called *tears*, and as a premixed liquid, which is sometimes called *lithogum*. The premixed solution is, of course, the most convenient to use; the powder is the next best choice. The concentration of the premixed type is generally measured and described in units of *Baumé*, which is a measurement of specific gravity using a special hydrometer scale. A concentration of 12–14 Baumé (a specific gravity of 1.090 to about 1.105) will work well for gum printing.

> Mix and use gum at room temperature. Heating the gum solution can cause undesirable permanent changes in its properties.

Gum arabic solutions are usually made in the ratio of one part gum to three parts water (1:3), although some people prefer a stronger solution of one part gum to two parts water (1:2). The stronger solution can hold more pigment but can be more difficult to coat evenly. If you use the stronger solution and have problems coating, you can easily dilute it to the weaker concentration.

> It will take a day or so for the powdered gum to dissolve completely in water.

For a 1:3 gum arabic solution:
Water (distilled) .. 210 ml
Gum arabic .. 70 grams

For a 1:2 solution:
Water (distilled) .. 200 ml
Gum arabic .. 100 grams

A traditional method of preparing the solution involves filtering the gum arabic: put it in a piece of cheesecloth, tie up the corners, and leave it in a container with the appropriate amount of water until all the gum dissolves, periodically squeezing the bag gently.

Another, faster, method is to use a blender, adding the powder gradually. This will build up a "head" that can be removed, leaving the gum ready to use.[6] A related method is to use a magnetic mixer, which creates much less of a foamy top.

Regardless of which method you use to prepare the solution, it's a good idea to filter the gum arabic through a layer of cheesecloth before use to make sure you've gotten rid of any impurities, although it has been suggested that the purity of today's gum powder is good enough that you should not have to worry about filtering it; simply drop the measured portion of powdered gum into the water, allowing it to dissolve by itself.[7]

The gum will eventually sour unless a preservative is added to it. A few drops of formaldehyde will work for this purpose. Several drops of a 2% solution of methylparaben (2 grams in 100 ml of water) or a 0.25% solution of sodium benzoate (1 gram in 400 ml of water) will also work. Both of these are commonly used food preservatives. Store the gum solution in a brown glass container in a cool, dark area.

> Mercuric chloride is sometimes suggested as a preservative for gum. Avoid it! It is highly toxic and it should not be considered for use.

Brushes

The sensitized gum mixture is applied to the paper with a brush. There are a number of different kinds of brushes that are suitable for this purpose, ranging from inexpensive hog hair or foam, to extremely expensive sable. In general, a brush should not shed bristles, nor should it be too stiff or moplike. A brush shape with a squared end, called a *bright*, works well, and some people use a fan-shaped brush. Traditionally, two brushes have been for coating: a coating brush and a blending one. A foam brush can be used for the initial coating, followed by a blending brush to smooth the coating lines. You may find that one brush is adequate for both brushing and blending. For larger prints, a width of at least 2 inches (5 cm) is suggested for the coating brush and a width of 2–3 inches (5–8 cm) for the blending brush.

Dichromate Sensitizer

Ammonium dichromate, potassium dichromate, or sodium dichromate can be used with equal success for the sensitizer. The one most commonly recommended is potassium dichromate, which is usually used as a 13% saturated solution.

Canal with Trees
(© Richard Farber), gum
print made with multiple
printings of ivory black
watercolor pigment.

To make a 13% potassium dichromate solution:

Water (distilled)	80 ml
Potassium dichromate	13 grams
Water (distilled) to make	100 ml

Since ammonium and sodium dichromate are of equal sensitivity in equal concentrations in gum arabic, a nearly saturated solution of 25% ammonium dichromate or a 25% solution of sodium dichromate can also be used to exploit its added sensitivity (see chapter 1).

In a gum solution, ammonium and sodium dichromate are nearly twice as sensitive as the potassium in approximately equal concentrations.[8] However, if each is used in a saturated form, its sensitivity will be quite different because of the greater amounts of dichromate ions in the solution. The more saturated ammonium and sodium dichromate solutions will be more sensitive to the light, with correspondingly shorter exposure times.

The type used, of course, is a matter of personal taste and possibly as a complement to the type of light source used (see chapter 1). It's important to remember that the use of different *types* of dichromates will not affect the contrast, only the speed. A further consideration is that as the concentration of dichromate goes up, the amount of staining usually increases. This is usually no problem after the print has been cleared.

Yellow Flower (© Chia Nohlberg-Loefqvist), four-color gum print. Although the subtleties may not be visible on the published page, a three- or four-color gum print has a beautiful translucency and delicacy.

To make a 25% solution of ammonium or sodium dichromate:

Water (distilled) .. 80 ml
Ammonium dichromate .. 25 grams

OR (but not both)

Sodium dichromate ... 25 grams

Water (distilled) to make .. 100 ml

> ! All dichromates are considered carcinogens and should be handled carefully with full protective gear.
> ● Mix the dichromate stock solution under local ventilation or outside, wearing a dust mask. Wear gloves and wash your hands well after removing the gloves. Ammonium dichromate has the added risk of being flammable. See the chemical list in the appendix for further precautions.

Preparing the Pigment and Gum Solution

It is possible to mix a large quantity of gum arabic with the desired pigment to keep as a ready-mixed supply, but there are several disadvantages to doing this. One is that it means being committed to one concentration of pigment until your ready-mixed supply runs out. If you're trying a new pigment, it's best to prepare solutions in smaller amounts until you've found the ratio of pigment to gum that best suits your needs. There is also the possibility that the gum may go bad long before it's used up, wasting expensive pigment.

Pigments vary in their density, so it's difficult to give a single measurement; however, a suggested starting point for ivory black is 0.5–1.0 gram added to 4–5 ml of gum solution. For lighter colors, such as burnt sienna, try 0.75–1.5 grams to 4–5 ml of gum solution.

Remember, this is just a starting point; you will probably need to adjust the ratio of pigment to gum to compensate for your printing conditions. In general, the maximum amount of gum that can be used without staining the paper or flaking will give the best results.

Sensitizing

To sensitize the paper, pin or tape it down by the corners and place the negative (or a piece of cardboard of the same size as the negative) on the paper and make light pencil marks at the corners or edges as a guide for sensitizing.

Problems such as the pigment flaking off during development and a print that's too weak are commonly experienced by beginning gum printers. You can avoid these problems by attempting not to make too thick a coating and by using an adequate amount of pigment. If the coating appears to be dark enough to completely hide the paper from view, then it's either too thick or too much pigment has been used. For an 8 × 10-inch (20 × 25-cm) image, 5 ml of gum solution should be more than adequate.

> ! Multiple printing doesn't need heavy pigment coats; the initial coating should look somewhat light.
> ●

Under a safelight, wearing gloves and protective glasses, add the measured amount of watercolor and the gum solution to a glass or plastic container. With a plastic coffee

stirrer or glass rod, mix the pigment into the gum solution. Add an amount of dichromate equal to the amount of gum (approximately 5 ml of each for an 8 × 10-inch, or 20 × 25-cm, print, for example) and mix well. If you've premixed a gum/pigment solution, stir it up to make certain that the pigment is evenly distributed, add the amount that you need (for the print you're making) to the glass or plastic container, add an equal amount of dichromate, and mix well.

Dip the coating brush into the sensitized solution and press out the excess. As quickly and evenly as possible without puddling the paper, brush the solution vertically and then horizontally to the pencil marks to make a thin, even coating. Don't worry about going past the pencil marks, the brush marks are a distinctive part of the print. However, if you prefer not have brush marks in the margins, you can mask the paper with tape or heavy black paper or use an opaque mask, such as a graphic arts material called Amberlith or Rubylith. Brush several times until the coating appears fairly even, but don't worry about trying to get it perfect—it will even out as it dries.

The gum bichromate process requires one container for the dichromate solution, one for the gum solution, two eyedroppers, pigment, a bowl to mix the pigmented sensitizer, and one or two brushes.

Brushing gently with the dry blender brush, smooth out the coating to eliminate obvious coating stripes. Use a very light touch with the blending brush, barely touching the surface. Some people find it easier to dip the blending brush into the gum mixture and squeeze it out well, rather than using it dry. You may also find that you can do equally well coating and blending with just one brush.

The gum mixture will dry fairly quickly, so don't brush longer than necessary for a smooth, thin coating. Remember, a coating that is too thick will flake off in development because the thickness will prevent the gum from becoming insoluble all the way to the paper base. After the paper has been coated, let it air-dry in a dark area; this will take about 20 minutes. It can be dried with warm—not hot—heat. Once sensitized, the paper will not keep well. If kept too long, the gum will become insoluble without any exposure, making the paper useless. Expose it as soon as possible after drying for the best and most consistent results.

Exposure

Once the paper is dry, under a safelight, put the negative on the paper, emulsion side down, and put it into a contact printing frame with the negative facing the glass. With gum printing, the exposure must be determined by time because the pigmented gum is too dark to permit visual inspection.

Exposure can be made with the sun or artificial UV source. An exposure made with the sun will be much shorter than with UV lights. It will also be shorter if you're using ammonium or sodium dichromate rather than potassium dichromate. A starting time for an exposure made with the sun might be 1–4 minutes, depending upon the negative density and the type of dichromate used. A starting point for an exposure made with UV lights might be 3–10 minutes, depending upon the negative density and the type, intensity, and efficiency of the light source.

It's important to note that even with the same amounts and concentrations of dichromate, different pigment colors may have different contrasts and speeds. This is due to what is known as the *internal filter effect*, which is the filterlike effect of the pigment or other colored substances.[9]

After exposure, remove the paper from the contact printing frame under safelight conditions. The exposed print must be processed promptly to avoid the *continuing effect*, which is a gain in speed: exposed but undeveloped for a period of time, the paper will appear the same as one exposed longer and processed at once.[10]

Developing

A method of development sometimes called "automatic" development is accomplished by sliding the exposed paper, coated side up, into a tray of water at room temperature (under a safelight). After a few moments, it's important to turn the print, pigment side down, in the water; otherwise, the lighter areas will have pigment streaming into them, causing staining. The print, which will float on top of the water, will gradually develop as the soluble unexposed gum floats away. After it's been in the water for 5–6 minutes, much of the dichromate will have dissolved into the water, leaving the image relatively insensitive to incandescent room light.

You can carefully pick up the print by a corner from time to time to check its progress. Remember that the pigmented gum is very soft and easily damaged at this stage. After a few minutes, the water will become clouded with dissolved gum, pigment, and dichromate. It will be easier to monitor development if the print is placed in a new tray of clean water or if the first tray is emptied and refilled while the print is held out of the water. A properly coated and exposed print will take about 30 minutes to develop in this way. But the print can be removed at any time if it looks as though it will develop past the appearance you want.

To increase the rate of development, the water temperature can be raised or a small amount of ammonia can be added to the water.

> This is a more drastic form of development and should only be used as a last resort.

When the print is developed, carefully remove it using tongs or gloves, and let it drain well. Hang the print up to dry with light areas up, so that dark areas won't run across the

lighter areas and make streaks. It can also be dried with the gentle heat of a hair dryer.

A print with good tonal qualities usually requires several printings, although some photographers, such as Demachy, made beautiful prints using only one coating. However, unless you are planning one printing with gouache, you generally can't expect the image to have the right density with the first printing. The first exposure will probably have weak shadows and look flat in contrast, leaving pure whites with no pigment. As mentioned in the next section, the image will increasingly improve in contrast and richness with each successive printing.

If there is a yellow dichromate stain on the print after it has dried, clear it with a 5% potassium metabisulfite bath (50 grams per liter of water) for 5 minutes, followed by a 5-minute wash. Be careful not to let the running water touch the surface of the print since the pigmented gum is very soft and easily damaged at this stage. Note that the metabisulfite will soften the emulsion, so clearing should be done after the print is dried. If you're doing multiple printing, wait until the last print has been developed and dried

Forks and Radishes
(© Richard Farber), three-color gum print. The colors were altered by switching the order of pigments and negatives.

before clearing the stain. If necessary, the print can easily be retouched with watercolors after it's dried. The finished print will not require an additional hardening step after it has dried because the dried surface is very durable.

Multiple Printing

Although it is possible to make a good image with only one printing, particularly with gouache, in practice you will find that depth and contrast, as well as color intensity, will be greatly enhanced with multiple printings. Don't discard weak prints, they can be greatly improved with this technique, and it's well worth the extra effort—the improvement in the quality of the image with multiple printing can be dramatic.

Multiple printing requires a registration system (see chapter 1) because the paper can, and probably will, change in dimension with multiple prints. This is especially the case with larger prints, so even with a registration system, it's a good idea to make certain that the marks made on the paper as a sensitizing guide match the negative placement. It's also important that the paper be well sized since it will be alternately soaked and have new coats of pigment applied to it. Sizing methods are discussed at the beginning of this chapter and in chapter 1.

Making multiple printings is no more difficult than making a single exposure, with the exception of negative registration. Follow the steps for sensitizing and making the first exposure given in the previous section. After the print has been developed and dried, you can determine how you want to make the rest of the printings, which will be sensitized and exposed in the same way as the first except that the pigment amount and exposure time will be modified to enhance either the shadows or highlights. A look through the literature will reveal many methods of multiple printing, but they essentially follow the suggestions given below.

For a full tonal range, it has been suggested that three coatings, one for the highlights, one for the midtones, and one for the shadows, are necessary.[11] To accomplish this, the highlight coating is done with a small amount of pigment, perhaps one-half the normal amount, for the full amount of exposure time. This will leave a weak-looking image with clear white highlights. If the white highlights are stained, try reducing the exposure time. The coating for the midtones and shadows is done with a larger amount of pigment for 25–50% less exposure time. The shadow coating uses the full amount of pigment but is also done for less exposure time. The amount of pigment used for the midtones and shadows should be great enough to add value but not enough to stain the highlights. It's also possible, of course, to simply use two coatings, a light one for the highlights and midtones and a second one with more pigment to enhance the shadows and midtones.

You can see that by controlling the amount of pigment and the exposure time, it's possible to have specific control of highlight and shadow areas. The highlights will be enhanced if a longer exposure is made with less pigment in the coating. The small amount of pigment has little effect on the already densely pigmented shadows, but the greater exposure time and small amount of pigment will strengthen the highlights, which have

less pigment density. If the print is recoated and exposed with the same or a smaller amount of pigment over a shorter exposure time, the shadows will be enhanced with little effect on the highlights: their higher negative density, along with the shortened time, prevents much exposure.

The image can be further enhanced by the use of two or more different pigments. For example, a subtle change in color can be made by first exposing a base layer of Talens ivory black, followed by successive shadow exposures using Winsor & Newton ivory black. The Talens, which is actually much blacker than the brown-black Winsor & Newton, adds a bit of contrast and strength to the image tone. Other color combinations can easily be found by mixing small amounts of pigment on paper.

Don't forget that brush and water manipulations can be used in conjunction with multiple printing to enhance specific parts of the image.

Problem Solving
Gum solution

- If the gum solution is too thin, it will take a longer time to dry and the pigment may stain the paper.
- If the gum solution is too concentrated, it will be difficult to coat smoothly, although a stronger solution will hold more pigment.

Sensitizer

- If more sensitizer is added, it will increase speed, but contrast will begin to be reduced at a certain point.
- If too much sensitizer is added, it will dilute the gum solution and will take longer to dry. It may also contribute to pigment staining.
- If too little sensitizer is added, it will reduce the sensitivity and also make the gum/pigment solution thicker. This will be more difficult to coat evenly.

Pigment

- If the amount of pigment is increased, the contrast will be higher, but there can be an increased graininess and possible flaking off during development. It's also possible that staining will occur if there is too much pigment.
- If the amount of pigment is decreased, the image will lose contrast and might appear too weak. This can be compensated by multiple printing.
- The amount of pigment may not be the cause of the problem. If the print has been overexposed, it will be difficult to develop because the gum has become too insoluble. If it's underexposed, the gum may be too soluble and dissolve in the water, leaving a very weak image. Make certain that the exposure was correct before adding or removing pigment from the solution.

Bottles (© Richard Farber), three-color gum print, showing the brush strokes to illustrate the different-colored exposures.

Opposite: Jo Berssenbrugge-Melis (Henri Berssenbrugge, © M. Berssenbrugge-Driessen, courtesy of the Rijksuniversiteit Prentenkabinet, Leiden). This Dutch photographer was well represented at salons internationally in the 1920s to 1940s. His excellent images deserve to be more widely known.

- Some unusual problems, such as poor tone rendition, can be the result of using pigments that are not compatible with the gum process. Changing the pigment should cure the problem, although this is not likely to be a problem with commonly used tube pigments.

Developing

- If the pigment virtually slides off the paper during development, it is probably because the paper is too smooth, or the exposure far too short.
- If the image is overexposed and does not dissolve in the water, the water temperature can be raised or a small amount of household ammonia can be added to the water. This treatment should be reserved as a last resort.
- If the print is removed before developing has finished, some of the pigment will still be soluble. This can run and stain parts of the image, as well as the border. To prevent this, remove the print, let the surplus water drain off, and at least partially dry it with a hair dryer to harden the gum.

HISTORIC PHOTOGRAPHIC PROCESSES

Creative Manipulation

For finer control, there are several methods that can be used to great advantage. You can use a brush to gently remove pigment from an area. A brush can also be used to create marks, swirls, or other shapes to help define the image. A gentle stream of water, or even drops of water, can remove areas of pigment—from broad to subtle. Manipulations should be done with the print surface covered with at least a film of water to soften and blend the effects.

Other options to consider are masking parts of the image with a liquid masking agent, such as frisket, after the first printing and then printing selected parts in different colors. You might also want to consider printing with two different negatives, both continuous tone, or one high contrast and one continuous tone. The print can also have additional color added to specific areas with watercolors or other coloring media.

Three-Color Gum Printing

A three-color gum print, sometimes called *tricolor gum,* is a full-color image derived from three (sometimes four) black-and-white separation negatives. A three-color gum print has a uniquely lovely appearance, with the translucent beauty of watercolors complemented by the surface texture and color of the paper. Unlike the high precision and more complex steps required for tricolor carbon and carbro, three-color gum is a relatively straightforward process. Because the paper can, and probably will, change in dimension when it is alternately soaked and dried, with several different coats of pigment applied to it, it's a good idea to make certain that it is well sized. Sizing methods are discussed at the beginning of this chapter and also in chapter 1.

Basically, for a tricolor print, color separations are derived from three images of the same subject made on panchromatic film through three different separation filters: a deep red (#25), a deep green (#58), and a deep blue (#47B). Sometimes a fourth separation negative, a black-printer, is used to enhance the shadows, but this is not required.

Separation negatives can be derived in several ways: from slides, from color negatives, from in-camera exposures, and from digitally produced negatives from computers. It is also possible to rephotograph separation prints made on *panchromatic paper* through separation filters, but there is little practical advantage to doing this.

It's important to note that the film recommended in many texts for color separations, Kodak Super-XX, has been discontinued. Kodak T-Max has been suggested as the replacement. Other panchromatic films, such as Ilford FP4-Plus, can also be used with good success for color separations and with the gum process. There is, or at least was, special film designed for color separations, but it is difficult to find, more expensive, and not a necessity for three-color gum printing. Orthochromatic films that can be used under safelight are not suitable because they are not sensitive across the color range.

To make color separations, you need to use a panchromatic sheet film. Before the exposure is made, you will have to make allowances for the amount of light being held

back by each filter. This *filter factor* differs with the type of filter, film, and light being used. There are two ways to compensate for this light loss: a new exposure time can be calculated by multiplying the filter factor by the exposure time with no filter, or the lens aperture can be opened the appropriate number of steps (see the chart below). For example, if the filter factor is 8, and the indicated exposure time with no filter is $\frac{1}{125}$, calculate the new exposure time by multiplying the filter factor by $\frac{1}{125}$ for the new exposure time of $\frac{1}{15}$. Or, using the same example, the lens aperture can be opened three stops (each additional stop is twice the value of the last, so $2 \times 2 \times 2 = 8$). Information on filter factors is provided with the film by the manufacturer. Additional information is also available directly from the manufacturer.

Because filter factors vary and may also result in a fractional f-stop if the aperture is used for correction, multiple filter corrections may need to be made. To simplify things, neutral-density filters (see chapter 1) can be used to eliminate having to use more than one filter factor. For example, if the #25 and #58 filter factors are 8 (3 stops) and the #47B is 6 ($2\frac{2}{3}$ stops), adding a 0.10 ($\frac{1}{3}$ stop) neutral-density filter to the #47B filter will allow it to be used with the same filter factor as the others.

If the difference between filter factors is a small one, such as in the example given above, it can be rounded to the next higher or lower value with little effect for the process used here.

FILTER FACTOR*	OPEN THE LENS (F-STOPS)
1.5	$\frac{2}{3}$
2	1
2.5	$1\frac{1}{3}$
3	$1\frac{2}{3}$
4	2
5	$2\frac{1}{3}$
6	$2\frac{2}{3}$
8	3
10	$3\frac{1}{3}$
12	$3\frac{2}{3}$
16	4
20	$4\frac{1}{3}$
24	$4\frac{2}{3}$

*F-stop corrections for other filter factors can be found on a log table or with a calculator

that has a log function: find the log value of the factor and divide by 0.3 (the log of 2).

Although Kodak T-Max and Ilford FP4-Plus have a more accurate film curve for color separations, the three-color gum process is flexible enough to allow the use of other panchromatic film types successfully.

The filter factors for Ilford FP4-Plus, Kodak Tri-X, and Kodak T-Max are as follows:

FILTER	#25	#58	#47B
T-Max			
Daylight	8	6	8
Tungsten	4	6	25
Tri-X			
Daylight	8	8	6
Tungsten	5	8	10
FP4-Plus			
Daylight	6	6	7
Tungsten	4	6	13

There is a considerable difference between the filter factors for daylight and tungsten light. It is also important to remember that since the characteristics of film are changed from time to time by the manufacturer, it's always best to check the manufacturer's current exposure recommendations.

Color separations from transparencies

The use of transparencies for color separations has several advantages over in-camera separations. These include being able to use a photograph of a moving subject and having a color record to refer to when printing. The disadvantage of using transparencies is that they tend to be contrasty and also that the resulting separation negatives are copies of the original. Although for processes such as Ilfochrome or tricolor carbon, masks can be made to reduce the contrast of the transparency, they really aren't necessary for three-color gum printing.

To make color separations from a transparency, it is best to use a transparency with good saturation and highlights that aren't washed out. The method of making separations described here generally uses the narrow band filters—deep green (#61), deep blue (#47B), and deep red (#29). The set of tricolor filters mentioned above (#25, #58, #47B) can also be used but with somewhat less precision. The separation filters can be used in the filter drawer of the enlarger or they can be placed under the lens.

Since the film is panchromatic, the exposure and processing must be done in complete darkness.

In the darkroom, with no lights on, carefully cut or punch one corner of the green-filtered film and two corners of the blue-filtered film, leaving the red-filtered film uncut. If you don't do this, there will be no way to identify which film belongs to which filter after it is processed. Exercise some caution when using scissors in the dark; it's easier than you might imagine to cut fingers as well as film. Each filter will probably require a different exposure time. A starting point, if the filter factors aren't available, might be to make the blue-filtered exposure 20–30% longer than the red-filtered exposure, and the

green-filtered exposure 50–60% less than the red-filtered exposure. Unfortunately, because different kinds of enlargers often have different types of light sources and because films differ in color sensitivity and speed, it isn't possible to give an exposure time. A few tests with the red negative should provide enough information for you to proceed with the other exposures.

The transparency should be emulsion side up in the slide carrier or the negative image will be reversed. (Place a piece of black paper on the easel to prevent light from reflecting back through the negative.) Focus and frame the image on the easel, and make one exposure through each filter.

> **!** Make certain that the negatives have been notched for later identification, as described above.

The three negatives should be balanced in density for the most accurate color rendition. This can be done by projecting a step tablet next to the transparency through each filter if the image is projected, or by contact printing a step tablet with the transparency if it's contact printed (see chapter 1). The step tablet can be purchased for the appropriate negative size, or you can photograph a gray scale and cut the resulting

Oekraine, 1995 (© Paul Kerkhoffs), gum print that was selectively colored with multiple printings.

171

negative down to size. An alternative method is to include a gray scale in the scene that is photographed, or if the light conditions are consistent for the roll, photograph a gray scale for a separate frame in the same light.

If, after developing, the shadow steps don't match, then alter the exposure by changing the time (not the f-stop, since this would alter the depth of field and resolution). After matching the shadow steps of the gray scale, the development can be made longer or shorter until the highlight steps indicate about the same density. The density range should be about the same as that of a negative used for monochrome gum printing: about 0.9–1.2. This can be checked visually over a light table or with a densitometer. It can also be checked by making a black-and-white print with a grade 3 paper or grade 3 filter, using the same exposure and aperture for each separation negative. The density does not need to be balanced exactly; it's rarely possible to achieve truly accurate color with gum because of the nature of the process and the pigments used.

The negatives can be processed in your normal film developer, but the time of development for the blue-filtered negative should be longer than that for the other two since blue produces lower contrast. A 30–50% longer developing time for the blue negative might be a good place to begin your calibrations.

Color separations from color negatives

Making color separations from color negatives has the advantage that the negative is already masked (the orange color) and a photograph of a moving subject can be used. The disadvantages are that the resulting negatives are copies of copies since both a positive and a negative must be made and there is also no color record to refer to as there is with transparencies.

The procedure for making separation negatives is the same as for making transparencies, except that the first copy is a positive and the negative is made from that. Although the positive must be made on panchromatic film or paper, the negative can be made with orthochromatic copy film, which can be used under a safelight.

> Remember to expose for the highlights and develop for the shadows for the positive and to expose for shadows and develop for the highlights for the negative (see chapter 1).

Color separations from in-camera exposures

The simplest and most direct method of all is to make three in-camera exposures. The advantages of this are that no additional darkroom work is needed after the negatives have been developed, and the negatives are the most accurate and have the most faithful color since they are first generation instead of copies of copies. The shortcomings of this method are that a large-format camera must be used and the subject can't move, limiting you to still-life studies.

An in-camera color separation might use the easily available Kodak Tri-X Professional

sheet film with an *adjusted* ISO of 160. Manufacturer's ISO recommendations are just that—the ISO generally needs to be adjusted for individual cameras, developers, and printing styles. The *daylight* filter factors for this film are as follows:

- 8 (3 stops) for the #25 filter
- 8 (3 stops) for the #58 filter
- 6 (2⅔ stops) for the #47B filter

For this example, however, the #47B filter factor will be rounded to 8 to match the other filters. Make the exposure compensation changes consistent for all three filters: shutter speed and aperture can both be changed, only the aperture can be changed for all of them, or only the shutter speed for all of them. For example, if the meter indicates $f/22$ and there is a filter factor of 8, then three additional stops would make the corrected exposure $f/8$. Or, if the indicated shutter speed was ¹⁄₁₂₅, then the corrected speed would be ¹⁄₁₅. Regardless of how you compensate for the filters, make certain that you end up with the same aperture for all three filters or the depth of field won't match.

It's easiest and most economical to use gelatin or polyester sheet filters, the polyester being more durable. Make one exposure through each filter, making certain to label the film holders for later identification. The three negatives should be balanced in density for the most accurate color rendition. This calibration can easily be done by photographing a gray scale through each filter. After developing, if the shadow steps don't match, then alter the exposure by changing the speed (not the f-stop, since this would alter the depth of field). After matching shadow steps in the gray scale, the development can be made longer or shorter until the highlight steps indicate approximately the same density. This can be done visually over a light table or with a densitometer. As mentioned above, density balancing can also be done by making a black-and-white print from each negative and comparing them. Once this calibration step is done, no further testing is necessary unless you change the type of film and/or developer. Although less convenient, another method is to include a gray scale within the scene that is being photographed.

In the darkroom, with no lights on, carefully cut or punch the corners of the film as described above: one corner of the green-filtered film and two corners of the blue-filtered film, leaving the red-filtered film uncut. If you don't do this, there will be no way to identify which film belongs to which filter after it is processed. The negatives can be processed in your normal film developer, but the time of development for the blue-filtered negative should be longer than for the other two, since blue produces a lower contrast.

It's difficult to give a standard developing time, since there are so many film-developer combinations. For the example of Kodak Tri-X Professional sheet film, you might want to try tray developing in Kodak HC-110 solution B for the following times: 3½ minutes for the red and green negatives and 5½ minutes for the blue negative (about 57% longer). These times are approximate only: you will have to find the best time for your conditions. Those who find the 3½-minute time too short can try a different dilution or developer.

To develop the negatives, it's easiest to put the blue-filtered negative in the developer until your timer indicates that 2 minutes have elapsed, then add the red and green

negatives for the remaining time. An alternative method to tray developing is a rotary developer. If you don't have a rotary developer, you can use developing tubes in a tray of tempered water. You can make these developing tubes or they can be purchased.[12]

Registration

Refer to chapter 1 for a description of different registration methods. For pin registration, follow the directions given with the following exception: before punching any holes, align the negatives over a light box. Start with one, then align the next over it, and so on, fastening the clear plastic together with small pieces of tape with each alignment. After all the negatives are in register, carefully pick up the taped group of aligned negatives, place it on the paper to be used, and punch the paper and clear plastic together with the two-hole paper punch. Then remove the bits of tape holding the negatives together.

Pigments

The pigments you will need are yellow, magenta, and cyan, and there are several possibilities. A good starting point is with cadmium lemon yellow or cadmium lemon pale, Winsor blue or thalo blue, and permanent rose. It's difficult to give the amount of each pigment with which to start; initially, you might use the same amounts of each pigment. The color balance can be altered by adding or subtracting pigment.[13]
- To darken green, make cyan bluer, and yellow redder, add magenta pigment.
- To make red darker, yellow greener, and magenta bluer, add cyan pigment.
- To make blue darker, magenta redder, and cyan greener, add yellow pigment.

Wear gloves when handling the pigments. Avoid inhaling the dust if you are using dry pigment, and avoid ingestion. Note the discussion and warnings about pigment selection in the section on gum printing, above, as well as specific warnings in the appendix.

Sensitizing

The paper is traditionally coated and exposed with the yellow pigment first, then the magenta, and finally the cyan, although there's no reason the order can't be changed. For a 5 × 7-inch (13 × 18-cm) image, a trial sensitizing solution for the yellow might be 1.5 ml gum, a 1-inch (2.5-cm) worm or 0.5 gram of pigment, and 1.5 ml of dichromate. Using the same amount of gum and dichromate, the magenta might use a 1½-inch (3.8-cm) worm or 0.75 gram of pigment, and the cyan might use a 0.5-inch (1.3-cm) worm or 0.25 gram of pigment.

First coat the paper with the yellow pigment and dry it. Put the blue-filtered negative

Nude at Window (© Richard Farber), gum print made with multiple printings of ivory black watercolor.

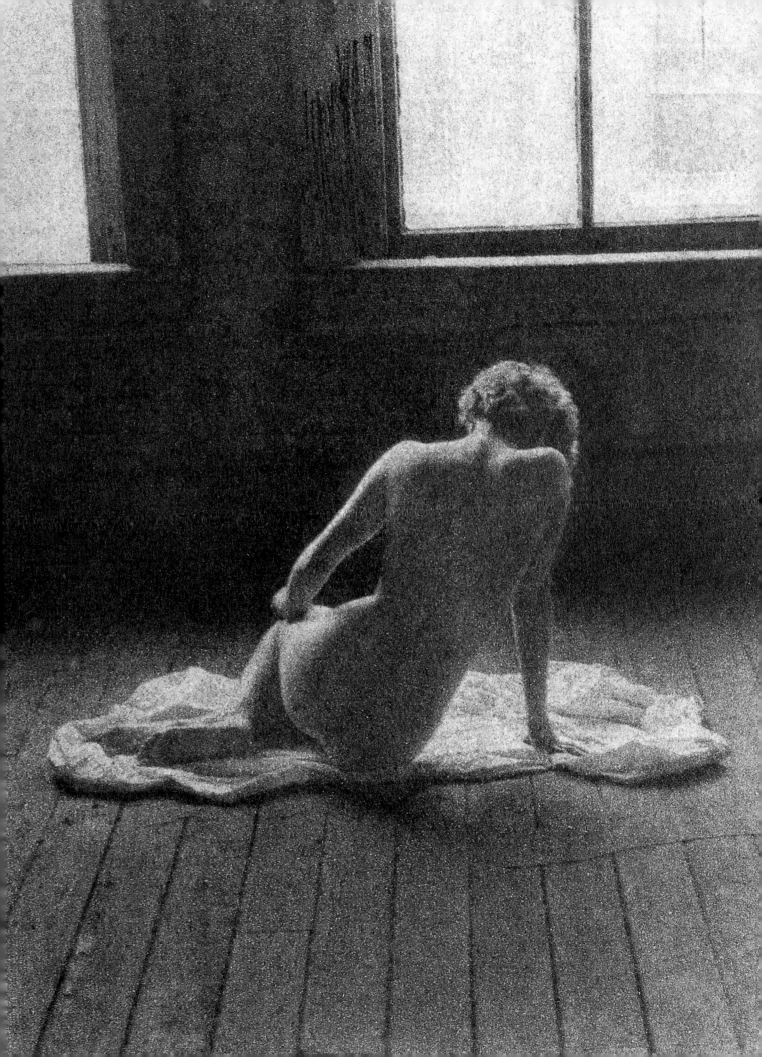

on the registration pins with the emulsion side facing you. Place the sensitized surface of the paper facing the negative on the registration pins and close the printing frame. The procedure will be the same for the green-filtered negative with the magenta pigment and for the red-filtered negative with the cyan pigment.

Exposure

Initial exposure times will vary with the light source, negative density, and pigment density. For the first printing with the blue-filtered negative, use your standard time for a monochrome gum print to start. A rough starting point for the exposure of the green negative might be 20% longer than that of the blue negative. And the exposure of the red negative might be 20% shorter than that of the blue negative.

Expose and develop each color using the directions given above for monochrome gum prints. Keep good notes of what you've done for future reference.

! Don't clear the print of the dichromate stain until all the colors have been printed.

Notes

1. There is a two-part article by Davis (1996) dealing with basic gum printing and three-color gum. Other sources of information about gum printing and three-color printing can be found in the bibliography. They include Crawford (1979), Green (1981), Nadeau (1987), and Wade (1978).

2. In the second installment of his article, Davis (1996) includes a particularly lucid and easy-to-follow description that is well worth reading on how to use a home computer to generate separation negatives with a laser printer. *Making Digital Negatives* by Burkholder (1995) is a very good introduction to using computer programs such as Adobe Photoshop to generate or enhance negative files digitally. It also gives advice on using service bureaus to create large-format negatives at a reasonable cost.

3. Davis (1996).

4. Shaw and Rossol (1991).

5. Ibid.

6. Sullivan (1985).

7. Davis (1996).

8. Kosar (1965).

9. Ware (1996).

10. Kosar (1965).

11. Neblette (1952).

12. See Darkroom Innovations in the list of sources in the appendix, Davis (1989), and Kachel (1995).

13. Crawford (1979).

Nemo's Voyage (© Wim Goossens). A fusion of new and old, this bromoil print in blue ink was created by altering and combining images with a computer, photographing the resulting image on the computer monitor, and finally making a bromide print from the new negative.

Bromoil

BROMOIL IS A PIGMENT-BASED PROCESS THAT INVOLVES TRANSFORMING A GELATIN SILVER image into a highly expressive, unique, permanent print in which the silver image is removed and replaced by a pigment. It is arguably one of the most beautiful of the pigment-based printing techniques and quite possibly the most versatile, controlled process in photography. Like the carbro and gelabrome processes, bromoil has the advantage of requiring neither an enlarged negative nor a UV light source, since the process is a chemical one. Its permanence is related to the permanence of the pigment used, blacks and dark browns being extremely permanent. It is interesting to note that the bromoil and carbro processes are basically the same chemically—the main difference is that in bromoil, the gelatin layer containing the image is made insoluble, while in carbro, the insolubility is produced in a different layer by diffusion.[1]

In the bromoil process, the silver in the bromide print is bleached in a solution containing such chemicals as copper sulfate and dichromate. This leaves a gelatin matrix that's differentially tanned, or hardened, in proportion to the amount of silver present. To begin the process, the bromide print is soaked in water, allowing the gelatin to swell in proportion to the degree of tanning present: the shadows swell less because they have a greater degree of tanning. Oil-based ink is then applied to the gelatin with specially shaped brushes. The more water-swollen highlights tend to repel the oily pigment, but it is accepted by the hardened gelatin (the shadowed areas of the image). Because the pigment is applied with a brush, the procedure of inking the print gives great creative control of density, color, and detail.

Bromoil evolved from the oil-printing process developed by G. E. H. Rawlings in 1904,

This chapter is based on an unpublished manuscript by W. Robert Nix (© 1997, W. Robert Nix) and is published with his permission.

which is a pigment-based process using paper with a dichromated gelatin matrix and requiring a negative the same size as the desired print size. In 1907, responding to the problems of using contact-sized negatives, E. J. Wall wrote a brief article suggesting the use of a bromide enlargement as the basis for an oil print.[2] Later that same year, C. Welborne Piper published an article detailing how to turn bromide prints into oil-pigment prints.[3] In a following article, Piper gave new and revised formulas for bleaching and fixing, along with new general procedures and techniques.[4]

Since Piper's introduction of the bromoil process, the key material has been the silver bromide, gelatin-coated paper upon which the pigment image is formed. Through the 1920s, almost all matte-surfaced bromide papers were suitable for bromoil. By the 1930s, most papers were supercoated with a layer of nonsensitive gelatin, which provided a harder coating to protect the image during processing and to help prevent the problems involved in using heated dryers. However, several manufacturers continued to produce a nonsupercoated paper for bromoil until World War II. Production was started again after the war, but only briefly. While not made specifically for bromoil, other suitable papers have been manufactured during the past forty years, but with somewhat unpredictable availability and reliability. The absence of a good, reliable bromoil paper, along with other changes in the photographic world, has led to limited interest in this once popular art-photo process.

With this decline in the market for their products, the major manufacturers of the highly specialized bromoil brushes, paper, inks, and prepared bleaches have ceased production. Fortunately, there are now a few specialized sources that have again started to make and distribute bromoil supplies. These resources are listed in the appendix in the section on sources.

The Bromide Print
The enlarging paper

Using the right paper is very important in achieving success with bromoil. There are some papers (nonsupercoated and fiber based) that are specifically designed for bromoil (for details, see the section on sources in the appendix). It's also entirely possible to make a fine bromoil with modern papers, despite the fact that most of them weren't designed with this process in mind.

Almost all modern photographic papers are supercoated, and photographic papers used for bromoil should not be supercoated. Aside from the papers specifically designed for bromoil, other nonsupercoated papers that are suitable include resin-coated (RC) papers such as Chen-Fu, Luminos Classic SW-Art, Kodak Polymax Fine-Art, and the document-art RC paper from Kentmere. RC paper has a fiber core that's protected on both sides by a plastic film. Contrary to popular belief, the emulsion is not under the plastic, but on top of it, and acts in the same way as it does on fiber-based paper. However, because only the emulsion has to be washed on RC paper—and not the paper fibers—washing is very efficient and fast. These papers also require shorter soaking times at lower

temperatures and may ink up much more readily with harder inks. Because RC paper is not a traditional material and hasn't been around long enough to establish a time-tested record of permanence, many prefer the known characteristics of a fiber-based paper.

Still at Rest *(© Luc van Quickenborne), bromoil print.*

All papers have their own characteristics and respond differently to bleaching, soaking, and inking. Semimatte papers generally work best for bromoil, glossy papers can be very difficult to ink, and dead-matte papers may contain too much starch, which tends to take up the ink too easily all over. Smooth-textured papers produce fine detail, but some images may be quite effective on rough-textured surfaces, although these are more difficult to ink up evenly.

Some supercoated fiber-based papers that have been reported to give satisfactory results with bromoil include the following:[5]

- Agfa PRN 118 (note that this paper has been reintroduced with a slightly changed emulsion)
- Arista Matte
- Ilford Galerie FB IG.5K
- Ilford multigrade FB matte
- Kodak Ektalure G surface
- Kodak Polymax Fine-Art G surface (resin-coated)
- Luminos Charcoal R
- Oriental FB-N (note that Oriental is no longer distributed and is now known as Cachet—the emulsions may not be the same)

Other double-weight semimatte or matte papers may also give satisfactory results and should be tested for performance if they are of interest.

Developers

The developers used in printing for bromoil should be nonhardening. Traditionally, the developer used has been amidol, but it is toxic, expensive, and has a brief tray life.

> ❗ If you use amidol, wear gloves and goggles and mix the powder under a hood or in a glove box to avoid inhalation. Refer to chapter 2 for proper precautions and see the chemical list in the appendix for specific hazards.

A developer called Ethol LPD (manufactured by Ethol Chemicals of Chicago) has been reported to give excellent results for this process and is suggested as a safer alternative to amidol. This developer uses phenidone and hydroquinone and is a good choice for those whose skin is sensitive to metol. Developers made by Ilford, such as P-Q Developer, are also based on phenidone and may be equally effective.

The alternative to the developers listed above is the M-Q (metol-hydroquinone) type, such as Dektol (D-72) or Selectol. A developer with a low carbonate content, such as Kodak D-52, is also worth considering. It has been reported that carbonate in excess of 2.5%,[6] as well as large amounts of hydroquinone,[7] has a tendency to harden the emulsion, causing the ink to be taken up too readily. This effect is probably minimal, but whether the hardening is actually enough to matter can only be determined by testing.

Regardless of the type of developer used, it should *always* be fresh; used developer may cause partial tanning of the gelatin.[8]

The Print

To make the bromide print, use a negative with a full range of values, with detail in both the highlights and shadows. Print on the appropriate contrast paper to produce well-defined highlights that are slightly darker than normal, a full range of middle values, and good separation in the darkest shadows. The exposure should allow full development of the image. However, don't expose for a maximum black shadow density; this can cause unnecessary loss of shadow density or detail when the image is inked later. High density can also cause problems in inking because heavy silver deposits may not bleach completely. Prints should have a white border, ½–1 inch (1.3–2.5 cm) wide, to serve as a working safe-edge. A print with a reflected density range of 0.10–1.65 will give excellent results.

Developing

Development should be for 2–3 minutes with fresh developer at the recommended temperature and with regular agitation. To avoid uneven developing, it's recommended that you develop only one print at a time. The developed print should be well drained before it goes to the next step of rinsing or a stop bath.

A Deserted Place (© W. Robert Nix), *duotone bromoil print made using black and brown inks.*

Fixing

In order to have a permanent image, unaffected by light, the print must be adequately fixed. *Fresh fixer should be used in all cases.* The traditional method of fixing a print for bromoil is to use plain hypo (sodium thiosulfate). Plain hypo has a proven record: it will not harden the emulsion or cause inking problems.

A pure hypo fixing bath has a pH of about 5.2, which would be altered rapidly and soon made useless if the print were taken directly from the alkaline developer to the fixer. Alternatively, stop bath will lower the pH rapidly and, at a certain point, form colloidal sulphur in the hypo.[9] If plain hypo is used, you can avoid either of these possibilities by simply rinsing the print well on both sides prior to fixing. It should be kept in mind that

183

using only a water rinse and no stop bath will also substantially reduce the life span of the fixing bath.

The print should be fixed for 5 minutes with constant agitation in a fresh 10% solution of plain hypo. If several prints are planned, however, either a fresh, single fixing bath can be made *for each print,* or two sequential fixing baths can be used for 2½ minutes each, with the print rinsed off between baths. A 1-liter fixing bath of 10% hypo (100 grams to 1 liter of water) provides an adequate volume of solution for a print up to 11 × 14 inches (28 × 36 cm) and will safely fix up to ten prints of this size if two sequential 1-liter fixing baths are used. Because this is a comparatively weak bath, be careful not to exceed its capacity.

Alternative formulas for fixers containing sodium thiosulfate that can tolerate the use of a *nonhardening* stop bath include the following:

Acid fixing bath

Water (distilled) 32°C/90°F	500 ml
Sodium thiosulfate	250 grams
Potassium metabisulfite	24 grams

OR *(but not both)*

Sodium bisulfite	24 grams
Water (distilled) to make	1 liter

Kodak F-24 nonhardening fixer

Water (distilled) 32°C/90°F	500 ml
Sodium thiosulfate	240 grams
Sodium sulfite (anhydrous)	10 grams
Sodium bisulfite	25 grams
Cold water (distilled) to make	1 liter

An area of controversy seems to be the use of acetic acid stop baths and/or the use of bisulfites in the fixer as opposed to plain hypo preceded by a water rinse. Whether this will cause problems with inking on some papers is best determined by individual testing and comparison. Many, however, prefer to use plain hypo and a water rinse because the results are proven.

Rapid fixer (ammonium thiosulfate) with no hardener added can also be used. All fixers can reduce delicate highlight densities if fixing is prolonged, but this can happen even more readily with ammonium thiosulfate. Because of this, special care should be taken not to exceed the manufacturer's recommended fixing time. Regardless of the type of fixer used, it's important to note that there must be no hardener in the stop bath or fixing bath; otherwise, it will not be possible to selectively harden the gelatin in the bleaching bath.

Generally, when a fixer has up to 2 grams of silver per liter, it's considered exhausted.[10] An easy way to test this is to use a commercially available hypo testing solution. A simple formula for making your own testing solution is given in the appendix.

! Do not pour used fixer down the drain. This is not only environmentally unsound, but also illegal in
most areas. Save used fixer in a clearly labeled container and take it to your chemical recycling center.

After fixing, prints should be rinsed off with running water for 1 minute and then given constant agitation for 2–3 minutes in a washing aid such as Kodak Hypo Clearing Agent or a 2% solution of sodium sulfite (20 grams per liter) for 2 minutes. The prints can then be washed for 15–20 minutes. If RC paper is used, the wash can be as short as 5 minutes in an efficient washer. If only one print at a time is being washed, a very efficient method of washing is to use a simple tray siphon or a wash tray that's designed for RC prints. Care should be taken to prevent prints from sticking together; this can result in uneven inking and spots. After washing, prints should be carefully blotted free of surface moisture and placed face up to dry. They can then be stored until you're ready to make the bromoil.

The Gelatin Matrix
Super drying

Preparation of a bromoil matrix is begun by super drying. This can be done by carefully holding the print over a hot plate or using a hair dryer until the print is crisply dry. It's suggested that you follow this procedure at any point where the print or matrix is dried.[11]

Bleaching

The next step in the bromoil process involves transforming the gelatin silver bromide print into a gelatin matrix through a bleaching/tanning treatment.

! The bleaching procedure requires careful attention to detail. Avoid chemical contamination. Stains, spots,
muddy tones, and failure to ink properly will inevitably result from poor procedure.

To make the bromoil matrix, the silver image is bleached completely to silver bromide, and the gelatin is tanned, or hardened, in direct relation to the amount of silver in the image. This differential hardening, which is also the basis of the carbro process, was discovered by E. Howard Farmer. He found that when dichromate comes in contact with the finely divided silver in a photographic print, it is reduced and causes the gelatin to become insoluble.[12] The bleached and tanned gelatin matrix is hardened in direct relationship to the range of values in the original silver print: in the darkest values, the gelatin will be tanned/hardened the most, with middle values tanned somewhat less, and the lighter values only slightly affected. When the gelatin is hardened, it is prevented from absorbing water. The bromoil process works on the principle that oil pigments are repelled by water-saturated gelatin but are accepted in varying amounts by the relatively harder areas of gelatin.

All the bleaches used in this process contain a chromium compound, such as chrome alum or potassium dichromate (which are known carcinogens); however, those using

LEFT: Untitled landscape, initial inking has been done with a roller (© W. Robert Nix).

RIGHT: Overall initial inking with a roller. The lower left quarter has had some brushwork and hopping for detail (© W. Robert Nix).

chromic acid for tanning the gelatin are particularly hazardous and should be avoided altogether. Also, bleaches containing acetic acid should be used, if possible, instead of bleaches using sulfuric acid or hydrochloric acid.

> ! Sulfuric and hydrochloric acids are dangerous by any means of contact and should be handled with caution. Wear acid-resistant gloves and protective goggles. Handle only under a ventilation hood. *Always add acid to water, not the reverse*, to avoid boiling and splattering. Refer to chapter 2 for proper precautions and see the chemical list in the appendix for specific hazards. Do not pour used bleach down the drain. This is not only environmentally unsound, but also illegal in most areas. Save the used bleach in a clearly labeled container and bring it to your chemical recycling center.

There are perhaps more formulas for the bromoil process than any other historic process. Different formulas for bleaches produce subtle differences, but all essentially perform the same task. The following formula has good keeping properties and works well with many papers.[13]

BLEACH SOLUTION 1

Mix the following in the order given to make a stock solution:

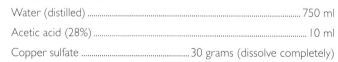

Water (distilled)	750 ml
Acetic acid (28%)	10 ml
Copper sulfate	30 grams (dissolve completely)

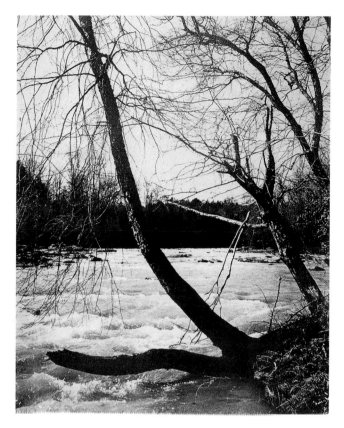

Potassium bromide ..30 grams (dissolve completely)

Potassium dichromate ..2 grams

Water (distilled) to make ... 1 liter

For use, dilute 1:3 (1 part stock to 3 parts distilled water) and use at 20–21°C/68–70°F. *Make a fresh working solution for each print.* Store the bleach in a well-labeled brown bottle in a cool, dark location.

! A solution of 28% acetic acid can be made by diluting three parts by volume of glacial acetic acid (99%) with eight parts of distilled water. Handle this material carefully. Wear gloves and protective goggles. Make sure there is good ventilation. Potassium dichromate is a known carcinogen. Wear gloves and goggles when handling it. Use a fume hood and avoid inhalation. See the chemical list in the appendix for further precautions.

Another formula is the following:[14]

BLEACH SOLUTION 2

Water (distilled) ..500 ml

Copper sulfate (10% solution) ..70 ml

Potassium bromide (10% solution) ...70 ml

Potassium dichromate (1% solution) ...30 ml

Water (distilled) to make ... 1 liter

One liter will bleach up to twelve 5 × 7 (13 × 18 cm) prints.

LEFT: Clearing the highlight detail with a 1 1/2-inch (3.8-cm) bear hair brush (© W. Robert Nix).

RIGHT: Completely inked print; no final spotting has been done (© W. Robert Nix).

The bleaching process should be carried out under subdued lighting conditions. Working temperatures should be held within 18–24°C/65–75°F.

> ! Refer to chapter 2 for proper safety precautions.

Soak the print in water for approximately 5 minutes and then drain the print thoroughly. With the image side up, the print can be slipped quickly into a glass or plastic tray containing the bleach, or the bleach can be poured over the print. While in the bleaching solution, the print should be agitated continuously. The print should never be permitted to float out of the solution; this will cause uneven bleaching and result in inking problems.

The bleaching time of the print is dependent upon many variables, including the type of paper and its surface, texture, exposure, and contrast; the developer formula; and the bleach dilution, strength, age, amount of use, and temperature. In general, times may vary from 5 to as long as 30 minutes. A bleaching time of less than 2 minutes is not long enough to provide a uniform bleaching action. If the bleaching time is this short, the bleach should be diluted. For times that are excessively long, use a stronger bleach solution, up to a stock solution. If light, middle, and dark tones bleach readily in a few minutes and heavy dark shadows refuse to bleach, it's an indication that the print was printed too dark; a lighter, softer print will be necessary. Refusal to bleach completely may also be due to improper fixing and/or insufficient washing before bleaching.

The bleached print will retain a faint yellow-green image, while incomplete bleaching of heavy black areas will leave a copper-colored image that may cause problems in inking. Prints should remain in the bleach for one-third longer than is required to remove the silver image to assure proper hardening of the gelatin. Old bleach may in time remove the silver image but it may not tan the gelatin properly. Fresh bleach is recommended, especially until you are thoroughly familiar with all phases of the process.

> ! Excessive bleaching will cause a general, *overall* tanning of the gelatin, rendering it useless as a bromoil matrix.[15]

After bleaching, the matrix must be washed thoroughly to remove all traces of the bleach solution. Wash with running water for 15 minutes, dumping and filling the tray six to seven times or until there is no hint of yellow on the matrix or in the wash water. Handle the matrix with caution to ensure that the delicate surface is not damaged.

After this wash, the matrix is fixed in a fresh, 10% plain hypo solution for 5 minutes with constant agitation to remove the bleached silver. This must be done to prevent the silver bromide that's still present from later discoloring the print.[16]

Following this last fixing bath, rinse the print off and put it in a bath of running water for 1 minute. The print can then be put into a commercial hypo clearing agent or a 2% solution of sodium sulfite for 2 minutes with constant agitation. This is followed by a 10–

15-minute wash. When the print is removed from the wash, there should only be a very faint greenish image in the matrix.

Black Water Lily (© W. Robert Nix), bromoil print.

Although it's possible to go directly from developing to bleaching and then to inking, it's strongly suggested that the print be dried in between each stage to strengthen the gelatin. The matrix image is fragile while wet and should be gently blotted free of moisture and air-dried face up. When dry, the matrix can be stored for up to several years before inking.

Tips

It has been suggested that modern supercoated papers could be conditioned in various ways to make them suitable for bromoil. The following is one method that's worth trying:[17]

- Make a stronger print with heavier tones, but still no maximum black, taking care not to exceed the fixing time.
- After the print has been dried following the bleaching step, it should be put into a presoak of 43°C/110°F.

Shaded Barns (© W.
Robert Nix), bromoil print.

It's important not to exceed this temperature. Putting the print directly into water of this temperature can cause reticulation or other damage to the gelatin: first immerse the print in water at room temperature until it's limp, then put it in water that's 26.6°C/80°F for a few minutes, and finally put it into a water bath that's 43°C/110°F, where it should remain for 15 minutes. The temperature of the last bath doesn't need to be maintained and can be allowed to gradually fall.

- Remove the print and blot off the surface moisture with a soft sponge or a well-washed linen or cotton cloth. Allow it to dry and then super dry it. It can later be soaked and inked.

As a last resort, the following methods might be worth a try.

If contrast is a problem with supercoated paper, it's possible that the difference in the degree of tanning corresponding to different areas of exposure isn't great enough to produce adequate contrast in the bromoil print. A suggestion for improving contrast is to bathe the print *before bleaching* in a 3% citric acid bath or in a weakly alkaline solution, such as a 2% solution of sodium carbonate or sodium metaborate. This de-tans the gelatin to some extent.[18] After this treatment, the print should be washed well for at least 10 minutes. The surface moisture should be blotted off with a soft sponge or well-washed linen or cotton cloth and then allowed to dry. It should then be super dried.

An alternative method for increasing the contrast in supercoated paper is to redevelop

and rebleach the print several times prior to the last fixing bath. Because greater tanning will take place in the shadow portions than in the highlights, the tanning of the exposed portions will be differentially increased each time.[19]

Soaking the matrix/conditioning the gelatin

It's necessary to soak the dried gelatin matrix in order to bring it into condition to be inked. When the matrix is soaked, the gelatin swells in direct relation to the degree of tanning brought about in the bleaching and tanning process. Also, the time and temperature required for optimum results will vary with the kind of paper used. Usually, the swelling of the gelatin produces a relief image that is often quite visible under an oblique light. Some papers will exhibit high relief while others may not, yet both may ink up with relative ease. The ability of the matrix to accept and reject ink, not the boldness of relief, is what is really important.

Only experimentation will give you the ability to make critical judgments about the desired results. There are, however, some visual and tactile indicators that may be of considerable help. For example, draining water from the surface of the matrix may reveal a shiny relief image that, with experience, can be used to evaluate and determine if proper swelling/conditioning has occurred. Another check is to carefully feel the surface of the highlights. They should have a slick, slimy quality that is unmistakable once it has been experienced.

The bleached matrix should first be super dried and then completely submerged face up in a clean tray of water. All air bubbles must be removed and the matrix weighted with wads of cotton or glass rods to prevent it from floating to the surface and soaking unevenly. The degree of swelling necessary to bring the matrix into proper condition is determined by soaking time and temperature. Each type of paper will exhibit its own soaking characteristics, which can be determined only with carefully controlled testing.

Make six identical gray-scale test prints (see chapter 1 for information on gray scales), 2×3 inches (5×7.5 cm) with a ¼-inch (6-mm) white border all around, and prepare them as test matrices for the type of paper being used. Number them on the back (1 through 6) with a pencil so that they can be identified later.

To determine optimum time and temperature, submerge test matrices 1 to 3 in a tray containing water at 26.6°C/80°F for 15 minutes. Make sure there are no air bubbles and that the matrices do not float to the surface. Remove test paper number 1, drain the water from the surface, and examine it. If it's properly conditioned, water will drain away from hard, dark steps, while light steps and the border may appear in relief and have a wet shiny surface. Carefully run your finger tip across the surface—the light areas should feel slick and somewhat slimy. Because these visual and tactile observations are not always reliable, another test should also be done.

Using the instructions found in the section on inking, attempt to ink up the gray scale using the basic hard ink. If it doesn't reveal the indicator signs or accept ink, put it back into the water, soak it for another 15 minutes, and check it again. Should it accept ink to

some degree this time, note the length of time and temperature and put it aside to dry. If it doesn't accept ink, increase the water temperature to 32°C/90°F and soak it for 15 more minutes. Inspect it and attempt to ink the matrix as before. Continue this pattern of increasing time and temperature until the ink adheres to hardened areas on the test matrix. Note the time and temperature and set it aside to dry. Continue to soak matrices number 2 and 3 for 15 additional minutes. Ink matrix number 2 and note the time and temperature. Increase the temperature 5.5°C/10°F and continue to soak matrix number 3 for another 15 minutes. Ink matrix number 3 and note the time and temperature.

Inspect the three inked prints and select the best image. *Using the test time and temperature of the best print as a reference point*, take test matrix number 4 and place it in a water bath that is 5.5°C/10°F warmer and soak for one-half the time. Place matrix number 5 in water that is 5.5°C/10°F cooler and soak it for double the time. Place matrix number 6 in water that is 5.5°C/10°F warmer and double the time. Ink matrices 4 to 6 as before and compare them. If needed or desired, further systematic tests can be made and the results recorded for use in determining the optimum soaking procedure. This testing will take a little time initially, but it will save a lot of frustration and paper in the long run.

A simpler method of testing, although it gives less information, is to use a test print rather than a gray scale. This should be soaked initially for 15 minutes at 26.6°C/80°F. If the image inks up easily with a hard pigment in an area of contrast that shows distinct differences between highlight and shadow values, then the swelling is suitable. If this isn't the case and the ink covers all of the trial section without differentiation, then the swelling is inadequate and the print will need a bath of a higher temperature. Increase the bath 5.5°C/10°F for 15 minutes each time until the desired swelling is obtained.[20]

All papers respond differently. Some, for example, will reach proper conditioning at low temperatures of 24–26.6°C/75–80°F and a long soaking time of 2–4 hours, while others may require temperatures of 38–49°C/100–120°F and a 15–30-minute soaking time. Once the time and temperature for soaking a given paper have been determined by testing, and all other factors are the same, similar matrices may be brought into condition under the same time and temperature.

Gelatin begins to swell when it is immersed in water and will in time reach a maximum amount of swelling for a given temperature. If more swelling is desired, the temperature must be increased. Papers designed for bromoil will generally reach proper swelling at 24°C/75°F after 15–20 minutes. Temperatures much higher than this will cause the gelatin to dissolve.

Conventional papers such as Kodak Polymax Fine-Art can safely handle temperatures of 38°C/100°F or higher. If high soak temperatures are needed, it is best to first soak the paper for 5 minutes at about 26.6°C/80°F and then place the matrix in the hot water. Soaking in hot water not only increases swelling, it also weakens the gelatin coating and makes it much easier to damage. Once the gelatin is damaged, it will not ink evenly, and attempts to correct the problem are usually futile. When soaking temperatures are above 32°C/90°F, the soaked matrix should be immersed in a 21–24°C/70–75°F cooling bath to help prevent damage to the fragile gelatin during inking.

Soaking for a short time at high temperatures tends to increase contrast, while long soaking at low temperatures may decrease contrast.

Soaking for an insufficient length of time results in highlights that accept too much ink. It also blocks up shadows. If this happens, soak the paper again for a longer time and/or increase the temperature.

Soaking for too long a time may make it more difficult to get ink to adhere to areas with lighter values, resulting in little or no detail in highlights. Softening the ink may help, but print quality will suffer.

If the matrix is not swollen enough to produce a full range of values, the image will accept too much ink in the highlights. To correct this, increase the soaking time and temperature until the desired quality is obtained. Once the gelatin has been swollen at a given temperature, however, resoaking at a lower temperature will not reduce the degree of swelling. Therefore, care should be taken to avoid initial overswelling. Remember, only objective testing can determine the proper time and temperature for a given image quality.

If your water is hard (containing minerals), you need to increase the soaking time. If this is a problem, 1–2 drops or two of household ammonia in the soaking water may increase swelling, but it is not recommended as a general practice since it tends to make the gelatin soft.

Ultimately, the degree of swelling for optimum results varies so much from paper to paper that only careful testing and experience can produce truly controlled results.

Bromoil Ink

Mixing and preparing ink is done on a palette made from an 8 × 10-inch (20 × 25-cm) or larger piece of ¼-inch (6-mm) glass that can be backed with a sheet of white paper. Solvent-resistant plastic can also be used for the palette. If glass is used, be careful to sand the edges smooth to avoid being cut. The palette must have adequate space for hard and soft inks, mixing areas, areas to spread ink, and areas to work in ink on brushes and/or rollers.

Traditionally, bromoil inks were manufactured in two consistencies, hard and soft, and bromoil inks are the obvious choice, if you can obtain them. But there are other options: lithographic inks, available at art-supply stores, work well. If they are not stiff enough, slowly add artists' dry pigment or magnesium carbonate and work it in thoroughly with a heavy palette or putty knife. A neutral black litho ink, stiffened with a little dry burnt sienna pigment produces an excellent warm black ink. If the ink is too hard or stiff, mix it with a softer ink or add 1–2 drops of pure artists' linseed oil. Mix the oil in thoroughly, check the results, and proceed as needed.

Different inks have different working qualities. Therefore, it is best to use only one ink until you're thoroughly familiar with the entire bromoil process.

Making bromoil ink yourself is one way to have a ready supply of ink with known

working qualities. To make the ink, you need the following materials (available from any art-supply store):

Dunes of Fantasy (© W. Robert Nix), bromoil print.

- one or more small jars with a capacity of 2–4 oz (60–120 ml)
- dry pigment, preferably ivory black to begin with (note the warnings about pigments in the appendix)
- a small bottle, 2–4 oz (60–120 ml), of sun-thickened linseed oil (*stand oil*)
- a small bottle, 2–4 oz (60–120 ml), of refined linseed oil, almost water-white and thin
- a 1-inch (2.5-cm) palette or putty knife with a flexible blade or an inexpensive smooth table knife

To prepare bromoil ink, place 8–10 drops of the sun-thickened linseed oil on the palette and begin working in small amounts of dry pigment with the putty knife until it is fully absorbed. (Different pigments are composed of different chemical compounds and require different amounts of oil to produce the same consistency of ink.) Continue adding small amounts of pigment, spreading, mixing, picking the ink up with the knife, and spreading again until a stroke of the knife spreading the ink leaves it with a matte

surface for about a second before the ink begins to turn glossy. At this point, the ink will be very stiff. Before using it, add a drop of the refined linseed oil and work it in thoroughly. Pigment or oil can be added and mixed in thoroughly as needed to adjust the stiffness of the ink for any particular application.

One method of checking the consistency of the ink for use with a soft-haired brush, such as fitch or bear hair, is to put a small amount on the palette and gently put your finger into it. If your finger goes in smoothly and is covered with ink after you withdraw it, then it's too soft. If it isn't possible for your finger to go into the pile of ink and very little ink sticks to your skin, then it's too hard. If you can penetrate it, if it feels similar to the grabbing sensation of chewing gum, and if your finger comes out with some ink on it, then it's about the right consistency.[21]

Once the ink is prepared, take a small amount, about the size of a pea, and spread it on the palette in a very thin, even coat, using the edge of a palette knife, putty knife, or old table knife. Touch a large bromoil bristle brush into the thin layer of ink and then, while holding the brush vertically, *dab* it on a clean area of the palette five to twenty times to thoroughly and evenly spread the ink to the tips of all the bristles (this action is sometimes called *pouncing*). When this is properly done, the palette will show only a very thin layer of ink and the brush will transfer only a hint of ink if dabbed in the palm of the hand. Repeating this action will leave a second thin layer of ink on the palette, which is what the brush should be recharged from as you work. It is essential to always work the brush out into the second area of ink thoroughly after recharging it from the main ink supply. This will prevent large bits of ink from being transferred to your image; only the smallest particles of ink should remain on the brush when you are working on the conditioned matrix. The process of inking the image is accomplished by gradually building up the ink.

Bromoil Brushes

There are two kinds of bromoil brushes, each producing a different effect. Brushes made with pure hog bristles are very good for general inking and will produce a bold, coarse image. Brushes made from fitch (European skunk, popularly called a polecat) or bear hair produce a much subtler range of tones and finer detail.

The bristle brush is good for initial inking of the matrix and general ink application. This is then followed by the hair brush to even out the inking and bring up subtle detail. The use of different brushes in selected areas provides the photographer with extensive control over how each part of the image is emphasized.

Bromoil brushes are designed for just the tips of the hairs or bristles to be used in applying a thin coating of ink to the gelatin matrix. The brush is round at the ferrule, with the hairs at the tips varying in length from one side to the other, producing a slightly domed working surface, which is set at about a 65° angle. A brush of this shape is known as a *stag* or *deer foot* brush, the shorter side being referred to as the *heel* and the longer

side being the *toe*. The handle of the brush is held vertically in relation to the matrix to apply the ink.

Historically, bromoil brushes were made in an assortment of sizes ranging from ¼ inch (6 mm) in diameter to as large as 3 inches (7.5 cm). For general use, 1–1¼-inch (2.5–3.2-cm) brushes are excellent. Good-quality hog-bristle brushes of this size are the least expensive; bear hair or fitch brushes cost respectively more. While there is no substitute for top-quality brushes and a variety of sizes, one of each in this size range will do the job. A good-quality brush may be expensive, but it will last for many years if cared for properly.

Making brushes

If no bromoil brushes are available, other workable brushes may be improvised. For the times when smaller sizes are needed, ¼–½-inch (6–12-mm) brushes can be made from relatively inexpensive artists' paintbrushes. Round-bristle brushes may be carefully cut at a 65° angle with a single-edged razor blade. Cutting the natural tip of the bristle removes the split, flag ends and produces a harsh blunt end. This will not apply the ink in as subtle a manner as a brush specifically made for the purpose, but it will work, and sometimes such small sizes are needed.

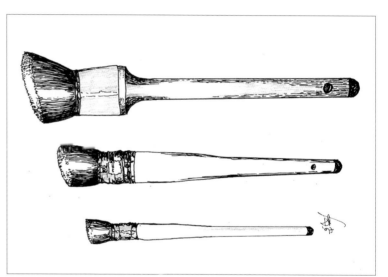

Bromoil brushes usually have a distinctive stag-foot shape. They are available in a variety of sizes and materials, bear and fitch being the most expensive.

Large-bristle stencil brushes, 1–1½ inches (2.5–3.8 cm) in diameter, may be obtained at paint stores and carefully cut with a razor blade and a good pair of scissors to the proper shape. Whether working with bristle or hair brushes, be sure to cut them at the proper angle and then trim them to give a slight domed form to the angled working face of the brush. Round camel, squirrel, or synthetic watercolor brushes, sizes 6 through 12, can be trimmed to work rather well, but these relatively small brushes will apply ink more heavily than a large 1–1½-inch (2.5–3.8-cm) brush.

Rollers

An alternative way to do the initial inking is to use soft rubber block-printing rollers or the polyester rollers designed to do trim work in regular house painting. The rubber roller is also excellent for rolling out a thin layer of ink on the palette.

A 4-inch (10-cm) polyester roller is inexpensive and can be easily slipped on and off

the roller handle, making it convenient to use one roller to apply ink and another (clean one) to clear up the image.

Care and cleaning of brushes and rollers

Fine brushes are essential to producing a fine product. They are expensive and need to be kept clean and shaped with a protective sleeve. There has been a lot of debate about how brushes should be cleaned, but regardless of the method chosen for cleaning, care should be taken when handling the wet brushes.

Rollers can be used for initial print inking and to roll out a thin layer of ink on the palette. They come in a variety of shapes, sizes, and textures.

It is essential that brushes and rollers be completely dry before use. Traces of water will produce spots, and solvents will soften the ink. Brushes that will be used again in a day or two may be cleared of excess ink by being worked out on a clean palette or piece of paper and put aside without further cleaning since they won't dry completely. However, more thorough cleaning is necessary when brushes are to be stored. Because they are made of natural hair fibers, for storage they should be placed in a mothproof container or one containing mothballs.

The least hazardous cleaning procedure is to work ink out of the brush on paper towels and then rub in a thick, warm lather of *100% pure soap*. (It is not advisable to use detergents or special brush cleaners.) Allow the lather to set for several minutes, then carefully work bristles between thumb and fingers. Gently work out the soap in the palm of the hand, then rinse and repeat until all traces of soap are rinsed out. Shake the excess water off and hang the brush vertically to dry thoroughly. When the brush is dry, place a paper sleeve around the bristles to protect them from damage and to retain the stag-foot shape. Regular household rubber gloves can be used to protect your hands from ink when you are cleaning the brush with soap and water.

Brushes can also be cleaned in benz*ine* (not benz*ene*) or odorless mineral spirits. If these chemicals are of good quality, they should leave no residue on the brush. Turpenoid is not a good substitute, since it may leave a residue.

> ! If you use these materials, make sure there is adequate ventilation and use fire precautions. These products can dissociate into toxic products with heat.[22] See chapter 2 and the chemical list in the appendix for further precautions.

! The following materials are sometimes recommended for cleaning, but they are hazardous and should *not* be used:

- Carbon tetrachloride causes cancer in animals and is expected to be named as a carcinogen in humans by the U.S. National Toxicology Program. This material is dangerous through every route: it can be fatal if swallowed, inhaled, or absorbed through the skin. Its effects are heightened with alcohol, and fatalities have resulted from drinking alcohol and using this substance. Specialized safety equipment and handling procedures are essential. *This material should be avoided. Do NOT use it.*

- Trichlorethylene, also known as trichloroethene, has caused cancer in test animals and is expected to be named as a carcinogen in humans. Inhalation of the vapor or ingestion of this material may cause nausea, vomiting, headache, and/or loss of consciousness. *This material should be avoided. Do NOT use it.*

- Solvents such as gasoline and lacquer thinner are toxic by every route and highly flammable. Turpentine is also quite toxic and leaves a slow-drying residue on the brush, which will adversely affect the inking qualities. *Because of the significant health hazards involved, these materials should not be used.* It's important to note that paper towels or other materials used with these materials are themselves fire hazards if exposed directly to heat and/or flame. All materials used with these chemicals should be disposed of in a specialized container designed to contain oily rags or other flammable material safely.

Inking the Matrix

At this point, the matrix has been soaked to swell the gelatin so that it exactly matches the consistency of the ink, or the ink has been adjusted to match the degree of swelling of the gelatin. In practice, one usually does a bit of adjusting to both while working within the parameters of ink quality and the fragility of the gelatin.

There are many descriptions of brush movements, which seem to vary from individual to individual. To begin, however, there are three basic brush movements that are used to control the inking process. These movements may be described as a sort of slow springing or patting action, a faster dabbing action, and a hopping or whisking motion.

Slowly using the natural spring action of the brush serves to deposit ink with little contrast. Fast springing/dabbing removes ink from the highlights and deposits it in the shadows. The hopping action increases contrast and removes ink mostly from the highlights, although a small amount will also be removed from shadows. It can be seen that the basics of controlled brush action involve the principle that downward strokes deposit ink, while the upstroke removes ink. Slow, deliberate pressure on downstrokes deposits proportionately more ink, while a more rapid upstroke removes more ink.

Preparing the matrix and inking the brush

Remove the conditioned matrix from the soaking bath and place it on a piece of plate glass or other smooth, nonabsorbent—movable—work surface, at least 2–3 inches (5–7.5 cm) larger than the matrix, which will not be affected by solvents. Carefully remove

all moisture from the back and front of the matrix using a soft, moist, viscose sponge or a chamois. View it at an angle and make sure that there are no water droplets on the surface of the matrix or the work support. Now, take a large-bristle brush (hog brush), lightly charge it with hard ink, and work it out well by dabbing it on the palette as described in the section on brushes. This action will distribute small particles of ink evenly on just the tips of the bristles.

Initial pigmenting

Hold the brush vertically, with the heel at the bottom, next to you, and the toe at the top, away from you. Select a section of the matrix where there are strong contrasting areas that will respond to inking rather quickly. Gently touch the tip of the brush to the matrix and press down until the face of the brush is just touching the gelatin, then allow the brush to spring back to its toe. The springing action will move the brush down the surface of the matrix a distance about equal to its diameter. Repeat this action down the matrix, then lift the brush, recharge with ink, and work out as before.

Continue to ink using slightly overlapping strokes until the entire surface has been covered. This initial inking will reveal a light, unevenly inked image. The matrix should then be rotated 90° and systematically inked all over again. The objective is to build up the image in thin overlapping strokes until the entire image is uniformly inked; the process should be repeated until the matrix has been inked from all sides. By rapidly covering the entire image with a thin coating of ink, the moisture in the gelatin is retained and the matrix will not dry out too quickly.

Inspect the image after this initial inking. At this point, the buildup of ink should reveal the image in considerable detail. Any unevenness or blotchy areas are usually caused by overinking with a fully charged brush and a heavy hand. Light, underinked areas may be evened up by selective applications of ink with a lightly charged brush.

Resoaking the matrix

As inking progresses, the matrix will begin to dry and will need to be resoaked for a few minutes to restore proper conditioning. The first indication of this will be in highlight areas that accept ink uniformly and do not clear up with stippling or hopping of a discharged brush, and in shadows that will not reveal detail. A final obvious sign is that the corners of the matrix will begin to curl up.

Resoak the matrix in water at room temperature, then place it on paper towels to absorb moisture from the back. Return it to the work surface and very carefully sponge the moisture from the surface of the matrix. There may be some water streaks and slight smudges, but the image can be quickly restored using a light overall stipple action with a discharged fitch brush. Continue inking the matrix as before. The matrix may need to be resoaked several times if the print is large and complex or if your inking technique is slow and indecisive.

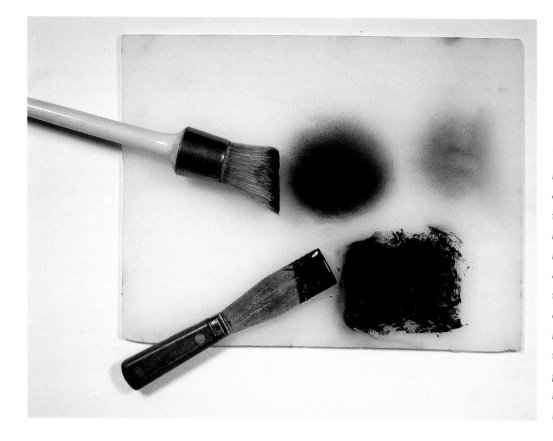

The palette, made of glass in this illustration, is the center of activity for inking the bromoil print. The brush is initially charged from the main ink supply and then dabbed on another area of the slab to spread the ink evenly on the tips of the bristles, leaving a second thin layer of ink on the palette for recharging the brush (Photo © W. Robert Nix).

Brush movements for selective contrast control

Slow dabbing or slow springing brush action. As the image emerges, it will become evident that more selective control of the inking is necessary. Some areas will begin to get too dark, or will become dull and muddy, while others may not be taking ink in the highlights. The initial brush action, a kind of patting motion, is a good means of generally applying ink. This brush action can be modified for more selective inking by pressing down on a charged brush and pausing momentarily before allowing the brush to spring back. This action deposits more ink in the darker areas than is removed in the lighter values when the brush springs back.

This action can be further modified to move ink from areas that are becoming too dark and losing separation in the lower values to deposit it in the middle and higher values, providing a richer, broader tonal range. This involves a rather deliberate, but faster, stippling action with a lightly charged brush, which can also be used very lightly, with a discharged brush, to remove ink. Discharging the ink is accomplished by gently pouncing the brush on a clean area of the palette.

Hopping or sweeping brush action. A final refinement of this brush action is referred to as *hopping*. This involves very rapid, light bouncing of a discharged brush off of the matrix. In practice, the brush is held vertically about ¼ inch above the surface, gently thrown down against the matrix, caught as it bounces up, and then gently thrown down

again, repeating the process in very rapid succession. This can also be visualized as a type of rapid tapping action. This action, using the toe of the brush, will further increase contrast and clean up the highlights. If needed, a quick, very light whisking or sweeping action with the toe of the brush may be used to sharpen detail and make highlights sparkle.

All the brush actions described above may be used with hog, bear, or fitch brushes. In practice, bristle brushes are generally used for overall and general application of ink, while fitch or bear hair brushes are frequently used to refine tonality and bring out subtle detail. Smaller brushes may be used to apply ink in a more select and controlled manner.

The secret to controlled inking is to use a very lightly charged brush that is frequently recharged and well worked out before being applied with a light touch. This slow, controlled buildup of ink keeps the overall range of values in the various areas in their proper relationship. Remember that adding ink is easy; removing it is difficult and very hard to control.

Brush action and touch can only be learned by experimenting; the actions of the brush may look the same to an observer, but the feel of the brush and ink on the gelatin is unmistakable and guides the actions needed to control the process in the making of a fine print.

Remember, the proper brush action should be light and easy. If you are having to work too hard at controlling the brush action, it isn't right.

Applying ink with rollers

The use of rollers is an alternative method for the general overall application or removal of ink. When a roller is used, it should be applied lightly and from all directions. Its action is somewhat like the use of the brush: slow pressure deposits ink while light rapid action removes it. Light charging with ink and slow buildup produces a full range of values and clean sparkling prints. In general, rollers tend to increase contrast and sharpness. They can be used to clear up and sharpen detail that has been locally controlled through careful brushwork. Work carefully with the roller from all directions. The matrix tends to hold to the roller with repeated action, which may cause blisters in the emulsion that could lead to the emulsion layer being ripped from the paper base.

Whether you are using brushes or rollers, blisters and damage to the gelatin surface will produce an irregular tonal quality that cannot be completely corrected.

Rollers give a mechanical quality and inevitably leave roller marks that require brush action to clean up and give the print the controlled application and removal of ink that is at the heart of the bromoil process. Going back into the print with relatively small fitch brushes will remove any roller marks and control transitions from one area to another as desired to finish the print.

Untitled bromoil print (© David Lewis).

Adjusting the consistency of the ink

If the matrix inks well in the lower values but refuses to take ink in the highlight areas, it may be necessary to use a softer ink or adjust the consistency of the ink. Many workers ink the matrix with hard ink and then switch to a slightly softer ink and a fitch brush for finishing. A softer ink may be needed to produce the delicate, subtle tones in the brightest highlights, but care must be taken to keep this ink from softening the hard ink in the shadows, producing an overall muddy print. Highlights can often be brought out by just touching the toe of a fitch brush that has been lightly charged with hard ink into some soft ink and then working it out on a clean area of the palette.

> Hard inks go on first. When used over soft, oily ink, they are also softened and the result may be a flat, disappointing image. Remember that inking and ink adjustment is more a matter of feel than of formula.

Matching ink quality to the swelling of the gelatin will take time, but it will soon become apparent that harder inks provide more control and that a little oil goes a long way. Another dramatic inking possibility involves using a hard, cold, neutral ink for the initial and general inking and then switching to a slightly softer, warm ink for the highlights.

Refining the print

When the inking of the bromoil print is finished, there may be times when it seems that the overall image is slightly overworked or that it could use a little more sparkle. In such cases, the print can be submerged in a tray of water and the entire surface gone over very lightly with a wad of cotton or a soft sponge. This will clear up highlights and increase contrast. Take care when doing this or highlight detail may be lost and the print will have to be given additional inking to replace necessary detail.

In the final stages of inking, you may see hundreds of tiny white spots beginning to appear. The hopping brush action used in cleaning up the highlights forces moisture out of the emulsion, and the white spots are from tiny droplets of water where the bristles of the brush have picked up this moisture. It is important to watch for moisture forming on the surface of the print and getting on the brush. When using the discharged brush to clean up the image, shake it and blot it to be sure that there is no trace of water on the bristles. Once this gets out of control, there is little that can be done except to re-ink. Excess moisture can be controlled to a large extent by blotting the print carefully each time it is resoaked during the inking process.

When the print is being finished up, there will probably be ink on the white border, which can be removed with a wet sponge. If there's ink that has built up in places and does not wipe away cleanly, thoroughly moisten the border with the sponge and use a clean bristle brush with a whisking, sweeping motion to remove all traces of ink. This technique can also be used to remove ink from areas in an image if necessary. However, if all ink is removed from an area of the image, it will result in harsh contrast that will

need to be toned down in the final print. This can be done after the matrix has become damp-dry, but while the ink is still fresh. At this point, a fitch brush can be extremely lightly charged with ink and applied to the cleared areas. Since there is no swelling of the gelatin at this time, the area will receive the light application of ink uniformly and none of the unwanted detail will be evident.

When the inking has been completed, the bromoil print will need to be dried. This can be done by pinning the print vertically to a clean support, such as a piece of foam building insulation or a board, to dry. It can also be laid *face up* on a screen to dry, but it will have to be flattened when dry.

Spotting the print

After a few hours, the fiber base of the print will be dry but the ink will still be wet and will not have begun to cure. At this time, the print should be carefully inspected for dark spots of ink, white spots, or unwanted details and highlights. Spotting can be done quite easily with the end of a round wooden toothpick. Moisten one end of the toothpick and press the tip on a hard surface just enough to soften the wood fibers on the tip. Use the same technique on the other end of the toothpick, but don't moisten it. Small black spots of ink may be removed by touching them with the moist end of the toothpick, while white spots can be corrected by touching them with a light charge of ink on the dry end. Both large and small areas may be cleared/spotted by using this technique. While being used, the toothpick may need to be repeatedly moistened and perhaps wiped clean of ink, or charged with ink to build up the desired value of ink in dark areas. If large areas need to have ink added, it may be best to do this with a small, well-worn watercolor brush, size 1 or 2.

Lint, broken hairs from the brushes, and any debris that may have stuck to the print should also be removed at this time. This can be done with the tip of a small brush or a sharp pointed hobby knife or similar tool. It is important to do all this work *before* the ink begins to cure so that all ink will blend together and dry with the same uniform surface quality. Corrections and highlight toning made in this manner will all have the same surface quality and will not be visible.

Drying the print—curing the ink—can take from a few days to several weeks, depending on the type of ink used, how heavily it was applied, and the general humidity. After a day or so of initial drying, curing can be speeded up by placing the print in direct sunlight for several hours. If the print needs to be flattened after the ink has cured, it can be moistened on the back with a clean sponge, placed under a sheet of hard-surfaced drawing paper, and pressed flat with a light weight for several hours. Or, it can be placed between two sheets of clean, hard-surfaced drawing paper and placed in a dry mounting press for 15–20 seconds at 93°C/200°F.

! The ink *must* be dry before the print is flattened.

The print should be mounted to an appropriate backing with hinges made of linen tape or acid-free corners and overmatted with a window mat for protection and presentation.

Notes

Recent new books about bromoil printing include *The Art of Bromoil and Transfer* by David Lewis and *Bromoil 101* by Gene Laughter. Bromoil paper and materials are available from Fine Print Studios in Germany, Bostick and Sullivan in the United States, David Lewis in Canada, and Bergger in France. (For details, see the section on sources in the appendix.)

1. Neblette (1952).
2. Wall (1907).
3. Piper (1907a).
4. Piper (1907b).
5. Lewis (1995).
6. Wall and Jordan (1976).
7. Gabriel (1930).
8. Neblette (1952).
9. Eaton (1986).
10. Ibid.
11. Whalley (1961).
12. O'Hara and Osterburg (1951).
13. Crawford (1979).
14. Lewis (1995).
15. Ibid.
16. Clerc (1930).
17. Whalley (1961).
18. O'Hara and Osterburg (1951).
19. Ibid.
20. Mayer (1926).
21. Thijs (1996).
22. Rossol, Monona (personal communication, 1996).

Appendix

Chemicals

While the information and data included in this book have been obtained from sources considered dependable and are correct and reliable to the best of the author's knowledge and belief, no guarantees of accuracy are implied nor stated by the author regarding information about chemical safety or hazards. The user assumes all risks upon using the chemicals discussed in this book.

Readers also have the responsibility to supplement information in this appendix by obtaining material safety data sheets (MSDSs) on each of the products they will be using. Manufacturers in most countries are required by law to create MSDSs containing prescribed technical information on a product's identity and hazards. MSDSs are usually available without cost via the Internet or directly from the manufacturer. While they vary greatly in quality of information from one manufacturer to another, MSDSs should be an important part of each photographer's safety database.

Readers are also advised to obtain MSDSs *before purchasing the product.* For example, the MSDS may indicate that you may need to obtain special protective equipment before you can safely use the chemical.

Be aware that both MSDSs and standard references often provide data limited to short-term or *acute* exposure to amounts that are larger than normally used. This simply reflects the fact that the majority of the chemicals we use have never been studied for low-dose, long-term, or chronic effects such as reproductive hazards or cancer. Yet we know that many of these chemicals are likely to have chronic effects at doses smaller than those addressed on MSDSs or in the literature. The safest practice is to handle all chemicals with equal respect and care—minimizing any possibility of exposure—even when using them in minimal amounts.

Dosage is also somewhat irrelevant for individuals who become allergic or sensitive to chemicals. Once this happens, there is no desensitizing procedure; all you can do, depending upon the severity of the allergy, is to wear gloves, avoid the substance altogether, or substitute another chemical. For those whose allergies are severe, only complete avoidance may suffice.

Most exposure to chemicals will be through skin contact or inhalation. Adults are highly unlikely to ingest chemicals unless they violate accepted laboratory procedures by such practices as storing chemicals in unlabeled containers or in family refrigerators.

The hazards of massive ingestion are usually not covered in this appendix since ingestion can be so easily prevented. Only effects from contact with eyes and skin and from inhalation are covered in this appendix. These are the most likely routes of entry to the body in the darkroom. To use this appendix properly, readers should assume that the following precautions are followed:

1. Gloves, chemical splash goggles, and a lab coat or smock should be worn when working with all the chemicals in this appendix whose profile includes skin and/or eye irritation or damage.

2. Chemicals also listed as hazardous by inhalation should be used with either appropriate ventilation or respiratory protection.

3. All chemicals that are hazardous by inhalation should be used with local exhaust ventilation when they are in powdered form to prevent both exposure by inhalation and possible contamination of the workplace with the powder.

! Specific precautions are included in this appendix only if they are *in addition* to the precautions given above.

In other words, all chemicals should be handled in a properly equipped facility with appropriate protective equipment by qualified individuals trained in laboratory procedures and familiar with their potential hazards. *If you haven't read chapter 2 on safety, please take a few minutes do so now.*

CAS registry numbers

All chemicals listed here include a Chemical Abstracts Service (CAS) registry number. This is a uniform, worldwide system of indexing chemicals. Since chemicals may have a number of legitimate chemical names, the CAS number will assure nonchemists of the identity of each chemical. This is especially useful when accessing data from standard references or the Internet.

Chemical listings

The information given in this section has been compiled from the following sources: *Patty's Industrial Hygiene and Toxicology*,[1] *Sax's Dangerous Properties of Industrial Materials*,[2] *Hawley's Chemical Dictionary*,[3] *CRC Handbook of Chemistry and Physics*,[4] *The NIOSH Registry of the Toxic Effects of Chemical Substances*,[5] and *Overexposure*.[6]

Acacia [CAS# 9000-01-5], also known as *gum arabic*. Acacia can cause allergic reactions, including dermatitis and asthma, in some people with repeated exposure. Fine dust may cause headache, coughing, or difficulty breathing. Eye contact can cause irritation.

Acetic acid, CH_3COOH [CAS# 64-19-7]. Concentrated solutions of the acid and its vapors are corrosive and irritating to the skin, eyes, and respiratory tract (see *glacial acetic acid*). Dilute solutions are not very hazardous. Vinegar is about 5% acetic acid.

Acetone, CH_3COCH_3 [CAS# 67-64-1]. Acetone is extremely flammable and volatile. A narcotic and

irritant to the eyes and respiratory tract; on contact with skin, it will remove the skin's protective oils and waxes, leaving the skin dry and vulnerable to chapping, infections, and penetration by other chemicals.

Aluminum chloride, $AlCl_3$ [CAS# 7446-70-0] and **aluminum chloride hexahydrate,** $AlCl_3 \cdot 6H_2O$ [CAS# 7784-13-6]. The unhydrated chloride is highly corrosive to human tissues; the hydrate is not very irritating. Both are soluble aluminum sources and have experimental teratogenic effects. Some experts suspect chronic exposure to aluminum of causing nervous system and brain diseases such as Alzheimer's disease.

Ammonia, NH_3 [CAS# 7664-41-7]. This is a corrosive gas that can cause severe irritation or burning of the skin, eyes, and respiratory system. Severe overexposure can cause pulmonary edema and death. The strong odor of ammonia usually provides sufficient warning to avoid acute overexposure. Although most ammonia-emitting chemicals used in photography produce ammonia in only small amounts, it can be sufficient to cause chronic respiratory and eye irritation.

Ammonia water, see *ammonium hydroxide.*

Ammonium bichromate, see *ammonium dichromate.*

Ammonium chloride, NH_4Cl [CAS# 12125-02-9], also known as *sal ammoniac* or *salmiac.* It is an eye and respiratory irritant. Heat will cause it to convert into a fine, white, irritating smoke composed of ammonium chloride fume particles, hydrochloric acid, and ammonia.

Ammonium citrate, $C_6H_{14}O_7N_2$ [CAS # 7632-50-0]. A moderate eye, skin, and respiratory irritant.

Ammonium dichromate, $(NH_4)_2Cr_2O_7$ [CAS# 7789-09-5], also known as *ammonium bichromate.* It is hazardous by every route of entry. Contact with the skin will temporarily discolor the skin and may cause allergic dermatitis including a skin disease called "chrome ulcers." It is a strong irritant to the skin, eyes, and respiratory tract. Chronic inhalation can cause respiratory allergies and ulceration of the nasal septum. Like all chromates, it is a carcinogen. Unlike other chromates, heat (around 200°C/390°F) will cause ammonium dichromate to decompose in a dangerous reaction of progressive intensity. Keep it away from heat and reducing agents.

Ammonium ferric citrate, see *ferric ammonium citrate.*

Ammonium ferric sulfate, see *ferric ammonium sulphate.*

Ammonium hydroxide, NH_4OH [CAS# 1336-21-6], also known as *ammonia water.* These are solutions of ammonia gas in water, which can range from household ammonia (about 5% ammonia) to solutions of up to 30% ammonia. They are all corrosive liquids that are also hazardous by inhalation because they emit ammonia gas (see *ammonia*). While gloves, goggles, and dilution ventilation are needed with ammonia solutions in the range of 5–15%, solutions in the range of 15–30% also need local exhaust ventilation. The goggles should be unvented. Splashes in the eyes can cause blindness. Overexposure by inhalation can cause varying degrees of damage to the respiratory tract, ranging from lung inflammation to pulmonary edema resulting in death. Fortunately, the strong odor of ammonia usually provides sufficient warning to avoid acute overexposure.

Ammonium hyposulfite, see *ammonium thiosulfate.*

Ammonium iron (III) citrate, see *ferric ammonium citrate.*

Ammonium sulphocyanide, see *ammonium thiocyanate.*

Ammonium tetrachloropalladate II, $Cl_4H_8N_2Pd$ [CAS# 13820-40-1]. A severe skin irritant with hazards similar to those of palladium compounds (see *palladium chloride*). Emits chlorine, ammonia, and

platinum fumes when it dissociates. If ammonia odor is noticed, users should be aware that the other two chemicals are also being released.

Ammonium tetrachloroplatinate (II), $Cl_4Pt \cdot H_4N$ [CAS# 13820-41-2]. An allergen. When heated to decomposition, it emits ammonia, chlorine gas, and platinum fumes. If ammonia odor is noticed, users should be aware that the other two chemicals are also being released. Dissociation is rapid at its melting point of 140°C/284°F.

Ammonium thiocyanate, NH_4SCN [CAS# 1762-95-4], also known as *ammonium sulphocyanide*. It is not significantly toxic by skin contact and only slightly toxic by ingestion. When it is absorbed, however, it causes hallucinations, distorted perceptions, nausea, vomiting, and other gastrointestinal effects. Store with other dry chemicals because it can react violently with certain liquids, including hydrogen peroxide and nitric acid.

Ammonium thiosulfate, $(NH_4)_2S_2O_3$ [CAS# 1183-18-8], also known as *ammonium hyposulfite* or *rapid fixer*. It is relatively benign by skin contact, but it is an eye irritant. It can decompose over time or with heat to release highly toxic sulfur dioxide gas.

Benzine. A petroleum distillate in the same boiling range as ligroin, VM&P naphtha, paint thinners, and mineral spirits.

Bichromate of potash, see *potassium dichromate*.

Borax, see *sodium tetraborate*.

Chromates. Highly toxic by all routes of entry. Contact with the skin may cause allergic dermatitis, including a skin disease called "chrome ulcers." They are strong irritants to the skin, eyes, and respiratory tract. Chronic inhalation can cause respiratory allergies and ulceration of the nasal septum. All chromates are carcinogens.

Chrome alum, see *chromium potassium sulfate dodecahydrate*.

Chromium potassium sulfate dodecahydrate, $KCr(SO_4)_2 12H_2O$ [CAS# 7788-99-0], also known as *chrome alum*. It can cause irritation of the skin, eyes, and respiratory tract. Contact with the skin may cause allergic dermatitis, including a skin disease called "chrome ulcers." Chronic inhalation can cause respiratory allergies and ulceration of the nasal septum. The chromium is in a trivalent state, which is not listed as a carcinogen, but some experts think it is.

Citric acid, $C_6H_8O_7$ [CAS# 77-92-9]. It has very low toxicity but is irritating to the eyes, skin, and respiratory system.

Copper sulfate, $CuSO_4$ [CAS# 7758-98-7] and **copper sulfate pentahydrate,** $CuSO_4 \cdot 5H_2O$ [CAS# 7758-99-8]. Moderately toxic by all routes. An experimental teratogen.

EDTA, ethylene diamine tetraacetic acid, [CAS# 60-00-4]. Only slightly toxic, but it can irritate the skin, eyes, and respiratory system. Causes allergies in some people.

EDTA Na₄, ethylene diamine tetraacetic acid tetrasodium salt [CAS# 64-02-8]. Sodium salt of EDTA. It has the same hazards as EDTA.

Ethanedioic acid, see *oxalic acid*.

Ferric alum, see *ferric ammonium sulphate*.

Ferric ammonium citrate (no formula is given since this compound has an undetermined structure) [CAS# 1185-57-5], also known as *iron ammonium citrate, ammonium iron (III) citrate,* and *ammonium ferric citrate*. Only slightly toxic, but prolonged contact may cause skin irritation. An irritant to the eyes and respiratory system. Keep well sealed in a dry, dark area.

Ferric ammonium sulphate, NH₄Fe(SO₄)₂•12H₂O [CAS# 10138-04-2], also known as *ammonium ferric sulfate, ferric alum,* and *iron alum.* Only slightly toxic, but the dust may cause eye and skin irritation.

Ferric oxalate, Fe₂(C₂O₄)₃ [this material apparently has no CAS number], see *oxalates.*

Ferrocyanides and ferricyanides. Generally of low toxicity, but can release hydrocyanic acid (cyanide gas) when exposed to strong acids (e.g., glacial acetic) or ultraviolet light.

Formaldehyde, HCHO [CAS# 50-00-0], see also *formalin.* Formaldehyde is a gas. It is given off by a number of photochemical processes and can be present in small amounts in liquid photochemicals as a hardener or preservative. Chronic exposure to the small amounts used in some photochemicals is most likely to cause skin and respiratory allergies and damage from irritation. It is a carcinogen with experimental carcinogenic and teratogenic data. Human mutation data are also reported.

Formalin, see also *formaldehyde.* A 37–50% solution of formaldehyde gas in water, which usually also contains about 15% methyl alcohol to inhibit the polymerization of formaldehyde (See *formaldehyde* and *methyl alcohol*). Use of formalin requires special precautions, including local exhaust ventilation. An industrial hygienist should be consulted for safety recommendations if products containing large amounts of formaldehyde, like formalin, are used regularly.

Formic acid, HCOOH [CAS# 64-18-6]. Mildly toxic by inhalation. A severe skin and eye irritant. Mutation data are reported.

Glacial acetic acid, [CAS# 64-19-7], 99.8% pure acetic acid, see also *acetic acid.* Called *glacial* because it freezes (crystallizes) at 16.6°C/44°F. Glacial acetic acid is a fire risk and can be stored safely with other flammables (e.g., in a flammable storage cabinet). The concentrated acid and its vapors are corrosive and irritating to the skin, eyes, and respiratory tract.

Glycerin, C₃H₈O₃ [CAS# 56-81-5], also known as *glycerol.* No significant hazards.

Glycerol, see *glycerin.*

Glyoxal, C₂H₂O₂ [CAS# 107-22-2]. It is a low-molecular-weight aldehyde and is expected to have hazards similar to those of *formaldehyde.* Limited studies indicate that this material has similar chemical reactivity and mutagenicity to those of formaldehyde and other closely related aldehydes.[7] Glyoxal reacts violently when mixed with several chemicals, including sodium hydroxide and nitric acid. If it is heated to 200°C/392°F in a closed container, it can explode, and it is corrosive to metal. Additional precautions are needed for handling this chemical, including local exhaust ventilation.

Gold chloride, HAuCl₄ [CAS# 16903-35-8], also known as *gold trichloride acid* and *hydrogen tetrachloroaurate (III).* A strong primary irritant, it can cause serious skin and respiratory allergies.

Gold trichloride acid, see *gold chloride.*

Gum arabic, see *acacia.*

Hydrochloric acid, HCl [CAS# 7647-01-0]. Toxic by all routes, it is a strong corrosive to skin, eyes, and respiratory tract.

Hydrogen sulfide, H₂S [CAS# 7783-06-4]. This is a gas to which photographers are likely to be exposed only when it is generated by chemical processes such as sulfide or sepia toning. It is a severe irritant to eyes and mucous membranes. It combines with the alkali present in moist surface tissues to form caustic sodium sulfide. At higher concentrations, it damages the central nervous system. It causes asphyxia. It has good odor warning properties at first, but it deadens the sense of smell in a relatively short time so the victim is unaware of exposure. When photo processes produce a rotten-egg odor, provide ventilation immediately. There are no approved respirator cartridges for hydrogen sulfide.

Hydrogen tetrachloroaurate (III), see *gold chloride.*

Hypo, see *sodium thiosulfate.*

Iron alum, see *ferric ammonium sulphate.*

Iron ammonium citrate, see *ferric ammonium citrate.*

Kodak Hypo Clearing Agent (At the time of this writing, this product contains by weight 1–5% sodium citrate, 1–5% EDTA Na4, 15–20% sodium metabisulfite, 75–80% sodium sulfite.) A mild irritant to the skin and eyes. It emits sulfur dioxide gas. (See *sulfur dioxide* and each individual chemical in the product.)

Kodak Rapid Selenium Toner (This commercially mixed toning solution contains by weight 2% sodium selenite, 25–30% ammonium thiosulfate, 5–10% sodium sulfite, 55–60% water.] It is toxic by all routes. The data include experimental teratogenic and reproductive effects. Human mutation data are reported, and it is a questionable carcinogen. Sodium selenite in solution can also be absorbed through the skin. Adding acid to this toner can create highly poisonous hydrogen selenide gas: *rinse acid fixer from prints prior to toning.* In addition to gloves and protective eyewear, this product should be used with a local exhaust ventilation system such as a fume hood.

Linseed oil, [CAS# 8001-26-1], also known as *flaxseed oil.* No significant hazards to the oil itself, but "boiled," "sun dried," and all other linseed oils used to set paints or inks contain chemical driers. These are often toxic lead or manganese compounds. Get material safety data sheets on these oils and avoid products with toxic driers. These oils also generate heat when they set. Many fires from spontaneous combustion of linseed oil rags have been documented. Methods of preventing fires include hanging rags out to dry for a week before discarding, placing rags in sealed metal cans, burning the rags, laundering the rags daily with strong detergents, or placing the rags in water.

Lithium chloride, LiCl [CAS# 7447-41-8], see *lithium compounds.*

Lithium chloropalladite. No data, but it is expected to have the same hazards as *potassium chloropalladite* plus those of *lithium compounds.*

Lithium compounds. Most lithium compounds are only moderately toxic, but there is a great deal of information on adverse effects in humans because of their use in controlling manic depression. At high doses, they have life-threatening effects on the brain and central nervous system. Lesser effects include lithium dermatitis, aggravation of psoriasis, goiters, kidney dysfunction, and possible birth defects. The major risk is to people taking lithium carbonate medications because therapeutic doses are close to toxic levels. These people cannot tolerate additional lithium exposure and should take extraordinary precautions when using lithium-containing chemicals.

Methyl alcohol, CH_3OH [CAS# 67-56-1]. It is a poison by all routes and is absorbed rapidly through the respiratory tract and skin. Causes narcotic effects resulting in damage to the central nervous system with particular effects on the optic nerve, which can progress to permanent blindness. Experimental data show it to be teratogenic and to affect reproduction adversely.

Nitric acid, HNO_3 [CAS# 7679-37-2]. It is highly corrosive to all human tissues. Experimental data show it to be a teratogen and a reproductive hazard. Pulmonary edema and death can result from inhaling emissions from nitric acid. There is no air-purifying respirator cartridge approved for nitric acid or the nitrogen oxides released by the acid. Only local exhaust ventilation is appropriate for control of emissions during use of this substance. It is a strong oxidizer that will react violently with a multitude of acids, solvents, caustics, etc. It must be stored separately from all other chemicals.

Oxalates. Oxalates in general are toxic by all routes. They are corrosive to the eyes, skin, and respiratory tract on contact. Even small amounts produce local irritation. Soluble oxalates can be absorbed through the gastrointestinal and respiratory tracts and can cause severe kidney damage. In addition to gloves and protective eyewear, oxalates require local exhaust ventilation or respiratory protection.

Oxalic acid, $C_2H_2O_4$ [CAS# 144-62-7], also known as *ethanedioic acid.* A highly toxic soluble source of oxalate. See *oxalates.*

Palladium chloride. $PdCl_2$ [CAS# 7647-10-1]. This material is irritating to the skin, eyes, and respiratory system. It does not appear to cause the sometimes severe allergies seen with platinum salts.

Potassium bromide, KBr [CAS# 7758-02-3]. It is slightly irritating to skin, eyes, and respiratory tract. Prolonged inhalation may cause skin eruptions, and large doses can cause depression of the central nervous system. It is an experimental mutagen.

Potassium chlorate, $KClO_3$ [CAS# 3811-04-9]. This material is a moderate irritant, causing irritation of the nose, throat, and eyes. Once absorbed into the body, it causes damage to the red blood cells, which can damage kidneys and heart. It is a very strong oxidizer that can explode when shocked, heated, or rubbed, particularly when contaminated with a little dust, such as wood dust, starch, sugar, or charcoal. It will react with many other chemicals. Keep it in tightly closed containers, away from organic or combustible materials and strong reducing agents. Clothing contaminated with this material is dangerously flammable. Clean up any spills immediately with large amounts of water.

Potassium chloroplatinate, K_2PtCl_6 [CAS# 16921-30-5], also known as *potassium platinic chloride.* It is irritating to human skin and can cause severe allergic effects with chronic exposure. It is an experimental mutagen.

Potassium chloroplatinite, K_2PtCl_4 [CAS# 10025-99-7], also called *platinous potassium chloride.* Poison and corrosive to human skin. It is an experimental mutagen. It can cause severe allergic effects with chronic exposure.

Potassium dichromate, $K_2Cr_2O_7$ [CAS# 7778-50-9]. It is highly toxic by all routes of entry. Contact with the skin will temporarily discolor the skin and may cause allergic dermatitis, including a skin disease called "chrome ulcers." It is a strong irritant to the skin, eyes, and respiratory tract. Chronic inhalation can cause respiratory allergies and ulceration of the nasal septum. Like all chromates, it is a carcinogen.

Potassium ferricyanide, $K_3Fe(CN)_6$ [CAS# 13746-66-2], also known as *red prussiate of potash,* see *ferricyanides.*

Potassium metabisulfite, $K_2S_2O_5$ [CAS# 16731-55-8]. Irritating to the respiratory tract and eyes. Reacts with acids to form sulfur dioxide and oxidizes to the sulfate form.

Potassium oxalate, $K_2C_2O_4 \cdot HOH$ [CAS# 583-52-8], see *oxalates.*

Potassium tetrachloroplatinate (II), see *potassium chloroplatinite.*

Rapid fixer, see *ammonium thiosulfate.*

Red prussiate of potash, see *potassium ferricyanide.*

Rochelle salts, see *sodium potassium tartrate.*

Sal ammoniac or **salmiac,** see *ammonium chloride.*

Selenium toner, see *Kodak Rapid Selenium Toner.*

Silver nitrate, $AgNO_3$ [CAS# 7761-88-8]. Skin or eye contact results in dark discolorations and burns. It

can cause permanent blindness if it comes in contact with the eyes. The eyewear used routinely to protect against chemical splashes should be used, but special vigilance is needed since the effect on the eyes can be so serious. It also can irritate or damage the respiratory system. It is a strong oxidizer; it can cause fires if it comes in contact with combustible materials.

Silver oxide, Ag_2O [CAS# 20667-12-3]. Often sold in a powder whose particles are 2–3 microns in diameter, it can be inhaled deep into the alveoli of the lungs. It is not very toxic, but it is radio-opaque, which can affect the appearance of lung x-rays. It is a fire and explosion hazard if it comes in contact with many organic materials or *ammonium hydroxide (ammonia water)*. Only mix with chemicals in precise accordance with directions.

Soda ash, see *sodium carbonate.*

Sodium acetate, $NaCH_3CO_2 \cdot 3H_2O$ [CAS# 127-09-3]. Only slightly toxic by all routes of entry.

Sodium borate, see *sodium tetraborate.*

Sodium carbonate, Na_2CO_3 [CAS# 497-19-8], also known as *soda ash*. An irritant to skin, eyes, and respiratory system.

Sodium citrate, $C_6H_5Na_3O_7$ [CAS# 68-04-2], also called *trisodium citrate*. Only slightly toxic. Contact with skin, eyes, or respiratory tract can cause minor irritation.

Sodium dichromate, $Na_2Cr_2O_7 \cdot 2HOH$ [CAS# 7789-12-0]. It is highly toxic by all routes of entry. Contact with the skin will temporarily discolor the skin and may cause allergic dermatitis, including a skin disease called "chrome ulcers." It is a strong irritant to the skin, eyes, and respiratory tract. Chronic inhalation can cause respiratory allergies and ulceration of the nasal septum. Like all *chromates*, it is a carcinogen.

Sodium formate, CHO_2Na [CAS# 141-53-7], a sodium salt of formic acid, see *formic acid.*

Sodium metabisulfite, $Na_2S_2O_5$ [CAS# 7681-57-4], see also *sulfur dioxide*. Irritating to the skin, eyes, and respiratory tract. When heated or mixed with acid, it can release sulfur dioxide gas.

Sodium palladium chloride, Na_2PdCl_4, also known as *sodium chloropalladinite* and *sodium tetrachloropalladate (II)*, same hazards as *potassium chloroplatinate.*

Sodium potassium tartrate, $C_4H_4KNaO_6$ [CAS# 304-59-6], also known as *Rochelle salts*. No significant hazards.

Sodium selenite, Na_2SeO_3 [CAS# 10102-18-8], see also *Kodak Rapid Selenium Toner*. It is toxic by all routes. Sodium selenite in solution can also be absorbed through the skin. The data include experimental teratogenic and reproductive effects. Human mutation data are reported, and it is a questionable carcinogen.

Sodium sulfite, Na_2SO_3 [CAS# 7757-83-7], see also *sulfur dioxide*. Strong irritant to the skin, eyes, and respiratory tract. Mixed with water or acid, or when heated, it releases toxic sulfur dioxide gas.

Sodium tetraborate, $Na_2B_4O_7 \cdot 10H_2O$ [CAS# 1303-96-4], also known as *sodium borate* or *borax*. Not harmful to normal skin but can be absorbed through broken skin. Toxic systemically if significant amounts are absorbed, inhaled, or ingested.

Sodium tetrachloropalladate (II), see *sodium palladium chloride.*

Sodium thiosulfate, $Na_2O_3S_2$ [CAS# 7772-98-7], also known as *hypo*, has the same hazards as *ammonium thiosulfate.*

Sodium tungstate $Na_2WO_4 \cdot 2H_2O$ [CAS# 53125-86-3], also known as *tungstate wolframate*. Only slightly

toxic and irritating to the skin, eyes, and respiratory tract. Experimental reproductive effects and human mutation data are listed.

Succinic acid, $C_{12}H_{22}O_4$ [CAS# 101-15-6]. A severe eye and skin irritant.

Sulfamic acid, [CAS# 5329-14-6]. A corrosive irritant to eyes, skin, and respiratory tract. When hot, it reacts violently with metal nitrates and nitrites.

Sulfur dioxide, SO_2 [CAS# 7449-09-5]. Strong respiratory irritant because it dissolves in moisture in the respiratory tract to form sulfurous acid. It is an air pollutant that is a strong allergen and common cause of asthma in the general population.

Tartaric acid, $C_4H_6O_6$ [CAS# 87-69-4]. Only slightly toxic, but concentrated solutions are mildly irritating.

Tungstate wolframate, see *sodium tungstate.*

Turpenoid. An unregulated term for any solvent or mixture of solvents that can be used to replace turpentine. Products sold currently often contain petroleum distillates of various grades. Natural turpenoids often contain substantial amounts of d-limonene from citrus rinds. D-limonene is actually more toxic than turpentine and is not recommended.

Turpentine, $C_{10}H_{16}$ [CAS# 8006-64-2]. A solvent derived from pine wood by steam, solvent, or destructive distillation. Highly toxic and allergy causing. Many common petroleum distillates are less toxic and should be used in preference to turpentine.

Chemical names historically used

MODERN NAME	OLD NAME(S)
Ammonium carbonate	sesquicarbonate
Ammonium chloride	sal ammoniac
Bicarbonate of soda	sesquicarbonate of soda, hydrosodium carbonate
Ferric ammonium citrate	ammonio-citrate, ammonio ferrous citrate
Ferric chloride	perchloride of iron, chloride of iron
Ferric oxalate	sesquioxalate of iron
Ferric sulphate	persulphate of iron, sesquisulphate of iron
Ferrous sulphate	green vitriol, protosulphate of iron
Mercury	quicksilver
Oxalic acid	acid of sugar
Phenol	carbolic acid
Potassium bromide	bromide of potash
Potassium carbonate	sub-carbonate of potash, salt of tartar
Potassium dichromate	bichrome
Potassium ferricyanide	red prussiate of potash
Potassium ferrocyanide	yellow prussiate of potash
Silver chloride	horn silver
Silver nitrate	lunar caustic
Sodium carbonate	natron, washing soda, hydro-sodium
Sodium thiosulphate	antichlor, hyposulphate of soda, hypo

Pigments

Nearly all pigments and dyes are identified by internationally accepted Colour Index (CI) names and/ or numbers. Some also have CAS numbers (see section on chemicals, above). CI numbers can be looked up in the *Colour Index International*.[8] You can also contact Arts, Crafts and Theater Safety, Inc. (ACTS)[9] or The Center for Safety in the Arts (CSA)[10] for questions about specific pigments. It is much more difficult to find health or hazard information about pigments than chemicals. Shaw and Rossol note that "little research has been done on natural or synthetic organic pigments to determine their long-term toxicity, particularly with regard to possible cancer hazards."[11]

The toxic elements in paints can be introduced into the body by three routes: skin contact, inhalation, and ingestion. While ingestion is the least likely contact for an adult, paint is an attractive hazard and could prove dangerous to a child or pet. However, smoking, eating, or drinking can introduce toxic substances into the mouth and should be avoided when you are working with chemicals or pigments of any kind. Skin contact can easily be avoided with the use of gloves. Inhalation, which is chiefly a problem with dry paints, can be minimized or avoided by mixing the paints in a glove box (a box with a plastic lid and armholes) or under a hood.

In summary, the following precautions should be taken when using pigments:

- wear gloves
- wash hands thoroughly after handling or mixing materials
- avoid using dry pigments in favor of tube pigments, if possible
- avoid activities such as eating, drinking, or smoking that could result in ingestion of chemicals and pigments while working with them
- keep all pigments and other chemicals out of reach of children and pets
- be aware of the health hazards of the specific pigments you will be using; look them up in the appropriate reference book or contact Arts, Crafts and Theater Safety, Inc. or The Center for Safety in the Arts for information

It is beyond the scope of this book to give specific information and health implications about all the different paints that could be used in the processes described in this book. There are many manufacturers of watercolor paints, each using different formulations, and the name of the paint may not accurately reflect the actual ingredients, since components may be altered without changing the name of the paint. For example, in the Winsor & Newton line of watercolors, cadmium red contains cadmium sulphoselenide, while cadmium red deep hue contains naphthol red.

Some pigments contain ingredients that are known carcinogens or toxic agents, such as antimony, lead carbonate (white lead), cobalt, cadmium, manganese, nickel, and chromates. Other materials, such as anthraquinones, are not yet required to have a health warning, but some experts feel that they may be carcinogens.[12] The resources listed below will be helpful in obtaining further information about pigments and associated hazards.

Suggested ways of finding information about specific paints include the following:

- Write to the manufacturer for the MSDSs on the paints you plan to use.
- Contact one of the organizations listed here.
- Refer to the books listed in this section and also in the bibliography.

- If you have access to the Internet, look up the Web sites listed in the resource section at the end of this section.

Note that in their large international catalog, Winsor & Newton gives CI numbers as well as the coloring agents used in each of its paints; other manufacturers may have a similar list available.

With the changing climate of today's environmental and health concerns, changes in the components used in paints will probably continue to occur. Because of this, it should be kept in mind that texts listing paint ingredients may not always be up-to-date.

Health and Safety References

- *Art Painting and Drawing* by Angela Babin (1991). The Center for Safety in the Arts lists sources for getting this book (note that they are only active through their Web site and newsletter). The Center for Safety in the Arts (CSA), 2124 Broadway, Box 310, New York, NY 10023; *www.artswire.org:70/1/csa*; e-mail: *csa@artswire.org*
- *The Artist's Complete Health and Safety Guide*, Second Edition by Monona Rossol (1994), available from Allworth Press.
- Arts, Crafts and Theater Safety, Inc. (ACTS), 181 Thompson St. #23, New York, NY 10012; (212) 777-0062; *www.caseweb.com/acts/*; e-mail: *ACTS@CaseWeb.com* (or directly to Monona Rossol at *75054.2542@compuserve.com*). ACTS provides a free information service on hazards in the arts and theater.

Poison Control

Note that the numbers given here are for *emergency* services for acute hazards, primarily ingestion and inhalation; they do not usually deal with long-term hazards, such as cancer or birth defects. For routine questions and questions about long-term effects, consult the references listed in the section on references, above.

- In the United States, call the emergency services number 911 and ask for the poison control center.
- In the United Kingdom, call the emergency services number 999 and ask for the National Poison Information Services, London Centre.
- In the Netherlands, call the Utrecht University Hospital at (030) 250-9111 and ask for poison control information.
- For other countries, call the emergency services number and ask for the poison control center.

Testing Fixer for Exhaustion

The Kodak Fixer Test Solution FT-1 can easily be made by adding 5 grams of potassium iodide to 25 ml of water at 26.6°C/80°F. Add 5 drops of the fixer and 5 drops of water to 5 drops of FT-1. If a heavy yellowish precipitate forms, then the fixer is exhausted.[13]

Testing the Print for Adequate Fixation

After the print has been cleared (if necessary), fixed, and washed, let it drain and put a drop of a 10% solution of sodium sulfide (10 grams per 100 ml of water) on a light area that was sensitized. If the spot tested gives a brown stain, it still contains some silver salts and has not been adequately fixed. If a brown stain results even after long fixing, it indicates that the fixing bath is exhausted.[14]

Ferric Oxalate
Making ferric oxalate

At one time it was difficult to get ferric oxalate at all, let alone a good grade that was largely free of ferrous material. Today, with the current interest in the historic processes, a good-quality product is available from several specialty sources. From the standpoint of safety, there is obviously much less risk involved in simply adding distilled water to a premeasured powder or using a premixed solution. Consider this carefully before deciding to make your own.

> You should not attempt to prepare your own ferric oxalate if you are not familiar with the hazards and safe-handling techniques for these chemicals and if you do not have a darkroom equipped for working safely with them.

For those who may have trouble obtaining ferric oxalate, who want to ensure a fresh, consistent supply, or who just enjoy making their own chemistry, here is a method for making it.[15]

> To make ferric oxalate you will need the following:
> Ferric (not *ferrous*) ammonium sulfate ...52 grams
> Ammonium hydroxide (27%) *See warnings below* ...20ml
> Oxalic acid* (anhydrous) ..21.5 grams
> Distilled water ..600 ml
>
> *If you use the crystalline (hydrous) form of oxalic acid instead of the anhydrous form, substitute 26.8 grams.

> Be cautious with these materials; they are quite toxic. Do not use them in a sink used for any other purpose (food preparation, bathroom hygiene, or any other nonchemical purpose). Keep them well away from children and pets. Clean up all spills. See the chemical listings in this appendix for the hazards of the chemicals used in this procedure and review chapter 2 on safety before going any further.

> Ammonium hydroxide, in particular, should be handled with great caution. Its intense fumes can not only cause severe irritation of the eyes and respiratory system, but in concentrated form, it can also cause the glottis to swell shut, resulting in suffocation. The liquid is corrosive and can cause blindness if it comes in contact with the eyes. Use this material under a fume hood and wear protective goggles and gloves. If you don't own, or have access to, a specialized fume hood, do not use ammonium hydroxide inside. To further reduce your risk, either order it in the smallest possible container or, better yet, have your local pharmacist measure out the needed amount. Note also that ordinary dust masks will not remove gases or vapors.

! Oxalic acid should also be handled with caution. Use gloves and goggles. It is corrosive to the skin and mucous
● membranes and, if taken internally, can cause severe damage. It can also cause severe eye damage.

Again, if you do not have a fume hood, perform steps A and B of this procedure outside. After the water has been exchanged once or twice, the fumes will be mostly eliminated. After step C, the rest of the procedure must be done inside.

To make ferric oxalate:
A. Dissolve in a 500 ml glass beaker

Ferric ammonium sulphate ..52 grams
Water (distilled) .. 100 ml

B. Add 20 ml ammonium hydroxide and stir well for 2–3 minutes. A reddish jellylike substance called *ferric hydroxide* will precipitate out.

Add water (distilled) .. 300 ml

Let it stand for 10 minutes or until the precipitate has settled to the bottom.

C. Decant the water, being careful not to spill out the ferric hydroxide, and fill the container again with water. Wait until the precipitate has settled to the bottom and repeat the decanting. Do this 5–7 times, or until the water no longer tests alkaline. Although a pH meter is more precise, a relative measurement of acidity or alkalinity can be done by using litmus paper or the more sensitive dip strips that have a reference scale for comparison.

! After this point, the rest of the procedure should be done under subdued tungsten light or a safelight.
●

D. Decant as much water as you can. Make certain the precipitate settles at or below the 85 ml mark.

Stir in oxalic acid .. 21.5 grams

This will liquefy the ferric hydroxide. Filter the solution.

Add water (distilled) to make ... 100 ml

The strength will be approximately 20%, with 1.2% oxalic acid in excess.

E. To make a solution with no excess oxalic acid:

Add oxalic acid .. 21 grams

There should be a bit of undissolved ferric hydroxide at the bottom. Filter it.

Add water (distilled) to make ... 100 ml

Testing ferric oxalate

As ferric oxalate ages, it returns to a ferrous state, which is useless for platinum and kallitype printing. As it acquires more ferrous material, the images produced may appear flat. There's a simple test that can be used to determine the quality of the ferric oxalate solution.

- Add a few grains of potassium ferricyanide (the exact amounts aren't critical) to distilled water (2–3 ml).
- Under a safelight, add a drop of ferric oxalate solution.
- Take it out of the darkroom into normal room light and look at it. If it looks yellow to orange, then it's a mostly ferric solution. If it appears blue, then there's a substantial amount of ferrous material in it: the deeper the blue color, the poorer the condition.

Clearing test for ferric oxalate

To test the efficiency of your clearing bath, a visual test can be done. Sullivan suggests that you place a short strip of masking tape on a piece of the same type of paper that you intend to use, and coat a spot the size of a coin with sensitizer, being careful to coat over the tape as well as the paper. Remove the tape and dry the paper. Without exposing it, process the paper in the developer and clearing bath as usual. (For a kallitype, it also needs to be fixed.) If it's not clearing properly, it will be easy to see the stain against the line of the tape edge.[16] Nadeau cautions that fog from inadequate lighting could be misinterpreted as a stain from incomplete clearing.[17]

Conversion Formulas
Criss-Cross Method of Finding Percentage Dilutions

- At *A*, note the percentage strength of the solution that is to be diluted.
- At *B*, note the percentage strength of the diluting solution. (Use 0 for water.)
- At *C*, note the percentage strength wanted.
- Subtract *C* from *A* and note the result at *Y*.
- Subtract *B* from *C* and note the result at *X*.
- If *X* parts of *A* are diluted with *Y* parts of *B*, the result will be a solution of *C* percentage.

For example, to make a 10% solution of ammonium dichromate from a 25% solution:
- Write 25 at *A* and 10 at *C*.
- Write 0 at *B*.
- Subtract 10 from 25 and write 15 at *Y*.
- Subtract 0 from 10 and write 10 at *X*.

If 10 parts of a 25% solution of ammonium dichromate is diluted with 15 parts of water, the result will be a 10% solution of ammonium dichromate.

Temperature

To convert from Fahrenheit to Celsius: subtract 32 from the temperature in Fahrenheit and multiply the remaining number by 5⁄9. To convert from Celsius to Fahrenheit: multiply the temperature in Celsius by 9⁄5 and add 32 to the product.

Freezing = 0° Celsius/32° Fahrenheit; boiling = 100° Celsius/212° Fahrenheit.

Weights and measures

Note that some British measures are not equivalent to U.S. measures with the same name. (All measures given in the text below are in metric or U.S. terms.)

1 Imperial pint	=	568.25 milliliters	=	20 ounces
1 Imperial gallon	=	4.5460 liters	=	160 ounces
1 U.S. gallon	=	3.785 liters	=	128 ounces
1 U.S. pint	=	473.168 milliliters	=	16 ounces
28.4123 milliliters	=	1 fluid Imperial ounce		
1 milliliter	=	16.894 Imperial minims		

- To change from ounces to milliliters, multiply by 29.573.
- To change from milliliters to ounces, divide by 29.573.
- To change from quarts to liters, multiply by 946.332.
- To change from liters to quarts, divide by 946.332.

Less recent formulas are generally given in avoirdupois measurements, in which the ounce contains 437.5 grains and the liquid ounce 480 minims. The term *drachm* or *dram* can refer to either the apothecary's measure of 60 grains (or 60 minims) or to the avoirdupois measure of 27.34375 grains. Older formulas are frequently given in apothecary's weight (the grains are the same in both measures).[18]

AVOIRDUPOIS WEIGHT			APOTHECARY'S WEIGHT		
1 dram	=	27.343 grains	20 grains	=	1 scruple
16 drams	=	1 ounce	3 scruples	=	1 dram
16 ounces	=	1 pound	8 drams	=	1 ounce
			12 ounces	=	1 pound

- To change from ounces to grams, multiply by 28.3495.
- To change from grams to ounces, divide by 28.3495.
- To change from pounds to kilos, multiply by 453.5924.
- To change from kilos to pounds, divide by 453.5924.

- To change from grains to ounces, divide by 480.
- To change from ounces to grains, multiply by 480.
- To change from grains to grams, divide by 15.432.
- To change from grams to grains, multiply by 15.432.
- To change from inches to millimeters, multiply by 25.4.
- To change from inches to centimeters, multiply by 2.54.
- To change from millimeters to inches, divide by 25.4.
- To change from centimeters to inches, divide by 2.54.

Sources of Supplies: Europe
United Kingdom

Note: To telephone from outside of the United Kingdom, dial 44 for the country code and remove the 0 from the city code. For example, to call Aldrich Chemical Company, you would dial 44-1747-822-211.

- Aldrich Chemical Company, Ltd., The Old Brickyard, New Road, Gillingham, Dorset SP8 4JL, UK; (01747) 822-211.
- *Alternative Photographic Review*, 1 Mabbotts Yard, Penzance, Cornwall TR 18 2 TD, UK. This is a relatively new journal devoted to the historic processes. Some excellent writers, such as Mike Ware, write for the journal.
- E. S. Caswell. Caswell carries the Chen-Fu nonsupercoated bromoil paper. Fax (01933) 315-003.
- Conservation Resources, Ltd., Unit 1, Pony Road, Horspath Industrial Estate, Cowley, Oxfordshire OX4 2RD, UK; (0865) 747-755; fax (0865) 747-035. As the name implies, the company has high-grade conservation materials, ranging from books and chemical restoration products to archival print and negative storage containers. The catalog is well worth getting just for the enlightening article about paper chemistry.
- Falkiner Fine Papers, Ltd., 76 South Hampton Row, London WC1B 4AR, UK; (0171) 831-1151. This is a great place to find that special paper as well as conservation products. Nice people—write or call for a price list or samples.
- Historical Impressions, John Benjafield, Old Post Office Cottage, Woodrising, Norwich NR9 4AH, UK; (01953) 850-253; *ben@hilgriff.demon.co.uk*. The company specializes in nineteenth-century photographs and the literature of photography.
- Johnson Matthey Chemicals, Ltd., Orchard Road, Royston, Herts SG8 5HE, UK; (01763) 244-161.
- Silverprint, Ltd., 12 Valentine Place, London SE1 8QH, UK; (0171) 620-0844; fax (0171) 620-0129. Silverprint has a great selection of specialty papers and historic process supplies, as well as conventional supplies. Highly recommended. Write or call for their catalog.
- Colin Westgate FRPS, 2 Marine Parade, Seaford, East Sussex BN25 2PL, UK. Westgate supplies the unique Gryspeerdt and the Bromoil Process Video. It has received good reviews and is reasonably priced at £22.45, including postage in the United Kingdom. Write for prices elsewhere. If your video standard is different, such as in the United States, tapes can be inexpensively converted to the proper standard by various companies. For a review, look in the March 1995 issue of *Photon Electronic* magazine.

Other European sources

- ACROS, Janssen Pharmaceuticalaan 3, 2440 Geel, Belgium; 32 (14) 575-211; fax 32 (14) 593-434. This is the main European office, but there are local offices in Belgium, Germany, France, the Netherlands, and the United Kingdom.

- Bergger, 104 Rue de Turenne, 75003 Paris, France; 33-1 (44) 598-688; fax 33-1 (40) 279-974. This French company carries conventional papers and large-format negative material as well as bromoil paper of their own manufacture, sensitized aluminum plates, and carbon tissue from Autotype by the roll.

- Fine Print Studios, Klaus Pollmeier, Muhlenfeld 43; D 45470 Mulheim a/d Ruhr, Germany; 49 (208) 431-051; fax 49 (208) 433-937; *100561.2417@compuserve.com*. The company's specialty is historic processes. It has supplies ranging from bromoil brushes to chemicals, papers, and books; and hopes to have a new nonsupercoated bromoil paper available soon. Workshops are also given for these processes. The company has frozen commercially made carbon tissue still in stock; refer to the chapter on carbon for caveats and testing. An excellent, knowledgeable source. Ask for a catalog. Incidentally, Fine Print Studios can supply most, if not all, of the chemistry used in this book.

Sources of Supplies: North America

- ACROS Organics, 711 Forbes Avenue, Pittsburgh, PA 15219, USA; (800) 227-6701; fax (800) 248-3079.

- A Photographers Place, P.O. Box 274, Prince Street Station, New York, NY 10012-0005, USA; (212) 431-9358; fax (212) 941-7920. The company specializes in photographic books, usually with very good prices. It also has used books available. An excellent source. Ask for the catalog.

- Aristogrid Products, 35 Lumber Road, Roslyn, NY 11576, USA; (516) 484-6141; fax (516) 484-6992. The company specializes in cold-light heads for practically any enlarger. Perhaps of more interest is its platinum printer with a specially designed tube. Ask for a catalog.

- Artcraft Chemicals, P.O. Box 583, Schenectady, NY 12301, USA; (518) 355-8700 or (800) 682-1730. The company specializes in photographic chemicals and can probably find anything that you need at a reasonable price. It will also make kits to order. The company can supply the chemistry for the argyrotype, the type II cyanotype, and the Ware print-out platinum/palladium process. Call for information.

- Dick Blick, (800) 447-8192. The company carries graphic art supplies.

- Boreal, 399 Vansickle Road, St. Catherines, Ontario L2S 3T4, Canada; (800) 387-9393; fax (800) 668-9106. The company carries general chemical supplies.

- Bostick and Sullivan, P.O. Box 16639, Santa Fe, NM 87506-6639, USA; (505) 474-0890; *richsul@roadrunner.com*. A terrific source for alternative photography supplies including platinum/palladium supplies, bromoil paper and brushes, a wide range of chemicals and related books, as well as kits for type II cyanotypes. The company has good prices, a lot of experience, and excellent-quality ferric oxalate. It has reprints of many out-of-print books, such as *The Autotype Book* and *Photo Miniature*, as well as the sometimes hard-to-find Nadeau books and the platinum book by Arentz. Get the catalog; it's good reading.

- Calumet Photographic, 890 Supreme Drive, Bensenville, IL 60106, USA; (708) 860-7458 or (800)

225-8638; fax (708) 860-7105. The company has camera and darkroom supplies and is also a very good source for gelatin and glass filters, not to mention other supplies. Calumet currently carries kits for the argyrotype and type II cyanotype. The service is dependable and professional. Ask for the catalog.

- Center for Safety in the Arts (CSA), 2124 Broadway, Box 310, New York, NY 10023, USA; *www.artswire.org:70/1/csa*; *csa@artswire.org*. They have a range of over seventy books and pamphlets about safety in the arts and can tell you where to obtain these publications.

- Chicago Albumen Works, Front Street, Housatonic, MA 01236, USA; (413) 274-6901; fax (413) 274-6934. The company will make enlarged negatives to order. It also carries a fine line of print-out paper.

- Condit Manufacturing Co., Philo Curtis Road, Sandy Hook, CT 06482, USA; (203) 426-4119. The company carries a vast assortment of pin-registration equipment, including a pin-registered contact printer.

- Conservation Resources International, Inc., 8000 H Forbes Place, Springfield, VA 22151, USA; (703) 321-7730; fax (703) 321-0629. As the name implies, the company has high-grade conservation materials, ranging from books and chemical restoration products to archival print and negative storage containers. The catalog is well worth getting just for the enlightening article about paper chemistry.

- Crown Art Products Co., Inc., 90 Dayton Avenue, Passaic, NJ 07055, USA; (201) 777-6010. The company makes pin-registration sets, which are getting more difficult to find these days.

- Darkroom Innovations, P.O. Box 3620, Carefree, AZ 85377, USA; (602) 488-5117; fax (602) 488-9782; *www.darkroom-innovations.com*; *73354.2425@compuserve.com*. The company carries the computer programs designed by Phil Davis for making sophisticated film curves, as well as specialty developing tubes for large format and more. You won't find this equipment anywhere else. Call for a catalog.

- Doran Enterprises, Inc., 2779 South 34th Street, Milwaukee, WI 53215, USA; (414) 645-0109. The company makes aluminum contact printing frames, ranging in size from 8×10-inches (20×25 cm) to 16×20 inches (40×50 cm).

- Edmund Scientific, 101 East Gloucester Pike, Barrington, NJ 08007-1380, USA; (609) 573-6295; international (609) 573-6263; fax (609) 573-6295. They have a huge assortment of science-related items, ranging from lasers and pinholes to lenses, labware, and glue.

- Evercolor Corporation, fax (916) 939-9302; *evercolor@aol.com*

- Fisher Scientific, 52 Fadem Rd., Springfield, NJ 07081; (800) 766-7000 for customer service. Fischer Scientific Ltd., 112 Colonnade Rd., Nepean, Ontario K2E 7L6, Canada; (800) 234-7437; fax (800) 463 2996; *www.fischersci.ca*

- Freestyle Sales Company, 5124 Sunset Boulevard, Los Angeles, CA 90027, USA; (213) 660-3460; fax (213) 660-4885; *foto@freestylesalesco.com*

- Gallery 614, 0350 C.R. 20, Corunna, IN 46730, USA; (219) 281-2752; fax (219) 281-2605. The company is strictly involved with the carbon process and has frozen, commercially made carbon tissue still in stock. Refer to the chapter about carbon for caveats and testing.

- D. F. Goldsmith, 909 Pitner Ave., Evanston, IL 60202, USA; (708) 868-7800. The company supplies precious metals such as silver nitrate and gold chloride.

- Great Basin Photographic, HC 33 Box 2, Las Vegas, NV 89214, USA; (702) 363-4490; fax (702) 363-4490; *ginthner@source.asset.com*. The company makes good-quality wooden contact frames from walnut or cherry, ranging from 4 × 5 inches (10 × 12 cm) to 20 × 24 inches (50 × 60 cm).

- Edward R. Hamilton, Bookseller, Falls Village, CT 06031-5000, USA. Yes, this is the complete address! The company has no phone since it is a mail-order business only. The monthly catalog has thousands of books in all categories but, most important, many in photography. Discounts range up to 90%! Write for a catalog.

- Doug Kennedy, 3851 20th Street, San Francisco, CA 94114, USA; (415) 824-7821. He makes contact printing frames of oak, ranging in size from 11 × 14 inches (28 × 35 cm) to 20 × 24 inches (50 × 60 cm).

- Kremer Pigments, 228 Elizabeth Street, New York, NY 10012, USA; (212) 219-2394; orders (800) 995-5501; fax (212) 219-2395; *www.sfo.com/~sinopia/*. An excellent source of pigments.

- David Lewis, P.O. Box 254, Callander, Ontario PO14 1HO, Canada; (705) 752-3029. He carries supplies for bromoil printing, including inks and brushes and may have a nonsupercoated paper available soon. He has recently written a book on this topic and also gives workshops on bromoil. Call or write for details.

- Light Impressions, 439 Monroe Avenue, P.O. Box 940, Rochester, NY 14603-0940, USA; (800) 828-6216; fax (716) 442-7318. This is a great source for archival supplies and books with superb service. Call for a catalog.

- Luminos Photo Corp., P.O. Box 158, Yonkers, NY 10705, USA; (914) 965-4800; fax (914) 965-0367. The company has kits for type II cyanotypes (new cyanotype) and also has precoated cyanotype fabric by the yard. It also carries a kit for the argyrotype. Other kits, including bromoil, may be available in the near future.

- Mottweiler Photographic, P.O. Box 817, Ranchos de Taos, NM 87557, USA; (505) 751-3255. The company makes printing frames in one size—8 × 10 inches (20 × 25 cm)—from alder wood and Baltic birch.

- Nash Editions, 2309 North Sepulveda Boulevard, Manhattan Beach, CA 90266, USA; (310) 545-4352. The company creates high-quality color and black-and-white prints with a specially (expensively) modified IRIS-type printer with special inks. It can provide scans and print on any substrate that can be bent around the printing drum.

- New American Platinotype Company, 200 Boston Avenue, Suite 2450, Medford, MA 02155, USA; (617) 391-3006; fax (617) 393-0817. This company can provide high-quality scans, large-format negatives from scans for alternative processes, and also IRIS or platinum prints from negatives or digital files.

- Northwest Supply, Ltd., 90 Monarch Road, P.O. Box 1356, Guelph, Ontario N1H 648, Canada; (519) 836-7720. The company carries general chemical supplies.

- The Palladio Company, Inc., #2400, 200 Boston Avenue, Medford, ME 02155, USA; (617) 393-0811 or (800) 628-9618; fax (617) 393-0817. This unique company makes and sells platinum-sensitized paper and UV light sources, one with a built-in vacuum frame. It is also a good source for large sizes of film, such as Agfa N-31P. Excellent quality and support. Get their catalog.

- Photo-Eye Books, 376 Garcia Street, Sante Fe, NM 87501, USA; (505) 988-5152; fax: (505) 988-4955; *www.photoeye.com*. A very comprehensive selection of photography and related books, great service. Get the catalog.

- Photographer's Formulary, P.O. Box 950, Condon, MT 59826, USA; (406) 754-2891 or (800) 922-5255; fax (406) 754-2896. The company specializes in photographic chemicals and kits, including salted paper, kallitype, gum, and platinum. It also has the sometimes hard-to-find Nadeau books. Call for a catalog.
- Powell's Books, 1005 West Burnside, Portland, OR 97209, USA; (503) 228-4651 or (800) 878-7323; fax (503) 226-2475; *www.powells.com/*. This bookstore, as noted in the Internet resources, has over one million new and used books, naturally including a fine selection of books on photography.
- *Shutterbug*, P.O. Box 1209, Titusville, FL 32781-1209, USA. This monthly magazine is one of the best sources available for used and new equipment, most at reasonable prices. The equipment range includes a large listing of view cameras, lenses, and darkroom equipment.
- Daniel Smith, 4150 First Avenue South, P.O. Box 84268, Seattle, WA 98124-5568, USA; (206) 223-9599 or (800) 426-6740; fax (206) 223-0672. A terrific source for pigments, papers, and related supplies. Ask for the catalog.
- Stouffer Graphic Arts Equipment Company, 319 North Niles Avenue, South Bend, IN 46617, USA; (219) 234-5023. An excellent source for reasonably priced step tablets in many sizes.
- Tri-Ess Sciences, 1020 West Chestnut Street, Burbank, CA 91506, USA; (818) 247-6910. The company's specialty is chemicals and related material.
- Ultrastable Color Systems, 500 Seabright Avenue, Suite 201, Santa Cruz, CA 95062, USA; (408) 427-3000; fax (408) 426-9900. The company manufactures a unique pigment-coated sheet with a polyester substrate that is presensitized. The process requires a screened or halftone negative.
- VRW Scientific Canada, 2360 Argentia Road, Mississauga, Ontario L5N 527, Canada; (800) 932-5000. This is a scientific supply house.
- Zone VI Studios, Inc., Newfane, VT 05345-0219, USA; (802) 257-5161; fax (802) 257-5165. The company has specialty photographic supplies, mostly of its own unique design, including an enlarger that's easily converted from 5×7 inches (13×17.5 cm) to 8×10 inches (10×25 cm) and wooden view cameras and contact frames. All with a lifetime guarantee. Write for the catalog.

Internet Resources

Because of the rapid expansion of the Internet, sources and sites seem to come and go at a dizzying pace. Hopefully, the resources given below will be around for a while, but it should be kept in mind that it is not uncommon for Web addresses to change or disappear. The sites given here may be regarded as the tip of the iceberg—they will link you to many, many more sites on related topics. There are, by the way, many photo exhibits that can be seen on the Net.

More and more sources, like the resources listed above, are getting on the Net every day, so keep looking. Use a World Wide Web search engine to find these and other sites; it's usually worth the investment of time. Different search engines tend to return different items, so it's worth trying more than one. For example, Alta Vista is very good at finding obscure things quickly but not in order of interest. Infoseek, on the other hand, reports in order of interest and finds somewhat different items. Keywords, such as *alternate process photography, platinum, gum bichromate*, etc., will usually locate interesting sites and related links.

WWW search engines

Altavista	*www.altavista.digital.com*
Argus	*www.lib.umich.edu/chhome.html*
Excite	*www.excite.com*
Infoseek	*guide.infoseek.com*
Lycos	*www.lycos.com*
Open Text	*www.opentext.com*
Webcrawler	*webcrawler.com*
Yahoo	*www.yahoo.com*

Books, new and used

- *www.massmedia.com/~mikeb/cissale.html#textsearch*. This is a massive link to book lists. Since there are something like five megabytes of books from different places, the added flexibility to be able to search by name/author makes this list easy to use. An example from this list is given below:
- David Morrison Books: *www.teleport.com/~morrison/morrison2/index.html*
- J. P. Books: *www.jpbooks.com/oldbooks/jpbooks/photo.htm*
- Mark Woehrle Books. There are many good booksellers. This one is for used photographic books, some of them rare. Many nineteenth- and early-twentieth-century books and magazines can be found here: *www.massmedia.com/~mikeb/catalogs/markwoehrle.cat*
- Pacific Rim Books. Many book titles and subjects from which to choose: *www.fidalgo.net/pacrimbks/photography.html*
- Pawprint Books. Send your snail mail address for its list of over two thousand books, or make a request for a search of print titles: *www.pawprintbooks.com/* (e-mail: *pawprint@buttercup.cybernex.net*)
- Photo-Eye Books. The store specializes in photography books and has a huge collection of over eight thousand books: *www.photoeye.com*
- Powell's Books. This bookstore has over one million new and used books of nearly every description. Naturally it has a fine assortment of photography books: *www.powells.com/*

E-mail discussion groups

There are many e-mail discussion groups that include photohistory, photoart, large format, Photoshop, and photogenealogy. A list of these, including a brief description of each, is available at: *www.rit.edu/~andpph/photolists.html*

Alt-photo-process

This is a group with a specialized interest in the alternate processes and is highly recommended.
- Join the group by sending an e-mail to: *listproc@vast.unsw.edu.au*. In the body of the message type: *subscribe alt-photo-process* and your name.
- A FAQ (frequently asked questions) sheet can be accessed by sending a message to: *listproc@vast.unsw.edu.au*. In the body of the message type: *get alt-photo-process faq*

- The postings are organized in archives that are a gold mine of information for those willing to look. To access an index, send a message to: *listproc@vast.unsw.edu.au*. In the body of the message type: *index alt-photo-process*. To access a particular archive, send a message to: *listproc@vast.unsw.edu.au*. In the body of the message type: *get alt-photo-process archive-yymm* (where *yy* is the year and *mm* is the month; for example, January 1995 would be 9501).

The archives are also accessible through its Internet site. To say that there's a lot of great information at this site would be an understatement. A must-visit: *dukeusask.ca/~holtsg/photo/faq.html*

Health and safety

- *palimpsest.stanford.edu/bytopic/health/* will return a very good gopher site with MSDSs and such topics as biohazards, ergonomics, cumulative trauma disorders, and much more.
- Arts, Crafts and Theater Safety, Inc. (ACTS) at *www.caseweb.com/acts/* provides "professional information about hazards posed by toxic materials and dangerous equipment used in art and theater." It provides the only free information on hazards in theater and the arts and can be consulted by phone (212 777-0062), mail (181 Thompson Street, #23, New York, NY 10012, USA), and e-mail (*ACTS@CaseWeb.com* or directly to Monona Rossol at *75054.2542 @compuserve.com*).
- Center for Safety in the Arts (SA) at *www.artswire.org:70/1/csa* Once you're in the menu, go to the art hazards menu, then go to the visual arts hazards files. This is well worthwhile; they have information on pigments, photo chemicals, visual arts hazards to reproduction, and a very good list of over seventy books and pamphlets.

Material Safety Data Sheets

Use your Web browser to search for *MSDSs*. There are many sources available; just a sample is listed here.

- *frontpage1.shadow.net/usa829fl/* This site is still being completed but promises to be an excellent resource for safety information. Selecting *Health/Safety* on the menu will connect you to Monona Rossol's page with further links to MSDS sources. Ms. Rossol can also be reached by e-mail for specific questions about safety and hazards in the visual arts (*75054.2542@compuserve.com*).
- *hazard.com/vtsiri/vtsiriact/n-safety.html* This site will give you information about an e-mail group that discusses environmental and occupational safety and health issues.
- *ntp-server.niehs.nih.gov/Main_Pages/NTP_ARC_PG.html* This is the National Toxicology Program (NTP) annual/biennial report on carcinogens.
- *ntp-support.nieh.nihgov/hdocs/arc/arc_Index_Noframe.html* This NTP server will also search out carcinogens.
- *ntp-server.niehs.nih.gov/cgi/ice-form_ARC.cgi* This NTP server provides searches and reports on current carcinogens.
- *ull.chemistry.uakron.edu/cgi.bin/wwwwais* This source of MSDSs from the University of Akron has over 1300 entries.
- *www.bna.com/bnac/bc_sttop.html* This site provides information on dichromate handling safety.
- *www.chem.utah.edu/MSDS/msds.html* This source of MSDSs is at the University of Utah.

- *www.efn.org/~fryguy/msds.html* This site has excellent MSDS links.
- *www.enviro-net.com/technical/msds/* This is Enviro-Net—an excellent site for MSDSs.
- *www.epa.gov/ngispgm3/iris/* This source for MSDSs is at the University of Oxford.
- *www.nwfsc.noaa.gov/msds.html* This site is maintained by the Northwest Fisheries Science Center. It provides several links to sources of MSDSs.

General information and resources

- *cyberbeach.net/~dbardell/bellows.html* This site has instructions for making bellows as well as information on pinhole photography.
- *everest.hunter.cuny.edu/~rwheeler/pinhole.html*
- *members.aol.com/dcolucci/index.html* An article on the albumen process, history of photographs from daguerreotypes to paper. Many good links.
- *www.csd.uu.se/~s93bni/photography.html* This site also has designs for building wooden 4×5 pinhole cameras.
- *www.cyberbeach.net/~dbardell* This site includes instructions for making bellows.
- *www.home.sn.no/~gjon/* This site has instructions for making your own large-format camera and darkroom equipment.
- *www.sn.no/~gjon* This site has information about pinhole and infrared photography. It also has images and very good links to other sites.
- *www.goodmedia.com/bignoll/build.html* This site has, among other things, an exposure guide, formulas for pinhole construction, and a gallery.
- *www2.ari.net/glsmyth/* This site also has links to information about the Ziatype, albumen printing, and the type II cyanotype (new cyanotype).
- *yatcom.com/pinhole/PINHOLE.html* This is an excellent site offering premade cameras, pinhole cameras, books, images, and some great links to related sites.
- Albumen. *public.asu.edu/~billjay/albumen_george.html* An excellent article on the albumen process.
- American Photographic Society. *superexpo.com/APHS.htm*
- Apogee Photo. *www.apogeephoto.com* This is an online photo magazine that includes workshop schedules and articles.
- Artcraft Chemicals. *www.nfinity.com/~mdmuir/artcraft.html;* e-mail: *jacobson@juno.com* This site is the online catalog from Artcraft. If you're looking for chemicals, the company probably has them. The service is prompt and accurate.
- Bengt's Photo Page. *www.algone.se/~bengtha/photo/* This is a very large site with too much information to list. Lots of very good links, too. It's worth a visit.
- Bostick and Sullivan. *www.bostick-sullivan.com/;* e-mail: *richsul@roadrunner.com* From Richard Sullivan, the developer of the Ziatype, this is the site to visit if you're looking for information about the Ziatype or platinum/palladium process. Lots of information, frequently updated, and interesting images. It's worth a visit.
- Bryant Laboratory, Inc. *www.concerto.com/bryant/html;* e-mail: *72050.2415@ compuserve. com* This is a good source for chemicals and labware, with excellent customer service. Unfortunately, it ships only within the United States.

- Daguerrian Society. *java.austine.edu/dag/*
- Darkroom and technical. *www.users.dircon.co.uk/~migol/photo/links.html* A darkroom meta-index. This is an enormous site with too much to list here.
- Darkroom Innovations. *www.darkroom-innovations.com/*; e-mail: *73354.2425@ compuserve. com* The company carries the computer programs designed by Phil Davis for making sophisticated film curves, as well as specialty developing tubes for large format. You won't find this equipment anywhere else.
- Digital and Photoshop tips. *the-tech.mit.edu/KPT/KPT.html* This site has good links to Photoshop-related links.
- Exhibits. *liu.se:80/~behal/photo/exhibits.html* This site has many links to Web exhibits.
- FAQ (frequently asked questions). *duke.usask.cal~holtsg/photo/faq.html* This is a very good starting point for information about the historic processes, ranging from the calotype to platinum print.
- Fisher Scientific. *www.fisher1.com* The company has a massive catalog of equipment and chemicals, also MSDSs.
- Freestyle Sales Co. *www.freestylesalesco.com* The company has many good deals on large-format negative materials, as well as paper and other related supplies. They carry precoated cyanotype material on paper as well as on fabric.
- History of photography. *www.kbnet.co.uk/rleggat/photo*
- Kremer Pigments. *www.sfo.com/~sinopia/* Note the company's address and phone number in the section above. An excellent source of pigments.
- Luminos. *www.luminos.com* Luminos carries kits for the argyrotype and the type II cyanotype (new cyanotype). Other kits, including bromoil, may be available in the near future.
- Maximum Monochrome. *www.nfinity.com/~mdmuir* This site has some solid information about developing formulas that you aren't likely to find elsewhere. It also has some very good links. Pay this one a visit.
- Luis Nadeau. *www.micronet.fr/~deriencg/nadeau.html* From the well-known author of alternate photography books, a very interesting site—worth a visit.
- Out-opts. *www.treeo.com/out-opts/fineartoutput.html* This is a site with information about Evercolor, UltraStable, inkjet printers, and more.
- Photographer's Formulary. *www.montana.com/formulary/*; e-mail: *formulary@ montana. com* The company carries kits and chemicals for nearly everything. It sells the type II (new cyanotype) kits and Luminos nonsupercoated paper.
- Photography exhibits. *math.liu.se:80/~behal/photo/exhibits.html* This is a very good source of photo exhibits and online exhibits.
- Photogum. *www.algonet.se/~photogum* A Net site for gum printing, it also has great links and a very good archive.
- Photon. *194.143.182.105/photon/photon.html* This is an electronic photographic magazine ("e-zine"). It has interesting articles and reviews as well as a useful archive.
- Polaroid transfer. *www.hooked.net/users/dupreh/trans.html* A good site for those interested in the Polaroid transfer process.
- RIT Photography. *www.ntid.edu/*; e-mail: *ritphoto@rit.edu* The Rochester Institute of Technology needs no introduction. This site has much useful information.

- Royal Photographic Society. *www.rps.org/*
- Silverprint Ltd. *www.silverprint.co.uk* The company has a great selection of specialty papers and supplies for the historic processes as well as conventional photography.
- Twinrocker Paper Company. *www.dcwi.com/~twinrock/welcome.html* This American company manufactures fine art paper for watercolor and other uses.
- Mike Ware. *www.mikeware.demon.co.uk* From the well-known English chemist and photographer, an excellent site with detailed instructions for his processes—print-out platinum/palladium, the type II cyanotype (new cyanotype), and the argyrotype, as well as other interesting items and images. If you're looking for information about these unique processes, this is the place to go.

Bibliography

Adams, Ansel. *The Negative.* Boston: Little, Brown and Company, 1981.

Airey, Theresa. "Photo-Transfers Using Copier Materials." *Darkroom and Creative Camera Techniques,* vol. 15, no. 2, 1994.

Anchell, Steve. "A Step by Step Approach to Gum Bichromate Printing." *Darkroom Photography Magazine,* March: 46, 1993. (a)

Anchell, Steve. "Gum Printing." *Darkroom Photography Magazine,* April: 30, 1993. (b)

Anderson, Paul L. "Special Printing Processes." In *Handbook of Photography* by K. Henney and B. Dudley. London: Whittlesey House, 1939.

Arentz, Dick. *An Outline of Platinum and Palladium Printing.* 2d ed. Self-published, 1990. Arentz is well known for his platinum printing skills. This is a self-published text by a recognized authority and is available from the author, Bostick and Sullivan, Artcraft Chemicals, and possibly Photo-Eye and A Photographers Place.

Atkins, Anna. *Sun Gardens.* New York: Aperture, 1985. Reproductions of her cyanotype work done between 1843 and 1853.

Babin, Angela. *Art Painting and Drawing.* New York: The Center for Safety in the Arts, 1991.

Baker, T. Thorne. *Photographic Emulsion Technique.* 2d ed. London: Chapman and Hall, 1949.

British Journal of Photography. *Photographic Almanac.* London: Henry Greenwood & Co., 1930.

Burbank, W. S. *Photographic Printing Methods.* 3d ed. 1891. Reprint. New York: Arno Press, 1973.

Burkholder, Dan. *Making Digital Negatives for Contact Printing.* San Antonio, Texas: Bladed Iris Press, 1995. An extremely well-thought-out how-to book for using computer photographic programs to make digital reproduction negatives. Available from Light Impressions, Photo-Eye, and possibly other mail-order sources.

Centers for Disease Control. "Carcinogenicity of Acetaldehyde and Malonaldehyde" and "Mutagenicity of Related Low-Molecular-Weight Aldehydes." *NIOSH Current Intelligence Bulletin* 55, 1991.

Clark, N., T. Cutter, and J. A. McGrane. *Ventilation: A Practical Guide.* New York: Center for Safety in the Arts, 1995.

Clayton, George D., ed. *Patty's Industrial Hygiene and Toxicology.* 4th ed. New York: Wiley Interscience, 1994.

Clerc, L. P. *Photography Theory and Practice.* London: Henry Greenwood & Company, 1930. This book,

long out of print, contains an amazing amount of information. A local university or public library may have a copy that you can look through.

Crane, Tillman. "Making Enlarged Negatives." *View Camera Magazine,* September/October 1992. It's well worth getting a copy of this exceptionally clear article from the magazine, located in Sacramento, California.

Crawford, William. *The Keepers of Light.* Dobbs Ferry, N.Y.: Morgan and Morgan, 1979. This contemporary book is an important work on the history and working procedures of historic processes. It belongs on any serious worker's bookshelf.

Ctein. 1983. "How to Use Professional Direct Duplicating Film." *Photographic,* January 1983. A very comprehensive article outlining how to get the most out of direct duplicating film.

Cutler, Bernice Halpern. "Albumen Printing." *Darkroom Photography,* December 1988. This is one of the few contemporary articles describing albumen.

Davis, Phil. "Curing Agitation Woes." *Darkroom and Creative Camera Techniques,* vol. 10, no. 6, 1989.

Davis, Phil. "Applying Personal Sensitometry." *Darkroom and Creative Camera Techniques,* vol. 13, no. 1, 1992. An excellent article about using Kodak T-Max film and basic sensitometry to make a duplicate negative for platinum/palladium printing.

Davis, Phil. "Basic Techniques of Gum Printing." *Photo Techniques,* vol. 17, nos. 1 and 3, 1996. The first part of this two-part article gives a basic overview of gum printing, including mixing the gum and pigments and sensitizing and processing the print. The second part provides a very good account of making a three-color gum print, along with a clear explanation of using a laser printer to make an enlarged separation negative from a computer program.

Eaton, George T. *Photographic Chemistry.* New York: Morgan and Morgan, 1986. This is a small but well-done book that explains the chemical side of photography in understandable terms.

Encyclopedia of Photography. London: Focal Press, 1969.

Gabriel, Leonard G. *Bromoil and Transfer: A Practical Manual for the Photographic Worker.* London: Henry Greenwood & Co, 1930.

Green, Robert F. *The Monochrome Trichrome Carbro-Carbon Handbook.* 3d ed. Corunna, Ind.: Gallery 614, 1981. This small book gives working details about the carbro-carbon process and tricolor printing.

Hall, Henry. "The Kallitype Process." *The Photo Miniature,* vol. IV, no. 47, 1903. This is a classic: *Photo Miniature* is in large part responsible for the continued interest in the kallitype.

Hasluck, Paul N., ed. *The Book of Photography.* London: Cassell and Company, 1905.

Hawley, Gessner. *Hawley's Chemical Dictionary.* 12th ed. New York: Van Nostrand Reinhold, 1991.

Henney, Keith and Beverly Dudley. *Handbook of Photography.* London: Whittlesey House, 1939. This book contains a section of special processes written by Paul Anderson that is very interesting.

Henry, Richard J. *Controls in Black and White Photography.* 2d ed. Stoneham, Mass.: Focal Press, 1986. Henry dispels many myths by carefully testing in a controlled and repeatable fashion, and provides much useful information.

Honigsfeld, Carole. "Cyanotype." *Photographic Magazine,* March 1982.

Hubl, A. von. *Der Silberdruk auf Salzpapier.* Halle, Germany: Wilhelm Knapp, 1896.

Jilg, Mark and Dennis McNutt. "Masking Black and White Negatives." *Darkroom and Creative Camera Techniques* vol. 10, nos. 4–6, 1989. This is a three-part series of articles that give a clearly detailed account of how to extensively modify negative contrasts with masks.

Kachel, David. "Rotary Processing in Trays." *Darkroom and Creative Camera Techniques* vol. 16, no. 4, 1995.

King, S. Carl. "Re: Carbon Printing." *Alternate Photo Process* (online), November 12, 1995. Available by e-mail: *listproc@vast.unsw.edu.au*

King, S. Carl. "Bl/Daylight Exposure." (original sender Phil Davis.) *alt-photo-process* (online), January 3, 1996. (a) Available by e-mail: *listproc@vast.unsw.edu.au*

King, S. Carl. "Carbon Printing UV/Cool White." (discussion). *alt-photo-process* (online), January 16, 1996. (b) Available by e-mail: *listproc@vast.unsw.edu.au*

Koenig, Karl. "Van Dyke Printing." *Darkroom and Creative Camera Techniques,* vol. 13, no. 3, 1992.

Koenig, Karl P. *Gumoil Photographic Printing.* Boston: Focal Press, 1994. This book describes an interesting but somewhat difficult method of using oils to create unique images based on the gum process.

Kosar, Jaromir. *Light Sensitive Systems: Chemistry and Application of Nonsilver Halide Photographic Processes.* New York: John Wiley and Sons, 1965. Although not recent, this book contains highly detailed information on nonsilver processes not found elsewhere.

Laughter, Gene. *Bromoil 101.* Self-published, 1997. Available from Bostick and Sullivan.

Lewis, David W. *The Art of Bromoil and Transfer.* Self-published, 1995. Available from Photo-Eye or directly from David Lewis (see sources in the appendix).

Lewis, Richard J. Sr., ed. *Sax's Dangerous Properties of Industrial Materials.* 8th ed. 1992. Updated. New York, Van Nostrand Reinhold Co., 1993. This book, which is periodically updated, lists many, if not most, of the chemicals mentioned in this text.

Lide, David R. *CRC Handbook of Chemistry and Physics.* 71st ed. Boca Raton, Fl.: CRC Press, 1990.

Luna, Nitza. "Blue Cyanotypes: An Archival Printing Process for Purists." *Photographic Magazine,* March 1992.

Malde, Pradip. "New Solutions for Platinum Printers." *View Camera Magazine,* September/October 1994. This is essentially the same article as the one done by Ware (1986) in the *British Journal of Photography.* It describes the first workable contemporary print-out platinum process in detail and also gives very useful details of how to use humidification to influence color and maximum density.

Matus, Todd. *Carbon Printing.* Self-Published, 1983.

Mayer, Emil. "Bromoil Printing and Bromoil Transfer." *American Photography* Vol. XX, 1926.

The Merck Index. 12th ed. Rahway, N.J.: Merck & Co, 1996. This book, which is regularly updated, has information on nearly all chemicals, including chemical structure, toxicity levels, uses, further references, and more (see also the company Web site at *www.merck.com*).

Nadeau, Luis. *Modern Carbon Printing.* Fredericton, New Brunswick, Canada: Atelier Luis Nadeau, 1986. Each of Nadeau's books is thoroughly researched, documented, and presented in a clear manner. He has a tremendous amount of experience, which shows very clearly. If you're at all serious, his books belong in your library. It's available from the author and from mail-order houses such as Bostick and Sullivan, Photo-Eye, and A Photographers Place.

Nadeau, Luis. *Gum Bichromate and Other Direct Carbon Processes.* Fredericton, New Brunswick, Canada: Atelier Luis Nadeau, 1987. Available from the author and from mail-order houses such as Bostick and Sullivan, Photo-Eye, and A Photographers Place.

Nadeau, Luis. *The History and Practice of Platinum Printing.* 2d ed. Fredericton, New Brunswick,

Canada: Atelier Luis Nadeau, 1989. This compact text by an internationally recognized expert should be on your reference shelf. It's available from the author and from mail-order houses such as Bostick and Sullivan, Photo-Eye, and A Photographers Place.

Neblette, C. B. *Photography, Its Materials and Processes.* 5th ed. New York: D. Van Nostrand Company, 1952.

The NIOSH Registry of Toxic Effects of Chemical Substances. NIOSH (online): *www.cdc.gov/niosh/homepage.html.* Available by e-mail: *Pubstaff@niosdt1.em.cdc.gov.*

O'Hara, Charles E. and James W. Osterburg. *Practical Photographic Chemistry.* Minneapolis, Minn.: American Photographic Publishing Company, 1951.

Piper, C. Welborne. *The Photographic News,* 16 August, 1907. (a)

Piper, C. Welborne. *The Photographic News,* 6 September, 1907. (b)

Procter-Gregg, Georgia. "The Gelabrome Process." Paper presented at a meeting of the Royal Photographic Society, London, 1978.

Reilly, James M. *The Albumen and Salted Paper Book.* Rochester, N.Y.: Light Impressions Corporation, 1980. Sadly, this fine book is out of print. It's the best and most comprehensive source of information about these two processes done in recent times.

Reilly, James M. *Care and Identification of Nineteenth-Century Photographic Prints.* Kodak Publication Number G-2S. Rochester, N.Y.: Eastman Kodak Company, 1986. An excellent guide, highly recommended.

Rice, Ted. *Palladium Printing Made Easy.* Santa Fe, N. Mex.: Eagle Eye Text Production, 1994. This text is apparently the only one to deal exclusively with palladium printing. It's available from Photo-Eye Books.

Roosevelt, Kate. "Cyanotypes." *Darkroom Photography Magazine,* May: 32, 1992.

Rossol, Monona. *The Artist's Complete Health and Safety Guide.* 2d ed. New York: Allworth Press, 1994. This book is almost unique in both scope and concept. With considerable background, Rossol gives a clear view to health risks and safe practices with artist's materials.

Rudiak, John. "Creating a Platinotype." *View Camera Magazine,* July/August 1994. This article describes using hydrogen peroxide in the sensitizer solution instead of potassium chlorate.

Ruth, Ken. "Blue Brew." *Darkroom Photography Magazine,* April: 38, 1992.

Sandquist, Michael. "Carbon Printing." *View Camera Magazine,* November/December 1990.

Scopick, David. *The Gum Bichromate Book: Contemporary Methods for Photographic Printmaking.* Rochester, N.Y.: Light Impressions Corporation, 1987. This is probably the most comprehensive single work about gum printing presently available. It's well worth having.

Shaw, Susan and Monona Rossol. *Overexposure: Health Hazards in Photography.* New York: Allworth Press, 1991. This book should be required reading for every photographer. There's no reason not to know the risks involved in photography and the safest way to approach them, particularly the historic processes. It belongs on your bookshelf.

Steinberg, Robert J. *Palladio Instruction Manual.* Cambridge, Mass.: The Palladio Company, 1990.

Stevens, Dick. *Making Kallitypes: A Definitive Guide.* Stoneham, Mass.: Butterworth- Heinemann, 1993. If you have any interest in kallitypes, this is, as the title states, the definitive and best guide available. Also included as a chapter is one of the most comprehensive explanations available about making ferric oxalate.

Sullivan, Richard. *Labnotes*. Van Nuys, Ca.: Bostick and Sullivan, 1982. (a) This collection of Sullivan's notes is worth having for his variation on making ferric oxalate, not to mention the information about platinum.

Sullivan, Richard. *Lumen Number 1*. Van Nuys, Ca.: Bostick and Sullivan, 1982. (b)

Sullivan, Richard. *Lumen V*. Van Nuys, Ca.: Bostick and Sullivan, 1985.

Sullivan, Richard. "Pt/Pd Standing Questions." *alt-photo-process* (online), October 14, 1994. Available by e-mail: *listproc@vast.unsw.edu.au*

Sullivan, Richard. "Sullivan's Gold Toning for Pt. Prints." *alt-photo-process* (online), March 7, 1996. Available by e-mail: *listproc@vast.unsw.edu.au*

Symmes, Ernest M. "Notes on the Carbro Process." *American Photography Magazine,* May: 38, 1947.

Thijs, Henk. "Re: Bromoil." *alt-photo-process* (online), February 27, 1996. Available by e-mail: *listproc@vast.unsw.edu.au*

Towler, J. *The Silver Sunbeam*. 2d ed. 1864. Reprint. Hastings-on-Hudson, N.Y.: Morgan and Morgan, 1969. This small book has a large amount of information in it about nearly all known processes up to 1864, including manufacture of chemicals and step-by-step directions for the processes.

Vee, J. "Monochrome Carbon Printing." *Darkroom Photography Magazine,* March: 40, 1992.

Wade, Kent. *Alternative Photographic Processes*. Dobbs Ferry, N.Y.: Morgan and Morgan, 1978. This book has unfortunately gone out of print. If you can find it, buy it, since the chances are that you won't find another copy anytime soon. Wade covers fascinating processes, ranging from photo-etching metal to color copier work and three-color separation.

Wall, E. J. *The Photographic News,* 12 April, 1907.

Wall, E. J. *Wall's Dictionary of Photography*. Revised and rewritten by A. L. M. Sowerby. London: Fountain Press, 1945.

Wall, E. J. and F. I. Jordan. *Photographic Facts and Formulas*. Revised and rewritten by John S. Carroll. Garden City, N.Y.: American Photographic Book Publishing Company, 1976. This book is out of print, but it contains many formulas and procedures that are difficult to find elsewhere.

Ware, Michael J. "Platinum Reprinted." *The British Journal of Photography*, October 1986. This is essentially the same article published by Malde (1994) in *View Camera Magazine*.

Ware, Michael J. "Carbon Printing/UV/Cool White." (discussion). *alt-photo-process* (online), January 10, 1996. Available by e-mail: *listproc@vast.unsw.edu.au*

Ware, Michael J. *Cyanotype. www.mikeware.demon.co.uk: 1997.* (a)

Ware, Michael J. *Argyrotype. www.mikeware.demon.co.uk: 1997.* (b)

Ware, Michael J. *Print-out Platinum/Palladium. www.mikeware.demon.co.uk: 1997.* (c)

Weese, Carl. "Ziatype: A Brand-New Nineteenth-Century Process." *PHOTO Techniques* vol. 18, no. 4, 1997. This is an excellent article on the Ziatype.

Whalley, G. E. *Bromoil and Transfer*. London: Fountain Press, 1961.

Wynne, Thomas A. *The Kallitype*. Missoula, Mont.: Photographers' Formulary, 1982.

Notes

1. Clayton, et al. (1994).
2. Lewis (1992).
3. Hawley (1991).
4. Lide (1990).
5. NIOSH (1997).
6. Shaw and Rossol (1991).
7. Centers for Disease Control (1991).
8. Shaw and Rossol (1991).
9. See the section on *Health and Safety References.*
10. See the section of *Sources of Supplies: North America.*
11. Shaw and Rossol (1991).
12. Rossol (personal communication, 1996).
13. Eaton (1986).
14. Focal Press (1969).
15. Sullivan (1982a) gives another method of making ferric oxalate in his *Labnotes,* and Stevens (1993) gives several.
16. Ibid.
17. Nadeau (1989).
18. Wall (1945).

Index

Books from Allworth Press

Mastering Black-and-White Photography: From Camera to Darkroom
by Bernhard J Suess (softcover, 6¾ × 10, 240 pages, $18.95)

Creative Black-and-White Photography: Advanced Camera and Darkroom Techniques
by Bernhard J Suess (softcover, 8½ × 11, 192 pages, $24.95)

ASMP Professional Business Practices in Photography, Fifth Edition
by the American Society of Media Photographers (softcover, 6¾ × 10, 416 pages, $24.95)

Pricing Photography, Revised Edition
by Michal Heron and David MacTavish (softcover, 11 × 8½, 144 pages, $24.95)

The Photographer's Guide to Marketing and Self-Promotion, Second Edition
by Maria Piscopo (softcover, 6¾ × 10, 176 pages, $18.95)

How to Shoot Stock Photos That Sell, Revised Edition
by Michal Heron (softcover, 8 × 10, 208 pages, $19.95)

Stock Photography Business Forms
by Michal Heron (softcover, 8½ × 11, 128 pages, $18.95)

Business and Legal Forms for Photographers, Revised Edition
by Tad Crawford (softcover, 8½ × 11, 192 pages, $24.95)

Legal Guide for the Visual Artist, Third Edition
by Tad Crawford (softcover, 8½ × 11, 256 pages, $19.95)

The Law (In Plain English)® for Photographers
by Leonard DuBoff (softcover, 6 × 9, 208 pages, $18.95)

Re-engineering the Photo Studio: Bringing Your Studio into the Digital Age
by Joe Farace (softcover, 6 × 9, 224 pages, $18.95)

The Photographer's Internet Handbook
by Joe Farace (softcover, 6 × 9, 224 pages, $18.95)

Overexposure: Health Hazards in Photography, Second Edition
by Susan D. Shaw and Monona Rossol (softcover, 6¾ × 10, 320 pages, $18.95)

Please write to request our free catalog. To order by credit card, call 1-800-491-2808 or send a check or money order to Allworth Press, 10 East 23rd Street, New York, NY 10010. Include $5 for shipping and handling for the first book ordered and $1 for each additional book or $10 plus $1 for each additional book if ordering from Canada. New York State residents must add sales tax.

If you would like to see our complete catalog on the World Wide Web, you can find us at *www.allworth.com*